THE OLDEST LIVING THINGS IN THE WORLD

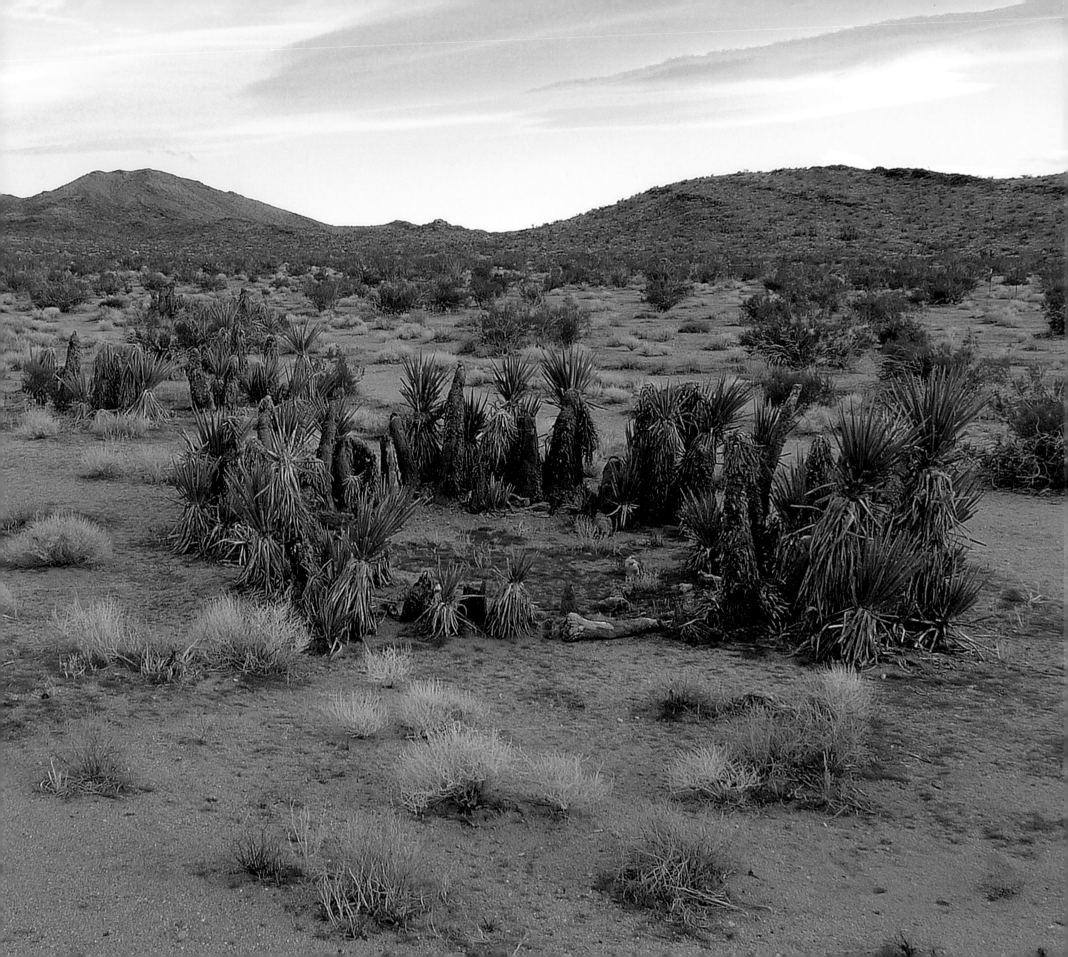

{ RACHEL SUSSMAN }

the oldest living things in the world

WITH ESSAYS BY HANS ULRICH OBRIST AND CARL ZIMMER

PHOTOGRAPHY EDITOR *Christina Louise Costello*
INFOGRAPHICS *Michael Paukner*

THE UNIVERSITY OF CHICAGO PRESS ✳ CHICAGO AND LONDON

RACHEL SUSSMAN
is a contemporary artist based in
Brooklyn. Her photographs and
writing have been featured in the
New York Times, *Wall Street Journal*,
Guardian, and NPR's *Picture Show*.
She has spoken on the TED main
stage and at the Long Now Founda-
tion, is a MacDowell Colony and
NYFA Fellow and is a trained
member of Al Gore's Climate Real-
ity Leadership Corps. Her work has
been exhibited in museums and
galleries in the US and Europe and
acquired for museum, university,
corporate, and private collections.

The University of Chicago Press, Chicago 60637
The University of Chicago Press, Ltd., London
© 2014 by Rachel Sussman
Essay © 2014 by Hans Ulrich Obrist
Essay © 2014 by Carl Zimmer
All rights reserved. Published 2014.
Printed in Canada

23 22 21 20 19 18 17 16 15 5 6 7 8 9 10 11 12

ISBN-13: 978-0-226-05750-7 (cloth)
ISBN-13: 978-0-226-05764-4 (e-book)
DOI: 10.7208 / chicago / 9780226057644.001.0001

Library of Congress Cataloging-in-Publication Data
Sussman, Rachel, 1975– photographer, author.
 The oldest living things in the world / Rachel Sussman ; essays by Hans Ulrich Obrist
and Carl Zimmer ; photography editor: Christina Louise Costello ;
infographics: Michael Paukner.
 pages cm
 Includes index.
 ISBN 978-0-226-05750-7 (cloth : alkaline paper) — ISBN 978-0-226-05764-4 (e-book)
1. Longevity. 2. Longevity in art. 3. Organisms—Pictorial works. I. Obrist, Hans-Ulrich, writer
of added commentary. II. Zimmer, Carl, 1966– writer of added commentary. III. Title.
 QH528.5.S87 2014
 2013048562

This paper meets the requirements of ANSI / NISO Z39.48-1992
(Permanence of Paper).

FOR MADELINE

AND ABIGAIL WITH HOPE

FOR THE FUTURE

ONCE WE LOSE OUR FEAR OF BEING TINY, WE FIND OURSELVES

ON THE THRESHOLD OF A VAST AND AWESOME UNIVERSE WHICH DWARFS—

IN TIME, IN SPACE, AND IN POTENTIAL—THE TIDY ANTHROPOCENTRIC

PROSCENIUM OF OUR ANCESTORS.

CARL SAGAN

ALL PHOTOGRAPHS ARE MEMENTO MORI. TO TAKE A PHOTOGRAPH IS TO PARTICIPATE IN ANOTHER PERSON'S (OR THING'S) MORTALITY, VULNERABILITY, MUTABILITY. PRECISELY BY SLICING OUT THIS MOMENT AND FREEZING IT, ALL PHOTOGRAPHS TESTIFY TO TIME'S RELENTLESS MELT.

SUSAN SONTAG

Contents

Preface

Nine billion years passed between the big bang and the formation of the Earth. It would be nearly another billion years before the first signs of life would appear, and even then our planet would have seemed not only foreign to us, but completely unrecognizable. There were no continents, nor was there nearly enough oxygen for us to breathe comfortably. It was the stromatolites—a unique amalgam of living, biologic matter and geologic, nonliving sediments—that are credited with oxygenating our atmosphere via photosynthesis, thereby setting the stage for all lives to come. It took a while. Today, the oldest living stromatolites are between 2,000 and 3,000 years old, still behaving in much the same fashion as their ancestors of 3.5 billion years past.

The Oldest Living Things in the World spans disciplines, continents, and millennia: it is part art and part science, innately tied to the environment, and underscored by an existential journey into deep time. I research, work with biologists, and travel the world to photograph continuously living organisms 2,000 years old and older. The photographs are images of the past in the living present, portraits of individuals meant to forge a personal connection to a time frame well outside our temporal comfort zone. By bringing living form to an otherwise abstract number, it encourages an anthropomorphic connection to a deep timescale that, more often than not, is too physiologically challenging for our brains to hold on to. Photography is the ideal medium to capture the temporal tension: thousands of years of a life, distilled down to small fractions of a second.

These ancient survivors have weathered the millennia on every continent, in some of the world's most extreme environments, enduring ice ages, geologic shifts, and humans' spread across the planet. Many are so small that you could walk right over them, none the wiser. Others are so large that you can't help but stand in awe before them. I've photographed thirty different species, ranging from lichens in Greenland that grow only one centimeter every hundred years, to unique desert shrubs in Africa and South America, a predatory fungus in Oregon, brain coral in the Caribbean and an 80,000-year-old colony of aspen in Utah. I journeyed to Antarctica for 5,500-year-old moss, and to Tasmania for a 43,600-year-old clonal shrub that is the last individual of its kind, rendering it simultaneously critically endangered and theoretically immortal.

The oldest living things have borne witness to the entirety of human history. The wheel and cuneiform in Mesopotamia—inventions that mark the birth of civilization—emerged about 5,500 years ago, the same age as the Antarctic moss on Elephant Island. Anything previous is prehistory. The 13,000-year-old Palmer's oak in the industrial sprawl of Riverside, California, lived through the die-off of giant reptiles, birds, and mammals that seem more like the stuff of science fiction, such as giant condors, mastodons, saber-toothed tigers, and even the last of the camels that once roamed North America. It was just 17,000 years ago that what might have been the closest relative to modern *Homo sapiens*, *Homo floresiensis*, went extinct. That was not very long ago.

Other individuals in this ancient club move at a more geologic pace: there are liv-

ing shrubs, clonal forests, sea grass meadows, and bacteria that predate the last ice age by tens of thousands of years, and in some cases, predate the human race altogether. The Antarctic beeches that now live in Queensland, Australia, for instance, used to populate Antarctica in its milder days . . . 180 million years ago. As the Gondwana landmass broke apart and the south got colder, the Antarctic beeches worked themselves northward to more suitable climes. Their original habitat was disappearing around them, leading to certain death, so, not unlike contemporary climate refugees, the Antarctic beeches had to find a new place to call home. It's hard enough for people to uproot themselves and make new homes in new lands. Imagine the perseverance and the cooperation over generations it would require for *trees* to make such a journey in the name of self-preservation. Plants move around on their own volition much more than you might think. Root by root, the Antarctic beeches pointed themselves in the direction they needed to go. Are we there yet? Their oldest surviving progeny are 13,000 years old.

What is the oldest continuously living thing in the world? We currently believe it to be the Siberian Actinobacteria, living underground in the permafrost, clocking in between 400,000 and 600,000 years old. The colony was discovered by a team of planetary biologists looking for clues to life on other planets by investigating one of the most inhospitable places on Earth. Over the course of their investigation, they found that these remarkable bacteria are actually doing DNA repair at temperatures below freezing, meaning that they are not dormant; they have been alive and slowly growing for half a million years.

What does it mean when the organic goes head-to-head with the geologic? We start talking about deep time and the quotidian in the same breath, along with all the strata in between. All of these organisms are living palimpsests: they contain myriad layers of their own histories within themselves, along with records of natural and human events; new chapters written over the old, year after year, millennium after millennium. When we look at them in the frame of deep time, a bigger picture emerges, and we start to see how all of the individuals have stories, and that all of those stories are in turn interconnected—and in turn, inextricably connected to us all.

How have these organisms lived so long? And why? Scientists know some of these answers on an individual level, but the scientific discipline of analyzing comparative longevity across species is so new it doesn't yet exist. We don't yet know if, or

how, this tantalizing staying power might be applied to human life spans. But while some of these ancient subjects flirt with immortality, we've also lost two of them in the past five years alone. I would like to see UNESCO designations bestowed upon each and every one of them. They deserve our respect and attention. But it is climate change—the ultimate emergency in slow motion, now unequivocally upon us—that must be dealt with head-on while there's still a fighting chance. These organisms are global symbols that transcend the things that divide us.

The oldest living things in the world are a record and celebration of the past, a call to action in the present, and a barometer of our future.

Essay

I was recently asked by John Brockman, in his annual Edge Question, "What *should* we be worried about?"

My answer was extinction.

Today we face multiple facets of extinction, such as the diversity in culture, language, and society through globalization, but it is one of the major problems our ecological system is affected by. The extinction of animal and plant species happens every day and every hour. Scientists today are increasingly debating the possibility of the extinction of human civilization, and even of the species itself. In his book *Our Final Hour* the astronomer Martin Rees questions whether civilization will survive beyond the next hundred years.

The spectre of extinction is felt across the humanities, too. In philosophy, Ray Brassier finds the inevitable fact of our eventual extinction to be of considerable philosophical interest. For Brassier, this single fact grounds the ultimate meaninglessness of human existence, and thus the only proper response for philosophy is to fully embrace and pursue the radically nihilistic implications of this most basic insight. As he writes in his book *Nihil Unbound* (2007), "Philosophy is neither a medium of affirmation nor a source of justification, but rather the organon of extinction." *Nihil Un-*

bound proposes a confrontation with the stark fact of nature's indifference to human being itself and to the fact that, as a species, we are only on this planet for a short time. For Brassier, "Nihilism is . . . the unavoidable corollary of the realist conviction that there is a mind-independent reality, which, despite the presumptions of human narcissism, is indifferent to our existence and oblivious to the 'values' and 'meanings' which we would drape over it in order to make it more hospitable." Most would stop short of this absolute nihilism, and there are of course other places to look.

The artist Gustav Metzger, for instance, has made extinction a central theme of his practice. In works that make use of his enormous archive of newspapers, he stresses the point that the prospect of human extinction is continually raised in the innumerable little extinctions that continuously occur in the world. By re-presenting newspaper stories on the subject of extinction, Metzger highlights the problem of our collective attitude of resignation in the face of the sheer regularity of this disappearance, and our apparent impotence regarding the major cause of its recent acceleration: climate change. As he comments: "Global warming is something that people are prepared to adjust to and are willing to adjust to." As Metzger has pointed out throughout his more than sixty-year career, the forward march of global capitalism has irreversible effects upon the world and its resources. And as these effects continue to snowball beyond our control, the challenges of survival and the spectre of extinction become ever more pressing. The fate of species and ecosystems, indeed the fate of humankind itself, rests in the balance, and the demand for urgent, globally coordinated action to halt the world's environmental decline simply cannot be repeated too often. Today, more than ever before, we should worry about extinction.

HANS
ULRICH
OBRIST

With Rachel Sussman's archive of *The Oldest Living Things in the World,* she establishes a kind of countermovement to what is the main focus when one talks about extinction. Sussman searches for living organisms that have actually survived for a long period of time. In doing so, she is unintentionally setting something against the general fear of extinction by emphasizing what has been living for a time span of at least 2,000 years; according to her presetting for the project, the individuals were not allowed to be "younger" than this. With this constraint Rachel Sussman is stretching our sense of the past in a whole different dimension—and this in times of which the late Eric Hobsbawm wrote that "modern society . . . essentially operates without a sense of the past; the standard method of solving problems doesn't consider the past. Yet in terms of human beings and society, the past is not irrelevant."[1] He emphasizes the importance of an awareness of the past, by saying that "everybody, in fact, is rooted in the past—in a personal past, in a social past—and knows it, and is interested in it. If you forget what happened in the past you simply have to repeat the same mistakes over and over again."[2]

Therefore Hobsbawm brought up what he calls "the protest against forgetting." And this is what Sussman's artistic research project constitutes, by finding the oldest living things in the world. Why allude only to what is threatened by extinction? Why not allude to the fact that something has survived for such an enormous amount of time (which does not mean that it is not threatened, as she states in her book)?

Rachel is an artist working at the interface of art and science, as she has been continually in contact with scientists all over the world who researched and even discovered organisms that are thousands of years old. At the same time she is an artist with a concept: to find the oldest living things in the world. What sets her apart from other conceptual artists is that her research project is closely related to the research of a scientist. The pursuit of a certain scientific problem that in fact has been overlooked before puts aside the focus on the aesthetics of depiction for the moment, in favor of a scientific research that she realized through empirical field studies all around the world.

1. Retrieved from: *032c Magazine* 17 (Summer 2009), http://032c.com/2009/eric-hobsbawm/, accessed September 1, 2013.
2. Ibid.

Sussman does not only utilize scientific strategies and tools for the aesthetics of her work; she actually builds up an archive, consisting of the images from the organisms, diagrams, and maps. Therefore the product of her research develops into an archive that will be the foundation of what will travel into the future. The oldest living things may well not be a clear category science-wise, but it is a category that is defined by curiosity, humane character, a fascination with deep time, and the courage of an explorer.

Sussman herself sees that her "role as an artist [is] to answer some questions, but to ask many more," and I am sure she will unearth many more questions where she finds answers, all over the world.

XVII

HANS
ULRICH
OBRIST

Essay

CARL ZIMMER

It is easy to feel sorry for the gastrotrich. This invertebrate animal, the size of a poppy seed and the shape of a bowling pin, swarms by the millions in rivers and lakes. After it hatches, it takes only three days to develop a complicated body, complete with a mouth, a gut, sensory organs, and a brain. Having reached maturity in just seventy-two hours, the gastrotrich starts laying eggs. And after a few more days, it becomes enfeebled and dies of old age.

To squeeze a whole life into a week seems like one of nature's more cruel tricks. But that's only because we are accustomed to measure our lives in decades. If the ancient animals and plants featured in this book could look upon us, they might feel sorry for us as well. We humans marvel at the longest-living human on record, Jean Calment, who lived from 1875 to 1997. But for a 13,000-year-old Palmer's oak tree, Calment's 122 years rushed by as quickly as a summer vacation.

Palmer's oaks, gastrotrichs, and all the species in between are the products of evolution. The head-swimming diversity of life is joined in an evolutionary tree made up of tens of millions of branches. And one of the most spectacular of that diversity's dimensions is longevity. If natural selection provides Palmer's oaks with millennia, why does it only spare a gastrotrich a week of existence?

Starting in the 1960s, evolutionary biologists have searched for an overarching explanation to account for all the different ways to grow old. The best-supported ones so far are variants on the old truth that a jack-of-all-trades is a master of none. An organism can collect a finite amount of energy, whether it's a lion killing gazelles, a tulip capturing sunlight, or a microbe breathing iron at the bottom of the sea. It can use that energy to grow, to produce offspring, to defend itself against pathogens, to repair its damaged molecules. But it has a limited budget. The energy spent on one task is energy that can't be spent on others.

Molecular repair and pathogen defense are both good ways to live longer. But a long-lived organism that produces few offspring will not pass on many copies of its genes to future generations. The organisms that will succeed are the ones that do a mediocre job of keeping their bodies in order, leaving more energy for making babies.

This balance goes a long way to explaining why some species live long and some short. It may give scientists clues to how we humans might battle the burdens of aging, such as Alzheimer's disease. But this balance is only part of the answer to why things live as long as they do. The environments in which species live may also be a part of the answer. In some places, life may simply run slower. Some lineages may evolve a way out of the binds that tie most species. They may escape the trade-offs that come with channeling energy in one direction or another, and be free to live longer.

The durable mystery of longevity makes the species in this book all the more precious, and all the more worthy of being preserved. Looking at an organism that has endured for thousands of years is an awesome experience, because it makes us feel like mere gastrotrichs. But it is an even more awesome experience to recognize the bond we share with a 13,000-year-old Palmer's oak tree, and to wonder how we evolved such different lifetimes on this Earth.

Acknowledgments

My heartfelt thanks to every single person who helped me along this journey of many years and many miles: the scientists, researchers, friends, strangers who reached out with ideas, strangers who became friends along the way, families-of-friends-of-friends who put me up in far-flung places, everyone who forged a connection, shared what they had, pointed me in the right direction, and helped with "a little way through." Heck, even that saying was a little gift. Thanks, Mara Bunn.

Thank you to my family: to my brother Scott and sister-in-law Lindsey, on whom I can always count, to my mother Shirley for always being my number one agent and providing a safety net through financially uncertain times, and to my sisters Lisa and Sara and stepfather Arthur for their tireless enthusiasm.

A bear hug to the MacDowell Colony, especially Cheryl Young and David Macy, who helped me build the confidence to pursue my art with a full heart back in 2005, and who graciously made space for me to complete the text for this book in the summer of 2013. There's no place in the world I'd rather have been.

Thank you to all the good folks at TED: especially Bruno Giusanni for inviting me speak on the TED stage, and to Amy Novogratz, Dan Mitchell, Kelly Stoetzel, and Chris Anderson, as well as the TED community, who continue to inspire and broaden my horizons in immeasurable ways. Thank you to everyone at the Long Now Foundation, and especially to Kevin Kelly for the early vote of confidence. Thank you to the grant makers at AOL 25for25 Artists and Innovators, to Paige West and the West Collection, David de Rothschild and the Sculpt the Future Foundation, and

Sven Lindblad and Lindblad Expeditions (without whom I probably would still be trying to get to Antarctica).

Thank you to Jerry Saltz for encouraging me to break down any walls in need of breaking, to Maria Popova for her unwavering support, to Tina Roth Eisenberg, who first put my work on the map, and to Mark Hurst of the GEL Conference, who first coaxed me up on stage to start talking about it. Thank you to every single one of my 2010 Kickstarter backers and Brooklyn Arts Council supporters. Thank you to the Mac Group for tuning up my trusty Mamiya 7 II after it went on some particularly rough adventures, as well as for outfitting me with some much-needed gear. Thank you to Patagonia for making sure I was properly bundled up in Antarctica.

I raise a glass to Christina Costello of MoMA for her keen and tireless eye—not to mention good humor—in editing down thousands of images over countless hours. My thanks to the team at the University of Chicago Press, especially Jill Shimabukuro and Carol Saller, for bringing tangible form to this expansive and complex project, to Caroline Zimmerman for setting this in motion, and to Katherine Flynn for seeing it through. To Alex Goldmark, Debbie Millman, Claire Mysko, Agnieszka Gasparska, and Ruben Gutzat—thank you for showing up for this, not because you had to, but because you wanted to. Sunny Bates, Andrew Roffman, Tonia Steed and Vic Bondi, Manu Lusch and Mukul Patel, David Rowan, Bettina Korek, Robert Elmes, Katherine Keating, the entire extended Todd family, Joan Borinstein, Charlie Melcher, Sharon Ann Lee: thank you for being there along the way. Your assistance, advice, friendship, and kindness made all the difference in the world.

Last but not least, a world of thanks to Mimi Oka and Jun Makihara for extending the invitation to Japan that would set this journey in motion, and to Jason Grayston and Maki Ito, who, in deciding to talk to a lone traveler, helped change the very course of my life.

LOCATION MAP

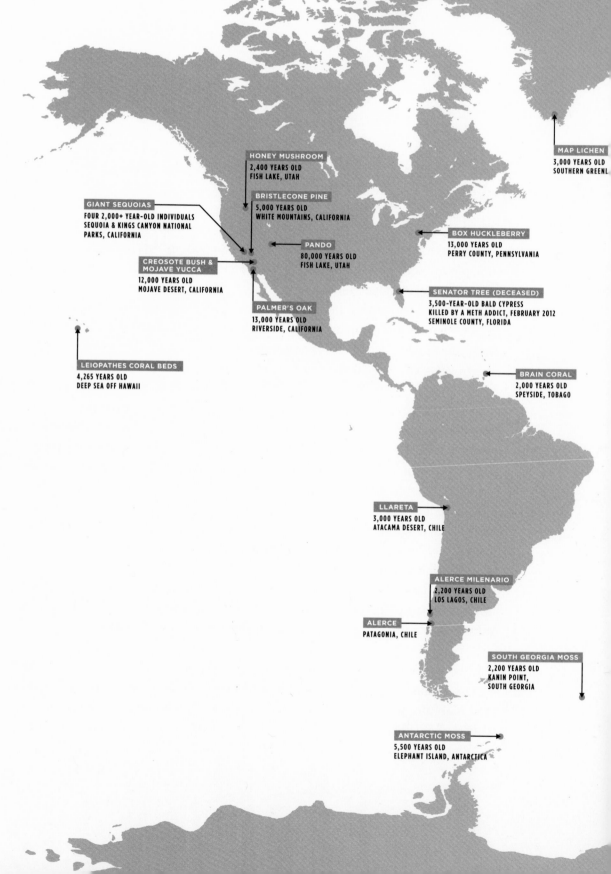

HONEY MUSHROOM
2,400 YEARS OLD
FISH LAKE, UTAH

BRISTLECONE PINE
5,000 YEARS OLD
WHITE MOUNTAINS, CALIFORNIA

GIANT SEQUOIAS
FOUR 2,000+ YEAR-OLD INDIVIDUALS
SEQUOIA & KINGS CANYON NATIONAL
PARKS, CALIFORNIA

PANDO
80,000 YEARS OLD
FISH LAKE, UTAH

**CREOSOTE BUSH &
MOJAVE YUCCA**
12,000 YEARS OLD
MOJAVE DESERT, CALIFORNIA

PALMER'S OAK
13,000 YEARS OLD
RIVERSIDE, CALIFORNIA

BOX HUCKLEBERRY
13,000 YEARS OLD
PERRY COUNTY, PENNSYLVANIA

SENATOR TREE (DECEASED)
3,500-YEAR-OLD BALD CYPRESS
KILLED BY A METH ADDICT, FEBRUARY 2012
SEMINOLE COUNTY, FLORIDA

MAP LICHEN
3,000 YEARS OLD
SOUTHERN GREENL

LEIOPATHES CORAL BEDS
4,265 YEARS OLD
DEEP SEA OFF HAWAII

BRAIN CORAL
2,000 YEARS OLD
SPEYSIDE, TOBAGO

LLARETA
3,000 YEARS OLD
ATACAMA DESERT, CHILE

ALERCE MILENARIO
2,200 YEARS OLD
LOS LAGOS, CHILE

ALERCE
PATAGONIA, CHILE

SOUTH GEORGIA MOSS
2,200 YEARS OLD
KANIN POINT,
SOUTH GEORGIA

ANTARCTIC MOSS
5,500 YEARS OLD
ELEPHANT ISLAND, ANTARCTICA

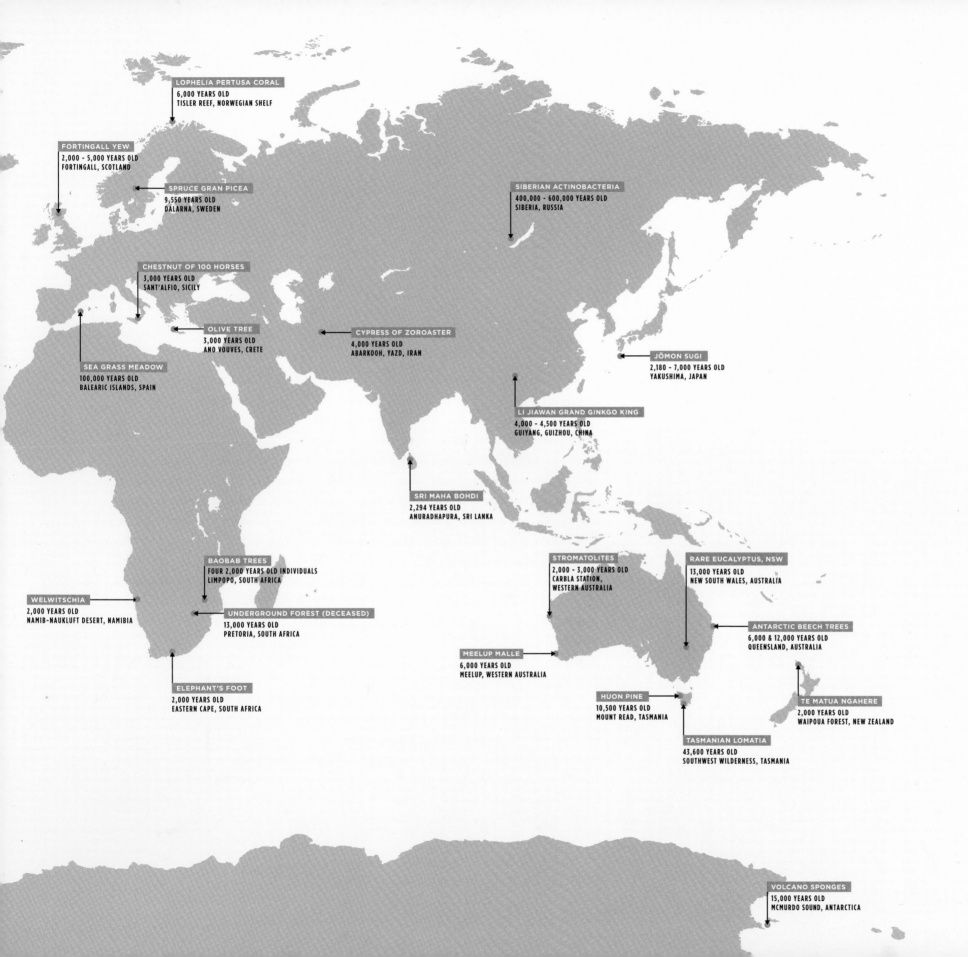

LOPHELIA PERTUSA CORAL
6,000 YEARS OLD
TISLER REEF, NORWEGIAN SHELF

FORTINGALL YEW
2,000 - 5,000 YEARS OLD
FORTINGALL, SCOTLAND

SPRUCE GRAN PICEA
9,550 YEARS OLD
DALARNA, SWEDEN

SIBERIAN ACTINOBACTERIA
400,000 - 600,000 YEARS OLD
SIBERIA, RUSSIA

CHESTNUT OF 100 HORSES
3,000 YEARS OLD
SANT'ALFIO, SICILY

OLIVE TREE
3,000 YEARS OLD
ANO VOUVES, CRETE

CYPRESS OF ZOROASTER
4,000 YEARS OLD
ABARKOOH, YAZD, IRAN

JŌMON SUGI
2,180 - 7,000 YEARS OLD
YAKUSHIMA, JAPAN

SEA GRASS MEADOW
100,000 YEARS OLD
BALEARIC ISLANDS, SPAIN

LI JIAWAN GRAND GINKGO KING
4,000 - 4,500 YEARS OLD
GUIYANG, GUIZHOU, CHINA

SRI MAHA BOHDI
2,294 YEARS OLD
ANURADHAPURA, SRI LANKA

BAOBAB TREES
FOUR 2,000 YEARS OLD INDIVIDUALS
LIMPOPO, SOUTH AFRICA

STROMATOLITES
2,000 - 3,000 YEARS OLD
CARBLA STATION,
WESTERN AUSTRALIA

RARE EUCALYPTUS, NSW
13,000 YEARS OLD
NEW SOUTH WALES, AUSTRALIA

WELWITSCHIA
2,000 YEARS OLD
NAMIB-NAUKLUFT DESERT, NAMIBIA

UNDERGROUND FOREST (DECEASED)
13,000 YEARS OLD
PRETORIA, SOUTH AFRICA

ANTARCTIC BEECH TREES
6,000 & 12,000 YEARS OLD
QUEENSLAND, AUSTRALIA

MEELUP MALLE
6,000 YEARS OLD
MEELUP, WESTERN AUSTRALIA

ELEPHANT'S FOOT
2,000 YEARS OLD
EASTERN CAPE, SOUTH AFRICA

HUON PINE
10,500 YEARS OLD
MOUNT READ, TASMANIA

TE MATUA NGAHERE
2,000 YEARS OLD
WAIPOUA FOREST, NEW ZEALAND

TASMANIAN LOMATIA
43,600 YEARS OLD
SOUTHWEST WILDERNESS, TASMANIA

VOLCANO SPONGES
15,000 YEARS OLD
MCMURDO SOUND, ANTARCTICA

Introduction

I was uneasy, but not entirely sure why. The sensation was amplified by the fact that it was my first time in Japan and I didn't speak the language, save for a few polite and practical phrases, and one improbable idiom more befitting the vernacular of a bygone era: *fundoshi o shimete*, or "tighten your loincloth." This translates to something akin to your grandfather telling you to buck up. It was the summer of 2004, and I was traveling with no agenda other than to make photographs exploring the tenuous relationship between humans and nature. I was fresh off an artist's residency at the Cooper Union, and after a week easing into Tokyo at the invitation of some friends, I wandered the winding streets of Kyoto on my own. Despite the quiet beauty of the temples and gardens, I couldn't help but feel a bit deflated by the Kinkos and Starbucks that punctuated the city. There was something I wanted to get from being in this quasi-ancient place, but I was unsure of what it was—like trying to discern an answer before knowing the question.

I was so uninspired (or, perhaps, uncomfortable) that I was actually considering cutting my trip short; quite unlike me, as I've always felt a pull toward travel in increasingly more unfamiliar places. A suggestion from several unrelated sources gave me pause. I was told to seek out Jōmon Sugi, a supposedly 7,000-year-old tree on the remote island of Yakushima, a several-hour ferry ride off the southernmost point of Kyushu. Once on the island, two full days of hiking are required to visit the tree. I was intrigued. I gave myself permission to go home, but then almost simulta-

neously decided to take my own advice. I bucked up, packed up, and headed in the opposite direction.

The train line ends in Kagoshima, and the next morning I boarded the ferry for Yakushima. While en route, a couple (her, Japanese; him, Canadian) approached me, quick to wonder what would bring a *gaijin* such as myself to this remote place that many know of, but few actually visit. Especially foreigners. Where was I staying, and how was I planning to get to the tree, they asked, eyeing my rolling suitcase. By the time we reached the shore, I was invited to stay with the family they were visiting, and they had decided to join me—or, rather, guide me—to the ancient tree. I was given a place to sleep, lent backpacking and snorkeling gear, and fed grilled *onigiri*. We talked about life and travel and politics. My host family found my fear of the *enormous* spider living in their bathroom deeply funny. And then there was our hike through a UNESCO biosphere reserve, with its endemic deer and monkeys, sea turtles and wild rhododendrons, dense, subtropical rainforest, and the very Japanese manner in which the caretakers of the forest tried to bring order to the bourgeoning vegetation. There was the amusing awkwardness of sleeping on the floor of a hut sandwiched between my new friends and a severe, snoring gentleman (and many other hikers taking shelter from the steady rain), and, finally, the quiet beauty and power of the ancient Japanese cedar, or *sugi*, called Jōmon for that selfsame historical era some 7,000 years ago. I looked up the steep slope at the tree from the viewing area. We took in the sight—massive trunk and gnarled branches, bark deep with the wrinkles of millennia—and then continued our hike to the other side of the island. I didn't have some sort of mystical revelation in that moment, but I knew that in taking a chance and continuing my journey, I'd opened the door to possibilities beyond my own experience and predictions.

I returned home to New York, and went back to my job as an interactive media producer. I attended another artist's residency the following year, this time at the Mac-Dowell Colony, where I'd return eight years later to work on this book, which magnified my sense that something was set in motion, but, almost like being heartsick, I longed to know more clearly what it might be. I was restless. I switched jobs. Then one evening, more than a year after that adventure, I was having dinner at a Thai restaurant in SoHo with some friends. As I was relaying tales of my adventure to them, suddenly all of those disparate, compelling components were vividly interconnected.

I ran home that very night and got to work on *The Oldest Living Things in the World*.

PARAMETERS

It's no coincidence that my subjects are all 2,000 years old and older—I selected that number for precisely this reason: it's downright remarkable that some 200,000 years after our species emerged, we came to a general consensus that the clock was to be reset. (Cue George Carlin,"What year did Jesus think it was?") Of course, it was not nearly so neat a process. The Buddhist calendar started approximately 500 years earlier. The Jewish calendar started in 3750 BCE, and the Chinese calendar started around 2637 BCE, but used a base-60 counting system, with various intercalations and regional and emperor-based anomalies, disallowing a stable, sequential count. The Mayan calendar, on the other hand, ended in 2012. The Long Now Foundation adds a zero up front (i.e., 02014.)

Perhaps we should turn it over to geology entirely: happy 4,500,002,014. Or thereabouts.

After demarcating the starting line, the next thing was to define—as an artist, for purposes of this project—what I would consider to constitute "continuously living." From a philosophical perspective, the idea of endurance on an individual level was the most important consideration, as we all innately relate to the idea of self. But once I started digging into the science, just as with the timescales, things would not prove so tidy. Unitary organisms, such as a single tree, are not hard to keep a handle on. A little trickier is the concept of "clonal colonies." Sometimes referred to as "vegetative growth' or "self-propagating," these individuals are able to generate new "clones" of themselves, if you will, as opposed to reproducing sexually (e.g., pollination in flowering plants). It's not always the case that these organisms *can't* reproduce sexually; it seems that sometimes it's easier to just do it yourself than find a suitable partner. In other words, individuals create new shoots, stems, or roots without the introduction of new outside genetic material. Thus the new growth is genetically identical to—and part of—the original organism; a process that can continue indefinitely, or as long as outside environmental factors allow. (This is what's meant when clones are referred to as theoretically immortal.) While not a perfect analogy, it could be helpful to think of your own body: while you probably

aren't spontaneously sprouting new limbs, with the exception of your neural cells, almost all other types die and regenerate. Throughout your life you are filled with new cells that you didn't have when you were born, but you are still, genetically, the same person.

You'll notice that the age numbers are often rounded, and some of them have ranges. These are often educated guesses. With clonal organisms in particular we find that things are at least a certain age, but possibly much older. Different species are dated using different methodologies.

To help further explain what I include, let me clarify what I do not. This book does not contain pyramids. Because they are not alive. You'd be surprised how many times I've been asked that. Nor does it contain ice or stalagmites and stalactites, which you could consider "living" in a poetic or physical sense but are excluded on the grounds that they are not DNA-based. There are no 2,000-year-old tortoises or whales, but if there were, they'd be in here. Nor is it enough simply to be primitive as a species. While horsetails, for instance—referred to as "living fossils," along with mosses, liverwort, and ferns—have an exceptional lineage reaching all the way back to the Precambrian era, there are none that live very long as individuals. I do not include organisms that have undergone extended periods in suspended animation or otherwise nonseasonal dormancy, nor ancient seedpods coaxed into germination. Nor am I interested in the largest/smallest/youngest living things. Superlatives don't interest me per se.

I chose only to seek out the oldest individuals—unitary organisms and clonal colonies alike—that have been alive for 2,000 years or more. It turned out that approaching longevity across species as an artist without a rote scientific methodology was a blessing in disguise. At first I'd sought out a scientist to partner with, but what I hadn't considered is that most science is an ever-specializing practice, and what I was setting out to do was quite broad, and as of yet undefined. After speaking with a couple evolutionary biologists, despite their enthusiasm for the idea, they deemed themselves unqualified.

So, before I could start looking for my subjects, I had to figure out what my subjects where. While finding old tree lists wasn't difficult, there was not an existing list of ancient life across all species that met my criteria. I pieced it together, first

Horsetails

NORTHERN CHILE

with some creative Google searches, and then by drilling down into the work of scientists across many specialties and subspecialties. The list grew—and sometimes shrank—the more I learned. It's a fluid and still ongoing process. Best was when I could find published, peer-reviewed papers, then the researchers who penned them. More often than not they have been more than happy to share their work with me, often extending invitations to join them in the field. I wouldn't have understood a fraction of the richness of their work and experiences had I simply read their papers and left it at that.

While I've endeavored to be as accurate as possible and support my statements with research, there is a chance that I misunderstood or misinterpreted something along the way. Additionally, it's helpful to keep in mind that the science isn't done. The science is never done, really. By the time you are reading this, things could be different. New facts and figures might have been discovered, old techniques debunked. As the physicist Freeman Dyson said, "All of science is uncertain and subject to revision. The glory of science is to imagine more than we can prove."

It was important to me to create an art project that was not simply "using" science. The best art and science projects enhance and extend each other, bringing something new to both; they are not about simply making the research pretty, or making artworks using novel scientific tools. Conceptually, I was able to take on this scientifically motivated work that the researchers themselves find interesting and valuable, yet sit outside of conventional scientific methodologies. There may be more that unites artists and scientists than divides them. Practitioners of both search for answers—Truth with a capital T, even—hoping to invent or discover or craft something that shakes up old thinking and makes a lasting impact on the world. Both artists and scientists employ analytic and synthetic approaches, take risks, and engage in sophisticated thinking in uncharted territories. There are a lot of happy accidents. I believe it's my role as an artist to answer some questions, but to ask many more. I've heard many scientists say the same.

Most of my photographs were made with a 6 × 7 medium-format film camera employing only natural light. I make large-format prints that have a physical presence meant to put viewers into human-scale context with the subjects, while simultaneously obscuring the organisms' exact scales. The title of each piece is a handwritten nod to the tradition of scientific field notes, and is part of the work. Each title com-

prises the organism name, date photographed, catalog number, age, and location.

While some early forms of scientific engagement are known to have been present in prehistoric cultures, it wasn't until the nineteenth century that science emerged as a formal, specialized field. Art, on the other hand, was important to the human experience even before we were fully human. Neanderthals were using ochre pigment for ornamental purposes 250,000 years ago, and many of our earliest relics are cave paintings and musical instruments. Hegel has a theory that as time progresses, the world is coming to know itself. Perhaps art is the very illustration of that idea: a collective creative embodiment of the world coming to know itself. Evolution combined with consciousness produces culture.

TIME / TRAVEL

My first planned expedition outside the United States was to Africa. Armed guards were required in South Africa's Kruger National Park to fend off any lions or other aggressive wildlife that might happen by while I was photographing a baobab tree. Later, I arrived in Namibia only to find the researchers I'd been counting on to guide me to the *Welwitschia* plant had left for Angola, and I had to figure out an alternate way to find it on the spot.

Some misadventures are par for the course. Nuisances such as getting leech bites in Australia and a coral sting in Tobago (I had coral living in my leg for many months afterward) serve as a reminder that you're doing something out of the ordinary. Others require serious and immediate attention, as was the case when I broke my wrist in a remote part of Sri Lanka. I also had moments of bona fide danger, getting lost alone in Greenland with no means of contacting the outside world. My travels were also full of delightful idiosyncrasies, wonderful (and yes, occasionally miserable) people, and the sights, sounds, and tastes of places I never thought I'd go. I faced fears again and again, from fear of driving on the Pan American Highway alone, to my fear of deep water in learning to scuba dive, to crossing the Drake Passage to Antarctica—among the most dangerous open waters in the world—on my first-ever overnight at sea.

Other adventures were of an academic nature, leaving an MFA program and then

a PhD program as I came to internalize the wisdom of Mark Twain's apothegm to never let one's schooling interfere with one's education. There have been financial challenges as well. I am not independently wealthy. There is a special kind of cognitive dissonance to being featured in the pages of the *Wall Street Journal* while simultaneously unable to pay one's rent. Still, I couldn't not do this work.

Sometimes it's not in the objective itself, but rather in the margins, where I've had the most profound experiences.

In Greenland in 2008, I went fishing in a glacial stream with archeologist Martin Appelt and his colleagues. We were hungry, and this was to be dinner. The stream was so packed with colossal trout it was like stepping through a time warp, getting a glimpse of what the planet must have looked like before humans overran it. I threw in a net, and instantaneously caught two. The gentlemen upped the ante and began to fish with their bare hands. It was Appelt who first pinned a trout against a rock, slid it upward toward the surface, and flung the fish onto the shore in one fluid movement. Then he called me over: if I was going to eat this fish, I should be able to kill it.

It was uncanny, but this was my food-chain philosophy put to the test. I'd been completely vegetarian as a teenager and into my twenties, but after a period of feeling less than physically optimal, I reintroduced seafood into my diet. I didn't want to eat something I couldn't (or wouldn't) kill myself, but killing fish felt like a comfortable place in the food chain. Or so I'd told myself. Rock in hand, I struck an unpracticed blow to the trout's head, and then another. Appelt finished the job.

It's a gift to come face to face with your ideologies and put them to the test, whatever they may be. It might unfold in a foreign place, but it's an experience you take with you.

I look back and laugh at an earlier time when I thought I'd never visit Antarctica because it was too cold. Not only did I go, but when I got there I literally dove in—embracing an Antarctic rite of passage, the Polar Plunge. I went headfirst into the Antarctic Sound clad only in a bathing suit, emerging several long moments later through the shock of pure cold, the water palpably heavy and almost viscous at 30°F. It's hard to convey the depth of my awe, both of the moss I went searching for there, and of the first explorers who dared venture into that terrifying unknown. Antarc-

Trout blood and glacial stream

IGALIKU FJORD, GREENLAND

tica and South Georgia are now among my favorite places in the world, along with Greenland and Namibia. These are profound landscapes I doubt I would have ever laid eyes on otherwise. All, in their own ways, are like traveling back in time: windows on what the world must have once been, producing pangs of pain—nostalgia for something devastatingly, unimaginably beautiful that is lost forever into the deep past—coupled with hope that we still might repair some of the damage we've done.

But as with deep water, it's a battle to stay in deep time. We're constantly brought back to the surface, engaged in our thoughts and needs of the moment. Connecting with these organisms that have been alive for at least 2,000 years, however, is not meant to diminish our experience in the here and now; in fact, it's meant to inspire quite the opposite. Perhaps, looking through the eyes of these ancient beings, and connecting with the deepest of deep time, we can borrow their bigger picture and adopt a longer view. I can't think of a single problem in the world that wouldn't benefit from the perspective of long-term thinking.

Spending nearly a decade researching, photographing, and traveling all over the world in search of ancient life puts mortality into perspective. I have a more immediate understanding of the briefness of a single human life (my life, others' lives) in the face of the incomprehensible vastness of "forever," and at the same time, when standing in front of these organisms, there are connections to moments, small as molecules, that shape a constantly unfolding narrative on both a micro and macro scale. Any given moment matters, and we are all in it together.

So with that said, please join me, dear reader, on a little journey back in time and around the world. I invite you to pick up and run with any fact or figment or fragment that captures your imagination—to the lab, to the studio, to conservation, to conversation. You don't have to know what you are looking for yet. Just be sure that you're looking.

NORTH AMERICA

Giant Sequoia

AGE
2,150–2,890 years

LOCATION
Kings Canyon and Sequoia National Parks, California, USA

NICKNAMES
General Sherman, Cleveland, Washington, Sentinel trees

COMMON NAME
Giant sequoia

LATIN NAME
Sequoiadendron giganteum

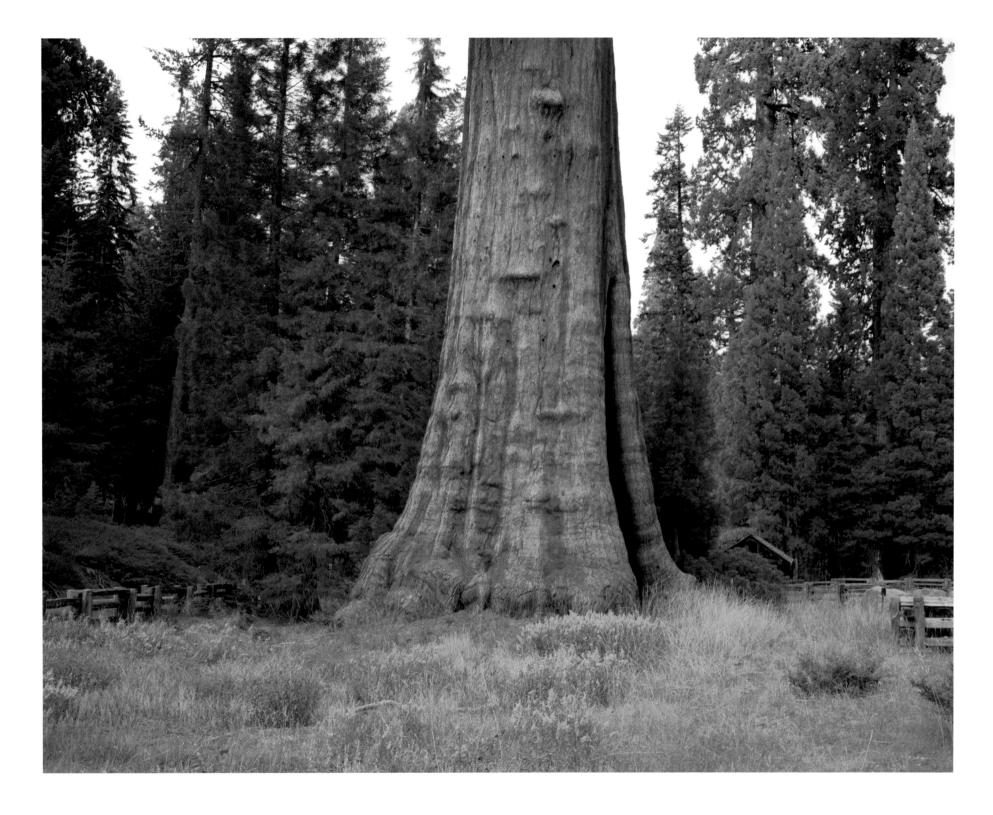

Sentinel Tree #0906-1437 (2,150 years old)

SEQUOIA NATIONAL PARK, CALIFORNIA

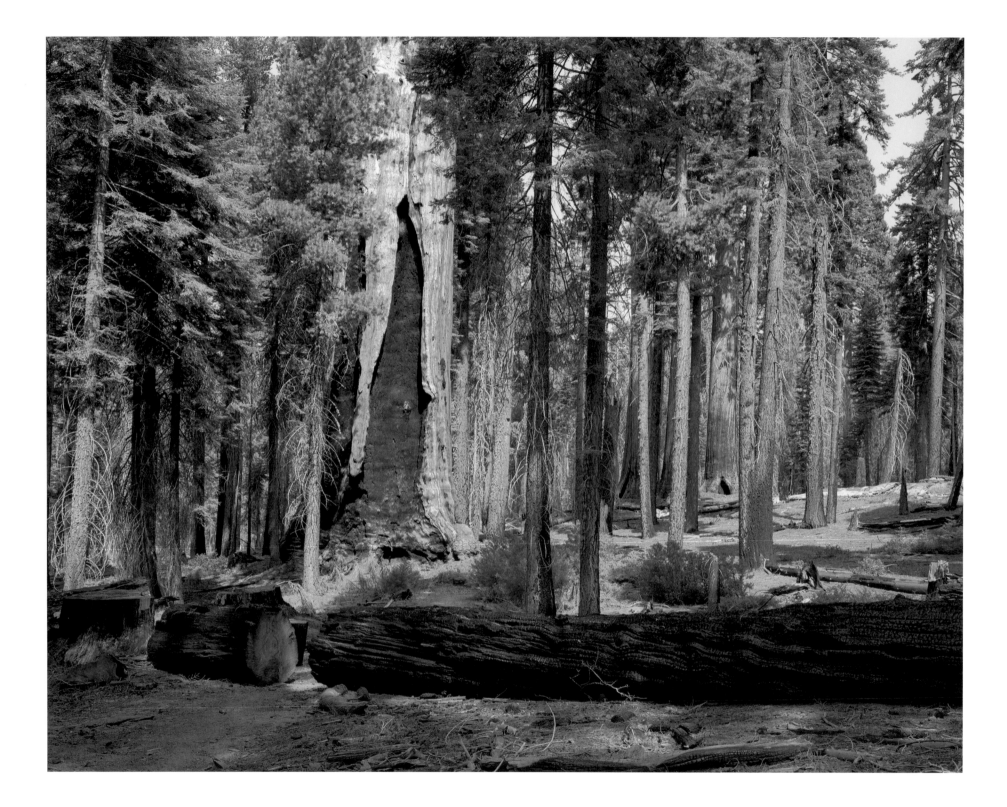

Giant Sequoia with fire damage #0906-2222

SEQUOIA NATIONAL PARK, CALIFORNIA

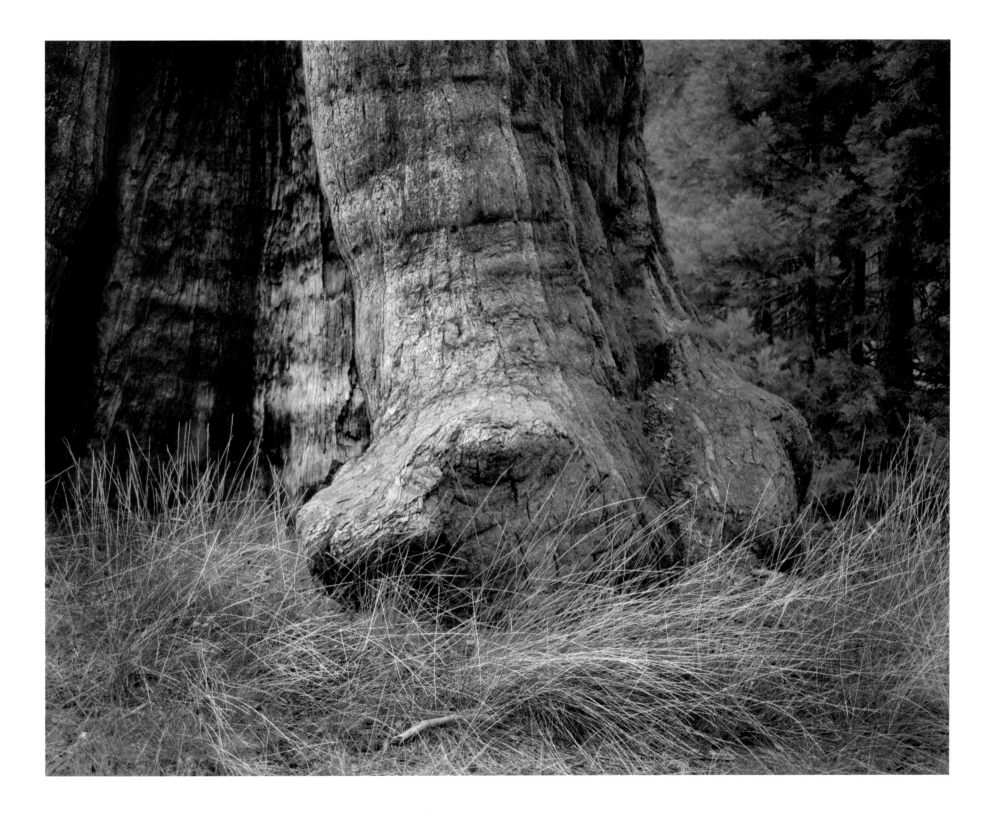

Sentinel tree #0906-1318 (2,150 years old)

SEQUOIA NATIONAL PARK, CALIFORNIA

If you ask someone what the oldest trees in United States are, the answer is often the redwoods. It's an understandable mistake: they're majestic, breathtakingly large, and admirable in both girth and height. But while the redwoods hold records for certain superlatives, their cousins to the south, the giant sequoias, are generally older individually. And even then, the giant sequoias are in fact the youngest of the five species in California alone that have surpassed the 2,000-year mark. The oldest known sequoia, now deceased, made it to 3,266 years.

California was the very first destination on my ancient itinerary, and the giant sequoias the first stop on a circuit that included the bristlecone pine, Mojave yucca, and creosote bush. It seemed to make sense to take these first, fledgling steps into the project in my home country. I didn't have a secure sense of what I was doing, but it was not too difficult to track down research (or researchers, for that matter), and there was nothing intimidating about flying into Burbank and renting a car. I enthusiastically turned off the highway at the first sign that said "Sequoia," which turned out to be at least a hundred miles too early for my destination of Kings Canyon National Park, which shares the old-growth forests with Sequoia National Park, but I was in no hurry. I drove for miles down a road I remember as gravel but was probably paved. At twilight I passed a rustic lodge, went a little further down the road, then doubled back. Hundreds of hummingbirds sipped at feeders among the pines. It was September, and they were migrating.

When I entered Kings Canyon with my National Parks pass the next morning, it felt exhilarating to be there for a reason beyond the splendor of nature. I had questions. I had people to meet with.

There are four trees in the forest that are documented to be above 2,000 years old. Dendrochronologist Nate Stephenson told me that in fact *hundreds* of trees could be over 2,000, but that they don't have the resources to date them all. The purpose of dendrochronology is not solely to count tree rings to determine their ages; it is also a critical tool in determining past climatic conditions. In the case of the sequoias, however, there does not seem to be enough scientific motivation to date a larger sample, at least for the time being. The approximate ages of the Kings Canyon elders, in ascending order: Sentinel 2,150 years, General Sherman 2,200 years, the Washington, 2,850, and finally the Cleveland at 2,890 years. The younger two are clearly demarcated; the latter require something called a "stem map" to locate them

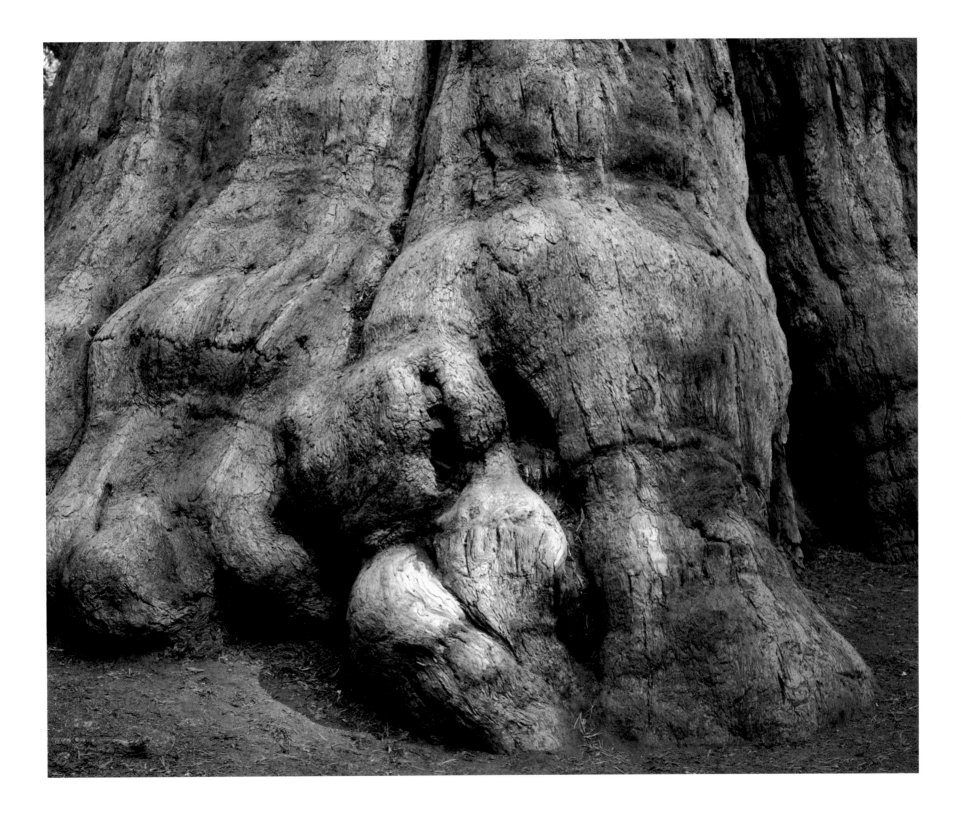

General Sherman #0906-1628 (2,200 years old)

SEQUOIA NATIONAL PARK, CALIFORNIA

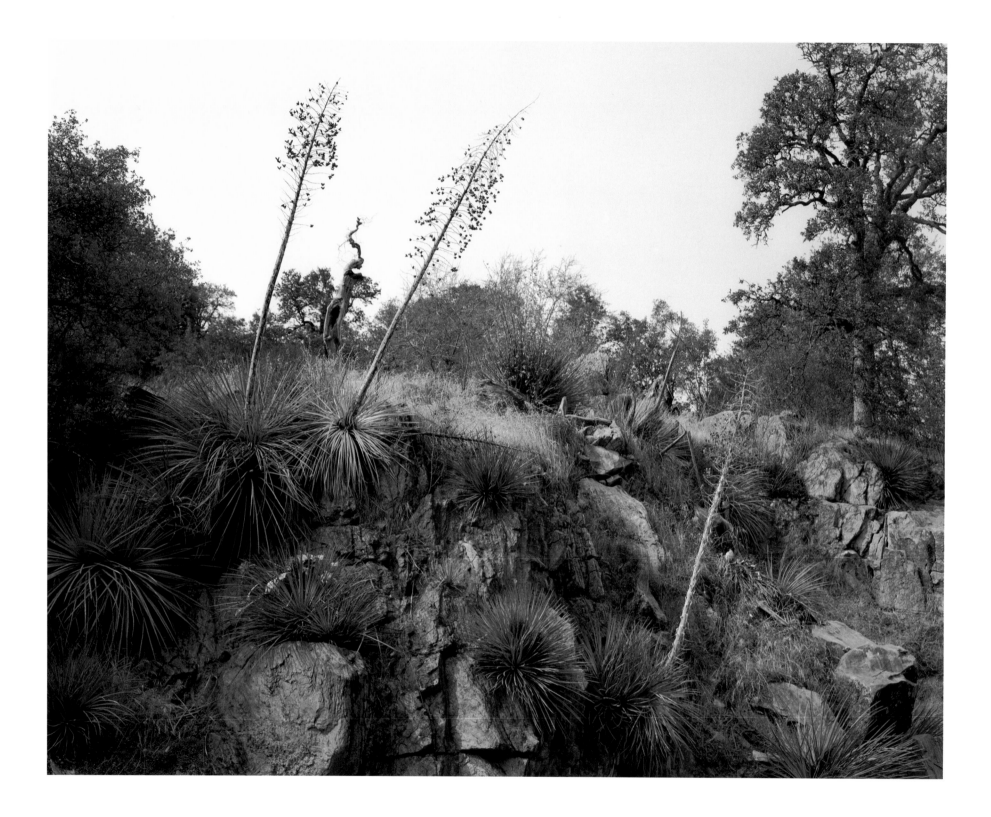

Yuccas on rocky outcropping #0906-1237

SEQUOIA NATIONAL PARK, CALIFORNIA

in another section of the forest. The map was reminiscent of a celestial navigation chart; the trees earthbound constellations. Circles denoted living trees, and straight lines the felled ones. Map in hand, I found the Cleveland, peeping out from amidst a hearty line of fellows. The Washington was further off the path, through some areas that had sustained heavy fire damage. Sequoias have small, rock-hard cones that only open and release their seeds with intense heat. Fires sweeping out the underbrush— not too much, not too little—are needed to maintain the health of the forest. Human intervention hasn't gotten it quite right.

Sequoia seedlings are particularly vulnerable to drought. Stephenson tells me that a "warming climate will lead to earlier snowmelts and deeper, longer summer droughts." Sequoia and Kings Canyon National Parks are in the process of developing more formal seedling motoring programs and rethinking long-term management goals that take climate change directly into account. This complex reassessment will take several years to complete.

Back at the visitor's center, a ranger joked that unlike the rest of us, the giant sequoias are getting younger every year; their ages having been wildly overestimated in the past. Conversely, the redwoods might in fact be getting older. About five years after that visit, it was brought to my attention that some redwoods in Humboldt Redwoods State Park were found to be growing clonally, opening up the possibility of revising their age upward many times over. However, no reliable estimates of their ages have yet been made. This only goes to show that science is never done, and that one lone fact never illustrates the whole picture.

Bristlecone Pine

AGE
5,068 years

LOCATION
White Mountains, California, USA

NICKNAMES
Methuselah, Prometheus

COMMON NAME
Bristlecone pine

LATIN NAME
Pinus longaeva

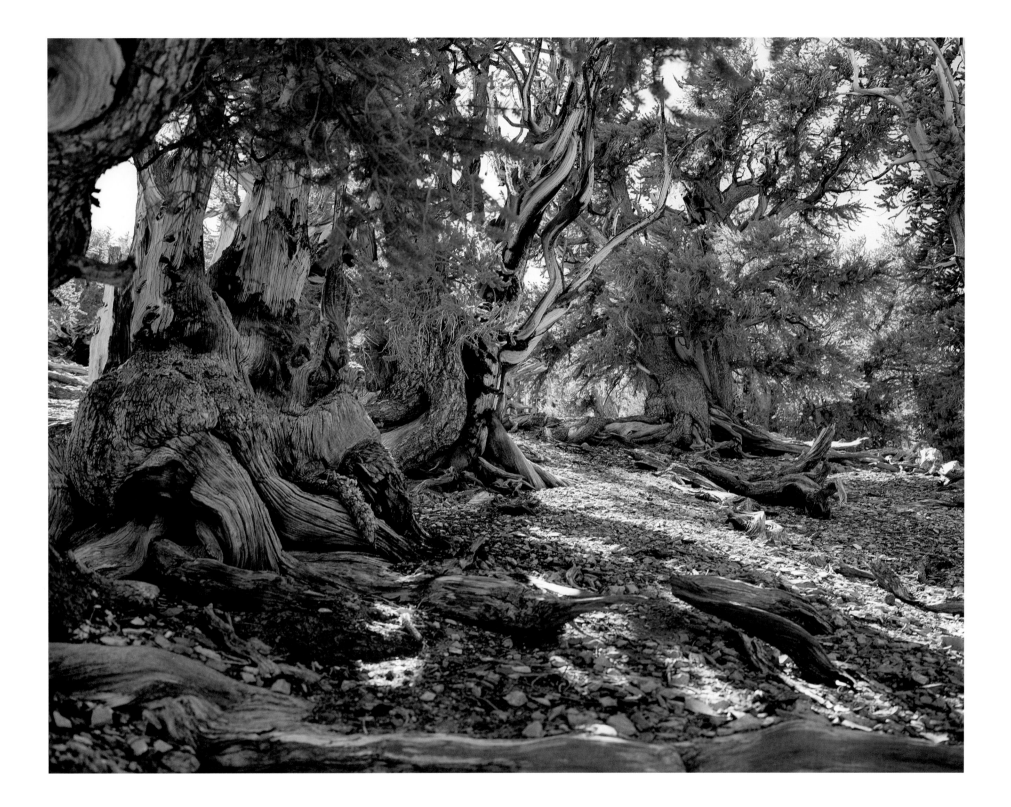

Bristlecone Pine #0906 - 3033 (Up to 5,000 years old)

WHITE MOUNTAINS, CALIFORNIA

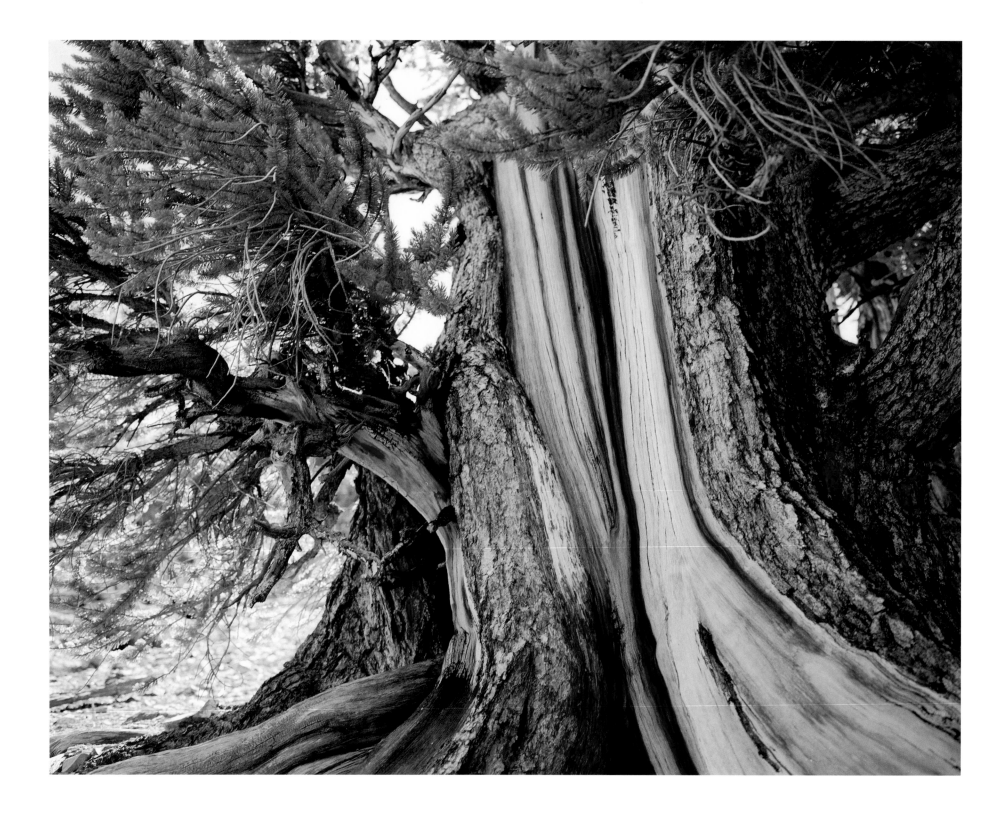

Bristlecone Pine, detail #0906-3030

WHITE MOUNTAINS, CALIFORNIA

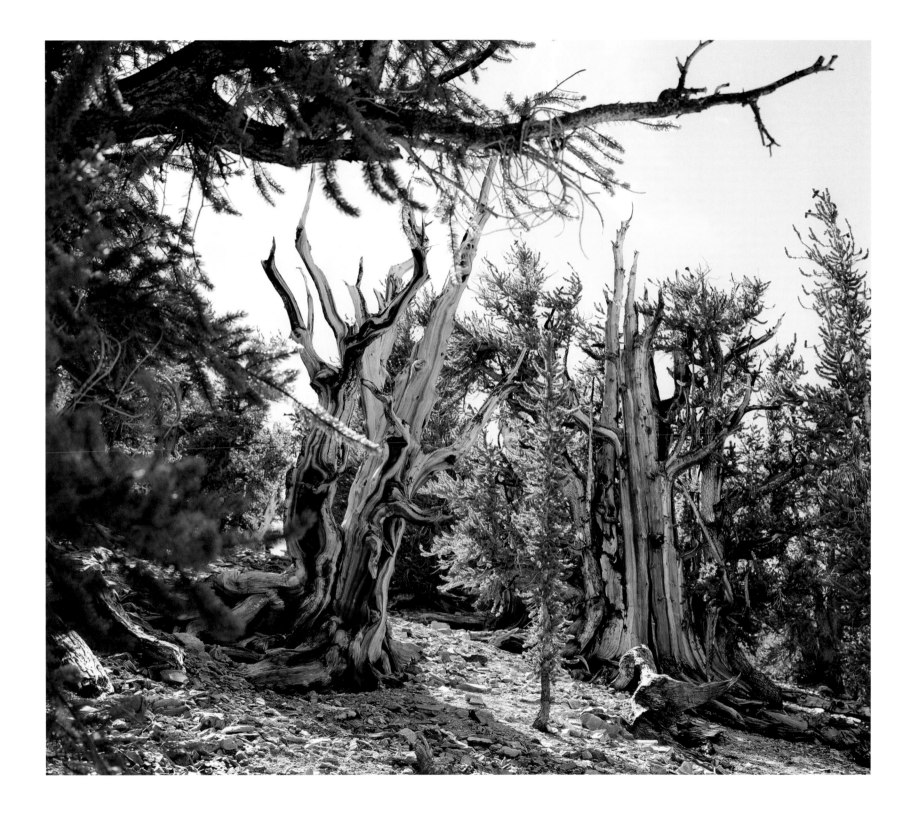

Bristlecone Pine #0906 - 3028

WHITE MOUNTAINS, CALIFORNIA

A lot can change in 5,000 years.

It was only a century ago when an astronomer, not a biologist, founded the practice of modern dendrochronology. Andrew Douglass was already studying climate change in the first part of the twentieth century, looking for a relationship between solar sunspot cycles and corresponding tree-ring data. In 1932, Douglass hired Edmund Schulman as his assistant. Shulman in turn would go on to dedicate his life to finding trees with the longest life spans (though his own was rather short at just forty-nine years), and collected a lot of material that has yet to be analyzed. Schulman began his work with the giant sequoias, but quickly learned that trees under greater adversity were in fact the ones reaching the most extreme ages. This was a lesson I was starting to learn across the board: it is not organisms that grow fast and furious that tend to have the greatest longevity; in fact it's often quite the opposite. The bristlecone pines lay claim to the distinction of being the oldest unitary (nonclonal, singular) organisms on the planet. In 1957 Schulman, along with then student Tom Harlan, discovered the Methuselah tree, currently 4,845 years old and the most famous of bristlecones. Harlan in turn would take the reins as a preeminent bristlecone researcher.

The story of the Methuselah tree is often eclipsed by that of an infamous mistake, however, an account that has grown into a field research cautionary tale of mythical proportions. In 1964, a graduate student named Don Currey was at one of the other few bristlecone forests in Wheeler Point, Nevada. Currey's coring bit broke off in the middle of a tree he was sampling. It was an expensive piece of equipment for a grad student, and a park ranger counseled him to just cut the tree down and retrieve the bit. There were hundreds of other trees in the forest, so what was the harm in cutting down just the one? It turned out that that tree, posthumously named Prometheus, was 4,844 at the time of its death, and the oldest known unitary organism on the planet at the time. A cross section of the tree used to be on display in a small-town casino, though I found that it has since been moved by the local chamber of commerce to the convention center. Another slice is being put to practical use in the Laboratory of Tree-Ring Research at the University of Arizona. Currey switched career tracks and became a geologist.

Harlan actually discovered a tree older than them both; perhaps amid the samples collected with Schulman before his death.

When I tracked Harlan down in 2006, he told me the oldest known bristlecone was not the Methuselah, as popularly assumed, but rather an unnamed tree in the same section of the park that was around 5,000 years old. (The Rocky Mountain Tree-Ring Research organization currently places it at 5,062.) Harlan and his colleagues determined the ages of many bristlecones using a combination of cross dating core samples and radiocarbon dating. Peter Brown, director of the Rocky Mountain lab, told me over e-mail that it was not just the individual ages that were of interest, but Harlan's last project had been going back through Schulman's unanalyzed samples in an attempt to build a fully anchored tree ring chronology all the way back to 12,000 BCE. I was sad to learn that Harlan himself passed away in 2012. News of his find has not been widely circulated, nor is Harlan's tree or the Methuselah marked on the trail. The sign that used to announce the Methuselah has long since been removed, as visitors were taking injurious "souvenirs" off it.

By the time I was to make my own visit in fall of 2006, Harlan's fieldwork was already completed for the season, so I was to go on my own. It was chilly at 10,000 feet in September, with barely another person on the road, and fewer still at the trailhead. Harlan had told me in advance what to look for, and where along the trail to look. He also said there was no reason to believe that we actually have found the oldest bristlecone—there are thousands of them.

Hiking along the exposed mountainside, I was moved by these gnarled old trees, battered by the elements—some of which have been around nearly *twice* as long as the oldest sequoias. It's an entirely different experience of "forest" as well. The giant sequoias awe you with sheer scale. It reminds me of photographer Duane Michals's quip in his book *Real Dreams*, "You would have to be a refrigerator not to be moved by the beauty of Yosemite." Likewise the sequoias. The bristlecones' beauty, however, is somehow wrapped up in their struggle at the upper limits of the tree line, becoming all the more compelling the more we learn about them. For instance, they subsist on limited nutrients and shut down nonessential systems to ensure their overall survival—a tree might look dead, save for a single living branch. A set of needles, clustered in groups of fives, can last up to forty years—far longer than most pines. Both are indicators that they value efficiency as a survival strategy. Knobby knees suggest age. One imagines they have some deep biological will to survive, signs of age cloaked around stalwart endurance.

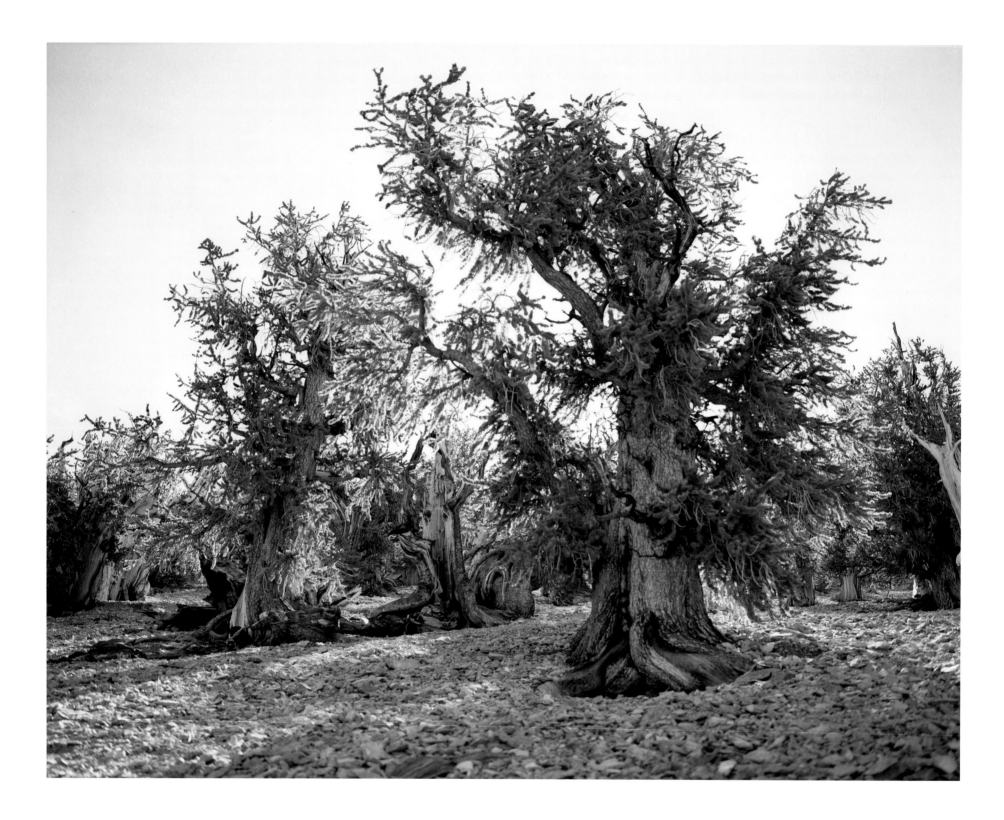

Bristlecone Pine # 0906 - 3237

Chillingly, atomic bomb tests were conducted just over the border at the Nevada Proving Grounds, only a hundred miles away. Had the bristlecone stand not been upwind, they all could have been irreparably injured in one fell swoop, if not killed outright. It's not as if they can get up and get out of the way. The most pressing current threat to the bristlecones is an ongoing one-two punch: white pine blister rust, an airborne fungus that came to the United States a century ago, combined with an influx of native pine bark beetles, are conspiring a slow demise, encouraged by the warming climate.

Bristlecones haven't survived *in spite of* their extreme conditions; they've survived *because* of them. Warming temperatures in alpine areas haven't just allowed for a host of threatening species to reach new heights. It also means that the bristlecones are growing faster now than in almost any previous time period. Recent ring counts show a 30 percent increase in their growth rate over the past fifty years, faster than any equivalent period from the 3,700 years preceding it.

Creosote Bush

AGE
12,000 years

LOCATION
Soggy Dry Lake, Mojave Desert, California, USA

NICKNAME
King Clone

COMMON NAME
Creosote bush

LATIN NAME
Larrea tridentata

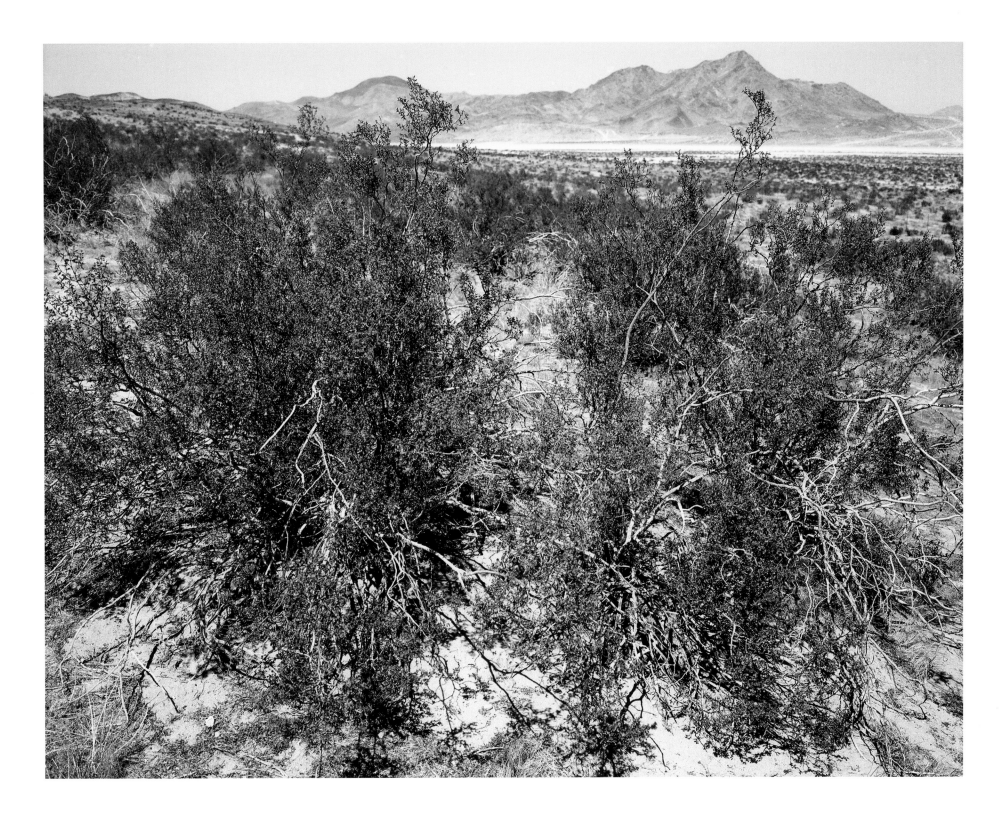

Creosote Bush # 0906-3628 (12,000 years old)

MOJAVE DESERT, CALIFORNIA

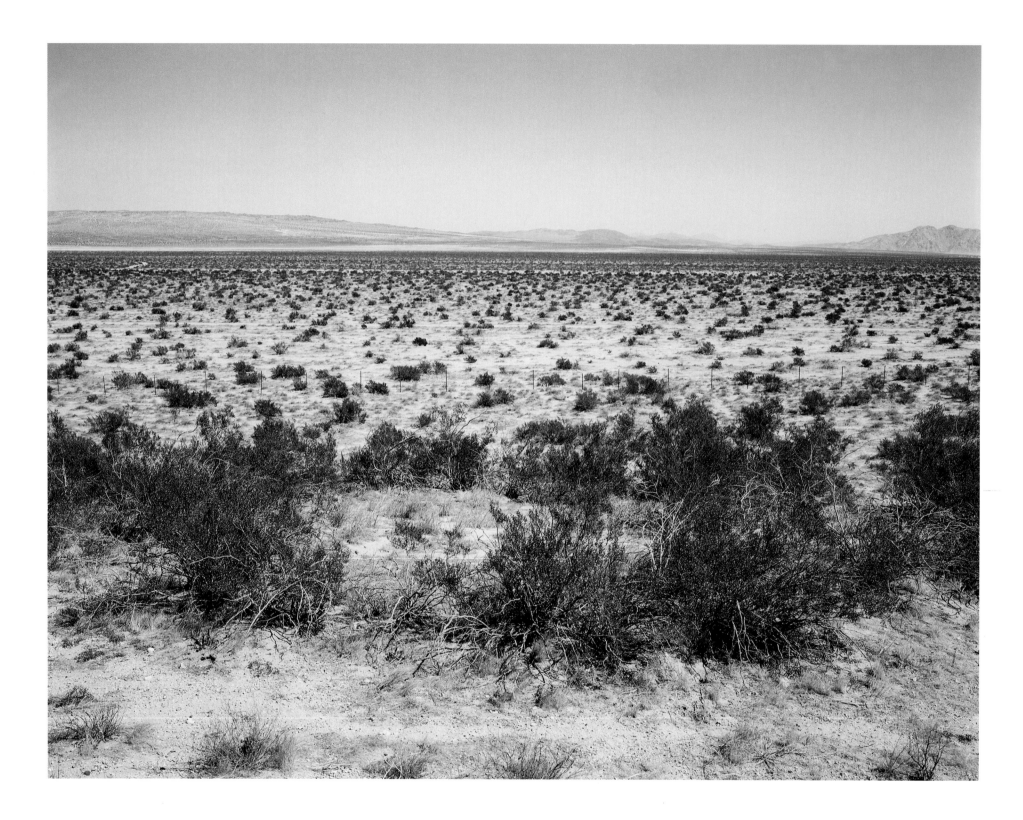

Creosote Bush #0906-3637 (12,000 years old)

MOJAVE DESERT, CALIFORNIA

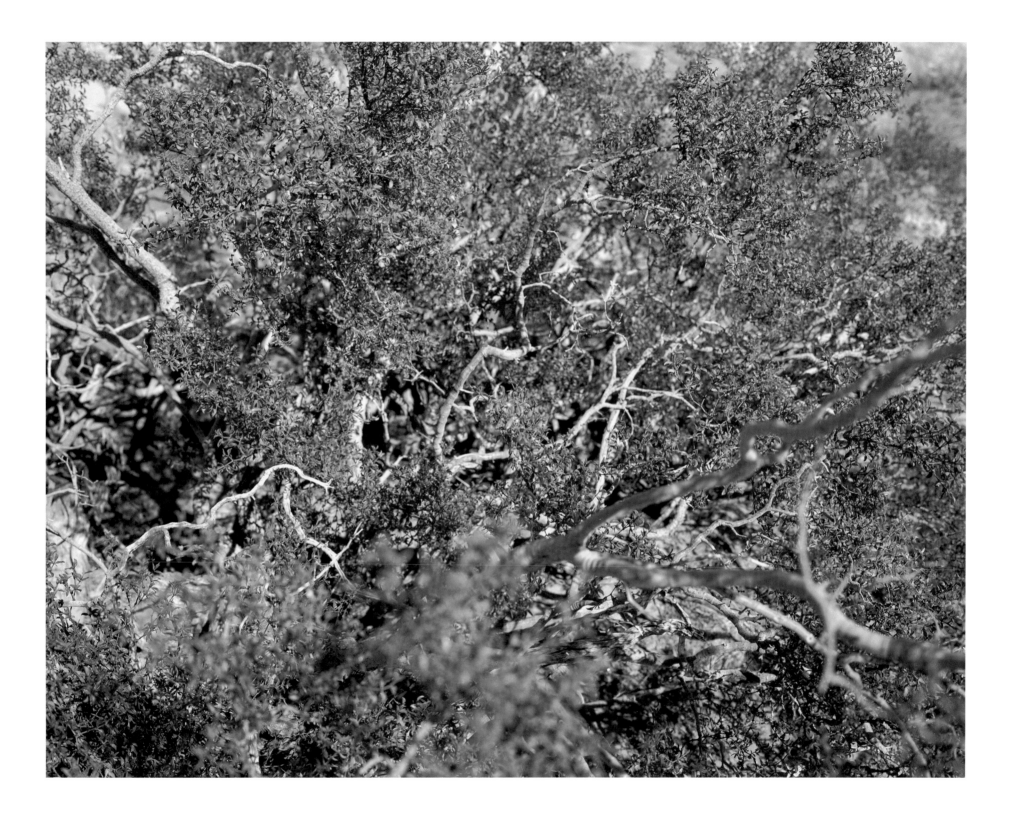

Creosote Bush, detail #0906-3905 (12,000 years old)

It's a drive of several hundred miles from the 14,000-foot elevations in the White Mountains, along the periphery of Death Valley—282 feet below sea level at its lowest—toward Barstow. I caught glimpses of Edwards Air Force Base and other outlandish desert military installations as I headed toward a small Bureau of Land Management (BLM) field office, and then out into the Mojave proper.

It was only 12,000 years ago that humans started farming and herding animals, the same time that the approximately 12,000-year-old creosote bush and Mojave yucca were getting their start. They were the first clonal organisms I ever knowingly encountered.

The two sit ten miles apart, cordoned off by wire fences on BLM property designated for recreational all-terrain vehicle "free play" (their term). Both King Clone and the nicknameless yucca have remarkable circular structures, pushing slowly outward from their central originating stems. There is no hole to bore that would prove out their remarkable longevity; theirs is a slow and steady continuation of self: new stems replace old ones, expanding outward by tiptoe rather than leaps and bounds. The best way to get the full visual impact of both the creosote and the yucca is from above. (In lieu of a helicopter, I climbed on top of the park ranger's truck for the best available angle.) The circular forms of the clones are the only clues that visually differentiate them from their younger brethren; in fact, the creosotes are ubiquitous in the region. There are fewer yuccas, but still, their circular formation, like little living Stonehenges, makes them unique. (There are several clones of both species in proximity to one another; I was concentrating on the oldest of each.)

King Clone, as the oldest creosote is sometimes called, was discovered in the 1970s by Frank Vasek, a retired professor at University of California, Riverside. Growth-rate analysis on its minuscule annual advance, in combination with radiocarbon dating performed at a UCR lab, helped inform the age estimate. Creosote bushes, so named for their smell when wet, can actually survive without rain for up to *two years*. The extensive root system draws up whatever water it can get its hands on. The valley floor temperatures of the Mojave range from –20°F up to 140° higher.

BLM research scientist Larry LaPre was my primary source of information before my visit. While creosote bushes are a ubiquitous feature of the desert landscape, LaPre described the clone as an oblong oval, approximately fifty feet in diameter.

Apparently the BLM scientists hadn't been out to the sites in years, but it turned out I was quite lucky to have a BLM ranger, Art Basulto, escort me to both sites. Basulto filled any gaps in our conversation with stories about woefully underprepared desert day-trippers, rescues of lost children, training for desert marathons, desert blooms in spring, how remarkable a storm in the desert is in any season. He leaned down as we walked, scooping up a snake skull on the upswing.

While the realities of contemporary life shape their present and future, there's also a philosophical counterpoint to ponder. Starting from a single, ancestral stem and slowly expanding outward, both the creosote and yucca clones are like a biological analogy of the expanding universe. This is not meant literally to set the Hubble Constant in comparison to fractions-of-a-centimeter annual growth rates. Rather, the creosote and yucca clones offer a living picture of a deep timescale through infinitesimal outward expansion that we don't normally have the perspective to observe.

Though it's hard not to worry that time is no longer on their side.

23

CREOSOTE
BUSH

{04}

Mojave Yucca

AGE
12,000 years

LOCATION
Mojave Desert, California, USA

NICKNAME
N/A

COMMON NAME
Mojave yucca, Spanish dagger

LATIN NAME
Yucca schidigera

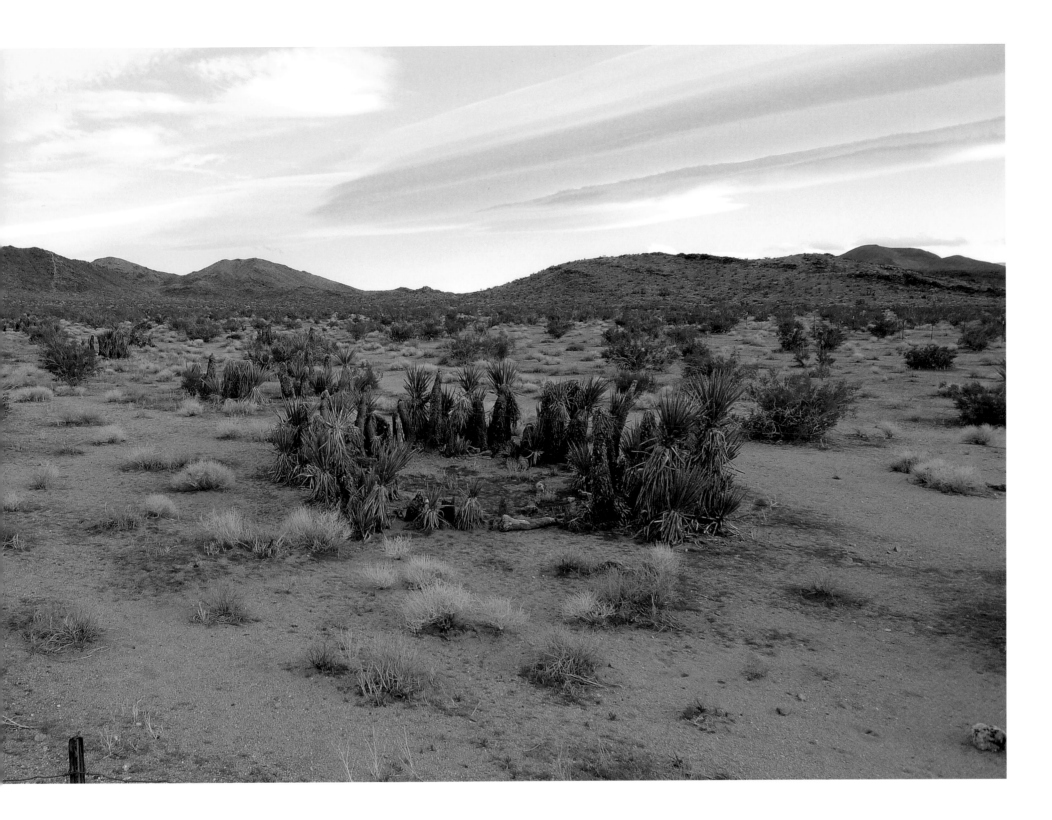

Mojave Yucca # 0311 - P0983 (12,000 years old)

MOJAVE DESERT, CALIFORNIA

I haven't revisited many of my subjects, but I hadn't been particularly pleased with my images from that first visit to the Mojave yucca in 2006, so when I was in nearby Riverside to photograph the Palmer's oak in 2011, I took the opportunity to pay the Mojave elders another visit, accompanied by the Palmer's oak researchers, themselves curious to see the clones. I was hoping to see its cream-colored spring flowers, but it must have been too early in the season for them, and earlier still for its late-spring fruits. Mojave yuccas are pollinated exclusively by moths—the yucca moth or *Tegeticula yuccasella* to be precise—but of course this yucca is growing by vegetative means, so it only need muster enough energy to generate its own new shoots. In other words, normally pollination is required for the fertilization of seeds, but in the case of this yucca clone, or any clonal organism for that matter, it is self-propagating, so it just keeps on creating copies of itself without all that messy fertilization business. It still would have been nice to see the flowers.

On my previous visit, Art Basulto had told me that native populations used the Mojave yuccas as shelters from desert storms. The yucca's fruits are suitable for human consumption, their fibers are woven for various goods, and saponin in their leaves can be used to make soap, but it was difficult to envision that they could provide much cover for anything other than small desert animals. Perhaps they were more vigorous in years past. In fact, the clone wasn't doing as well as it was in 2006. While my work isn't conversation photography per se, it does underscore the importance of it: going to a site and photographing it one time, as if it is a static thing, is misleading. A photograph of a receding glacier is never so powerful as when it's paired with an image from a few years before, illustrating the retreat. Photographs can be records of a moment in time, but just because they were true once does not ensure that it's a continuing condition: things change.

There had been several years of drought between my visits—even less rain than the next-to-nothing the desert usually gets. (The yucca doesn't need much, but unlike the creosote bush, it does require around six inches a year to maintain its virility.) The drought, a problem in and of itself, is made worse by desert rats. They gnaw at the leaves for moisture. Scientifically speaking, the pack rats aren't all bad news, however. Their burrows, or middens as they're called, are chock-full of valuable information about the climate. Generation after generation uses the same nests over tens of thousands of years, collecting and depositing layers and layers of outside debris and genetic information that can be read like a book—if you know how to read it.

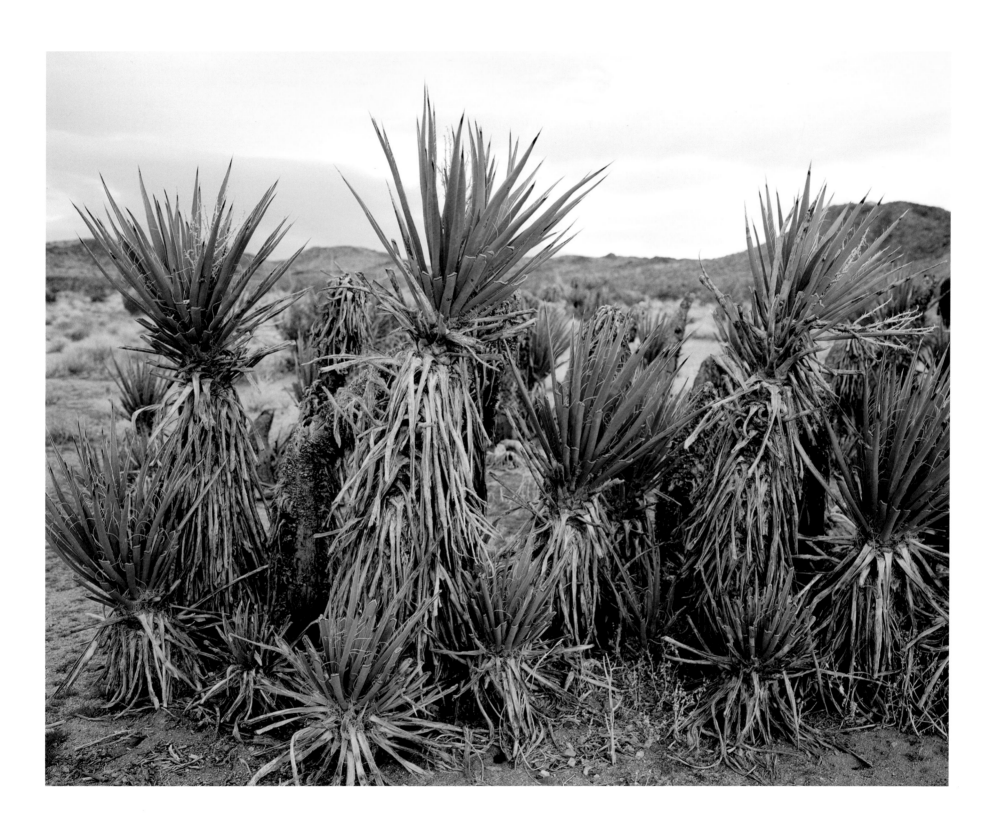

Mojave Yucca #0311-1430 (12,000 years old)

When I first began this project, I never would have thought about anything living all that long in the desert. Joshua trees, perhaps—which are yuccas themselves, in fact—although they are not thought to live more than several hundred years. But by the time I revisited the Mojave, having seen remarkable deserts on four continents, home to some of the most extraordinary, long-lived life forms anywhere on the planet, my perspective had changed entirely. As with the bristlecones, it was becoming clear that extreme conditions can foster uniquely adapted life.

While BLM land does not offer the same protections as a national park, at least the creosote and yucca clones are fenced off. However, I recently read that the military might be expanding its desert presence, possibly overtaking the "free play" recreation area. Suddenly the mere weekend warriors aren't seeming like such bad neighbors.

MOJAVE
YUCCA

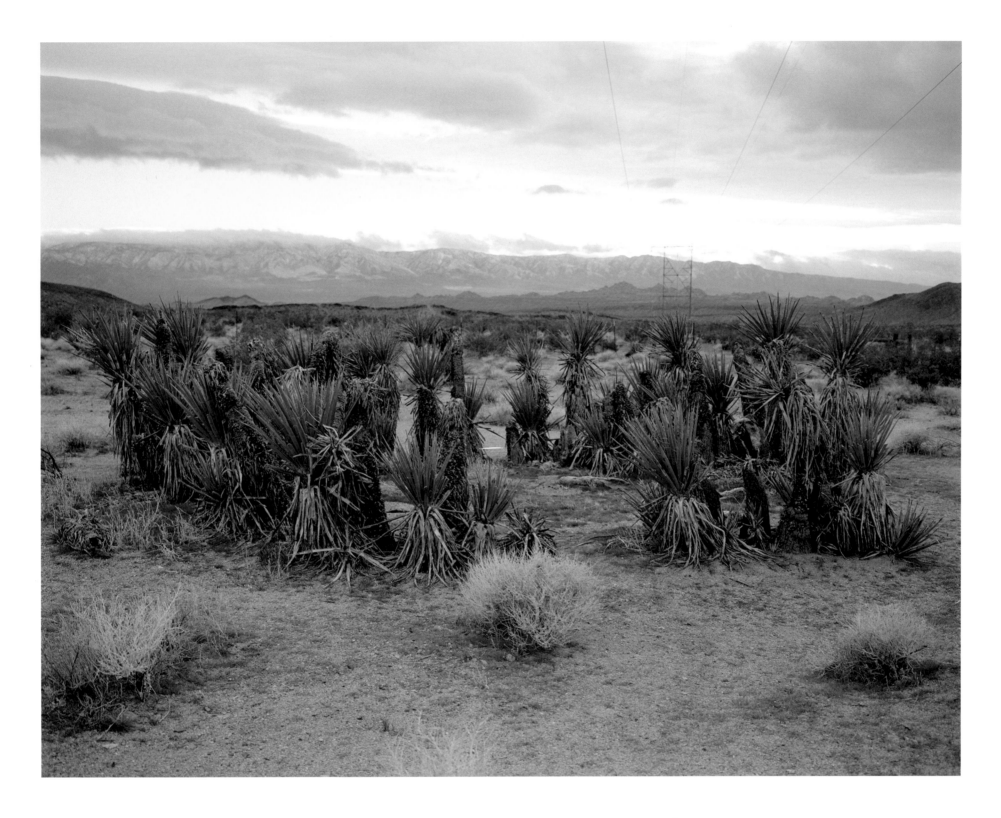

Mojave Yucca #0311-1320 (12,000 years old)

MOJAVE DESERT, CALIFORNIA

Honey Mushroom

AGE
2,400 years

LOCATION
Oregon, USA

NICKNAME
Humongous fungus

COMMON NAME
Honey mushroom

LATIN NAME
Armillaria ostoyae

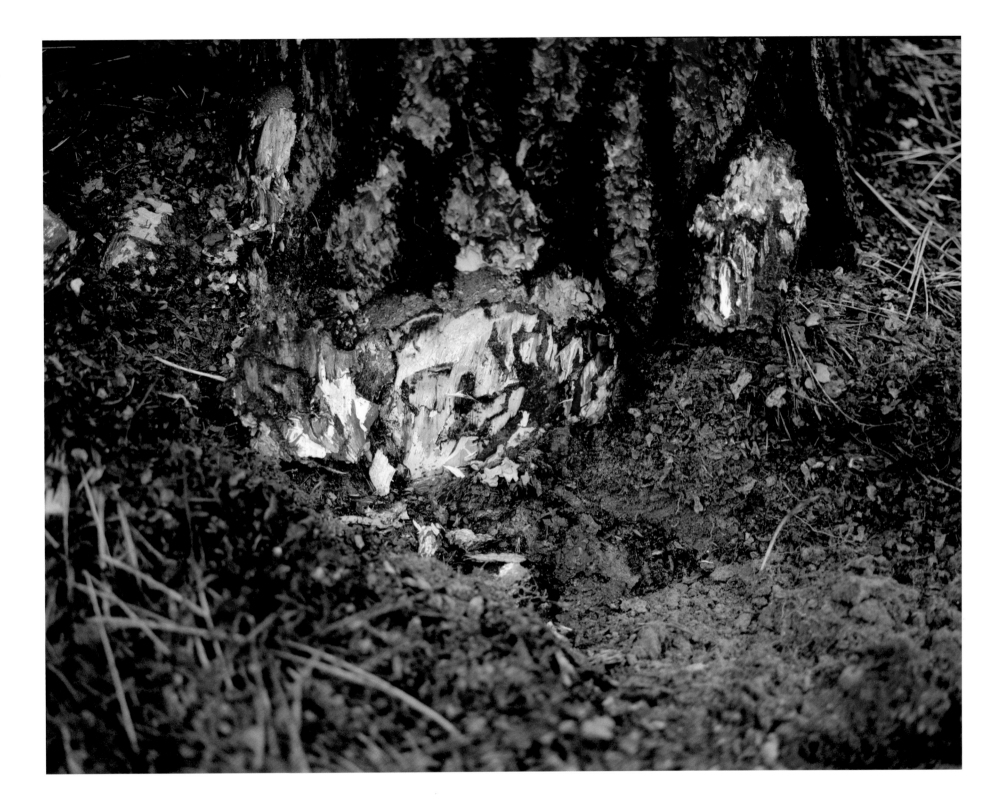

Armillaria #1106-2232 (2,400 years old)

MALHEUR NATIONAL FOREST, OREGON

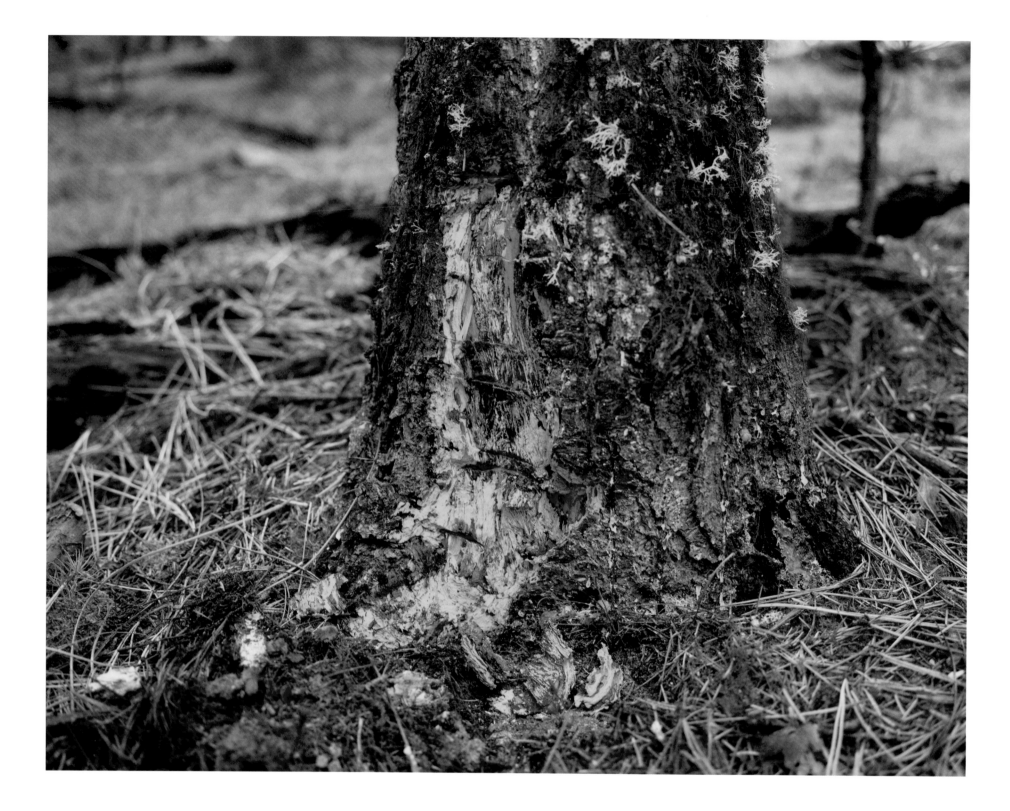

Armillaria #1106 – 19B24 (2,400 years old)

MALHEUR NATIONAL FOREST, OREGON

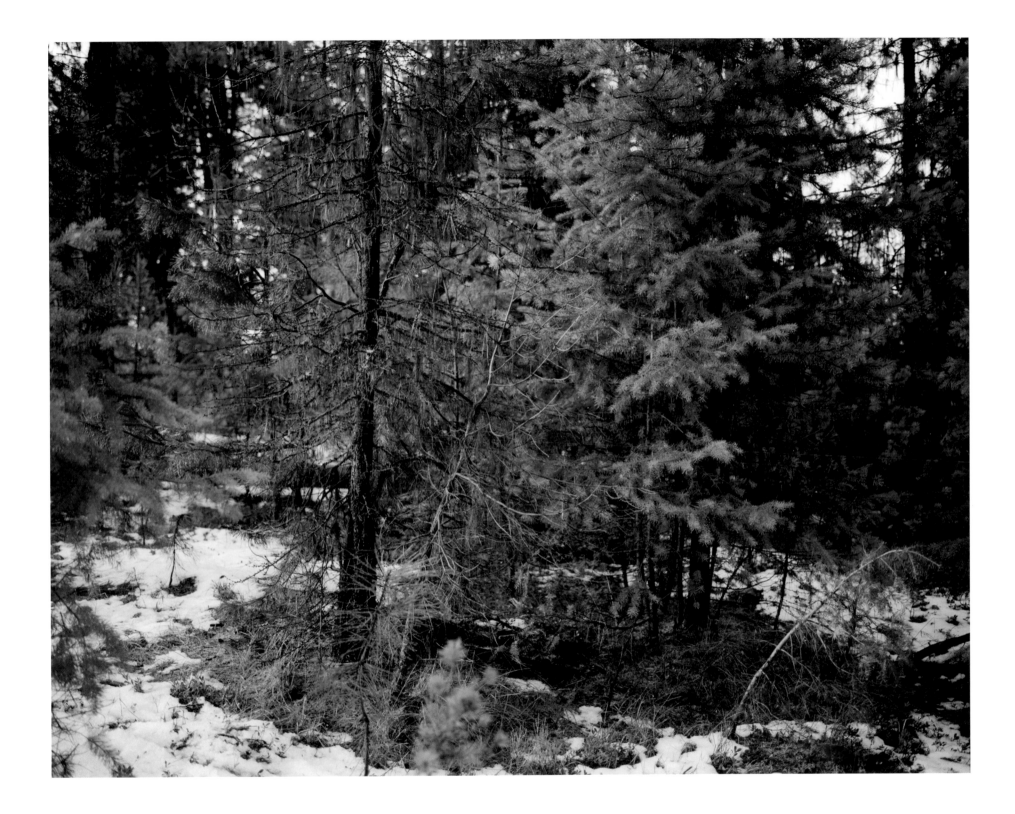

Armillaria casualties #1106-1414

Armillaria ostoyae, aka honey mushroom, aka the humongous fungus, bears the distinction of being the only predatory oldest living thing. (Predatory to certain species of trees, that is. Not people. You can also think of it as a pathogen, but that doesn't quite conjure the same horror-film image.) It is also one of the largest organisms on the planet, with an area of nearly three and half square miles (nearly 2,200 acres)—genetically the same individual organism from end to end. Despite the fact that fungi are among Earth's most widely distributed organisms, *Armillaria* is the only fungus in this ancient group. Fungi comprise their own kingdom, and surprisingly enough are more closely related to animals than plants—animals and fungi appear to share a common ancestor which branched off from plants 1.1 billion years ago. (It is still unknown exactly when animals and fungi went their separate ways, but imagine *that* family reunion.) The *Armillaria* also lives almost entirely underground, making it a bit challenging to photograph.

I visited Malheur National Forest in eastern Oregon in November 2006, and unfortunately snow had already fallen in the mountains. Actual mushrooms fruit above ground in the autumn, but not for long, and never under snow. It was my first lesson in paying stricter consideration to seasonal constraints before planning my travels. But the roiling clouds, pierced by occasional shafts of bright light, and a rainbow glowing against the threatening gray skies were mesmerizing as I drove from the speck of a town called John Day toward the US Forest Service Prairie City Ranger Station, adjacent to the sawmill on the west end of town.

Forest pathologist Craig Schmitt has a kind, grandfatherly demeanor, like Santa Claus by way of a lumberjack. He quizzed me on the different types of evergreens as we walked through the woods: larch, Douglas fir, lodgepole pine, ponderosa. He easily picked out which trees had been invaded by the fungus, and chopped into the trunk of one past the point of no return, exposing the fungus underneath the surface. *Armillaria* works by slowly strangling trees to death. White mycelial felts force themselves up from the ground between the bark and the sapwood of a tree, eventually preventing the flow of all water and nutrients. Despite the fact that it kills its host, you could say it's a smart fungus, if not polite; it doesn't kill trees that have not yet reached reproductive age, thereby ensuring its continued survival. Human intervention is another matter. The *Armillaria* is the only organism in this venerable group whose growth is being purposefully curtailed. The forest management plan includes planting trees that aren't susceptible to the fungus, in hopes of reducing its

Searching for Armillaria Death Rings #1106 - 1129 (2,400 years old)

MALHEUR NATIONAL FOREST, OREGON

growth and limiting its destructive reach. And while the *Armillaria* mushrooms are actually edible, I don't think a dinner party is part of the forest management plan.

The following day I visited another part of the forest with mycologists Mike Tatum and Jim Lowrie. They were likewise perfectly at home, talking about everything from their work to how they hunted deer, and making fun of another mycologist for only studying one aspect of the *Armillaria*, as opposed to the whole thing. (Yes, that was a couple of mycologists making fun of another mycologist for being a nerd.) We also discussed the broader social problems surrounding forest management. Emotional decisions made by laypeople, such as voting against controlled burns and other best practices, can undermine the expertise of the scientists, deepening problems. Nature isn't always "nice" in a human sense, but imposing human values on the natural cycle of an ecosystem is often a recipe for disaster. As we walked, I collected samples of lichens and mosses and they indentified them, and I added them to the collection of cones and *Armillaria* samples from my previous day's excursion with Schmitt.

While the *Armillaria* is the most well-known tree-killer in the forest, there are other root diseases, such as *Phellinus weirii* (laminated root rot) and *Cryptoporus volvatus* (known as pouch fungus or gray-brown sap rot), that break down wood fairly quickly—part of nature's recycling program, if you will. Tatum went on to tell me, "Many trees also show evidence of beetle attack, which commonly occurs on trees dying of various root diseases. The beetles often just accelerate the mortality, as they are attracted to disease-weakened trees, and as those weakened trees are unable to 'pitch out' the beetles which healthy trees can successfully do." (I like the visual of a tree locked in such unlikely mortal combat as with a beetle. That would make for quite a slow-motion battle scene.)

Signs of the fungus need not only be witnessed from the ground, or under it. Before I'd arrived, I'd arranged to charter a plane, to set out in search of what are known as "*Armillaria* death rings." The *Armillaria* slays its victims in a circular pattern (circular growth already becoming a theme with the long-lived set), which can be spotted from above if you know what you're looking for. I was armed with some maps and GPS coordinates, and at the very least knew the *Armillaria* was lurking below the surface. I'd never been up in such a small Cessna before, and wasn't so much scared as airsick. I made as many photos as I could before vomiting up acidic motel coffee, and the pilot and I unceremoniously returned to the hangar.

HONEY
MUSHROOM

Before I left town, I found the local post office and mailed my botanical collection back east, where the box would greet me in the hallway of my Brooklyn apartment building. The *Letharia vulpina*—wolf-killer lichen, poisonous to canines—is still living in a planter on my windowsill, alongside some Namibian *Sarcocaulon patersonii* (bushman's candle) and a small set of Yakushima Japanese deer antlers. Months after returning, I photographed the piece of *Armillaria*-laden bark in the studio with a large-format 4 × 5 camera. But it felt—and quite literally was—lifeless out of context.

HONEY
MUSHROOM

{ 06 }

Box Huckleberry

AGE
8,000 to 13,000 years (disputed)

LOCATION
Perry County, Pennsylvania, USA

NICKNAME
Jerusalem huckleberry, Bibleberry

COMMON NAME
Box huckleberry, box-leaved whortleberry

LATIN NAME
Gaylussacia brachycera

Box Huckleberry #0906-0103 (8,000 - 13,000 years old)

Box Huckleberry branches stripped by deer # 0906 - 07A07 (8,000 - 13,000 years old)

Antler wall on the Doyle's barn # 0906-09A09

My search for the oldest box huckleberry ended in someone's backyard. After contacting the Forest District Headquarters of the Tuscarora State Forest, home to a 1,300-year-old individual in the Hoverter & Sholl Box Huckleberry Natural Area, to my surprise I was directed to private landowner Jim Doyle for a huckleberry that was a full ten times its senior.

The box huckleberry (so named for its likeness to the boxwood shrub) is a relative of the blueberry, with shiny, evergreen leaves. It flowers in spring, then bears edible, if reportedly tasteless, fruit that is favored more by the ruffed grouse than by humans. It is self-incompatible, which may sound like it needs some therapy, but actually indicates that unlike some flowering plants, it cannot pollinate itself. Given that fewer than a hundred far-flung individuals survive between its Pennsylvania home and Mexico, the chances of reaching a partner are so minute that vegetative growth is only the way to, well, grow.

In 1889, Jim Doyle's great-grandparents—homesteaders—purchased tracts of land in central Pennsylvania back when the hundredth-anniversary celebrations of the signing of the Declaration of Independence in nearby Philadelphia were still a point of pride. The Doyles mined shale and felled trees for lumber. During the Great Depression the family hunted and fished and otherwise lived off the land. Doyle also proudly relayed a tale of George Washington falling in the Juniata River (a tributary of the Susquehanna), just around the bend from where we stood. I wasn't able to locate any outside verification for the claim, but it certainly added to the already rich family folklore. As chance would have it, my own family has a connection to the area as well. My grandmother, originally from Czechoslovakia, has called Harrisburg home since 1957. I paid her a visit, and my mother drove up from my hometown of Baltimore to join me for my visit to the huckleberry.

It was 1920 when the Doyles learned there was something else of note about their property. Harvey A. Ward, secretary of the Harrisburg Natural History Society, describes his discovery in a letter dated February 14, 1929:

I left the party to explore the ravine. I at once noticed a growth of low shrubbery with shining green leaves. It was entirely new to me. I decided it was a vaccinium of some sort and no doubt an evergreen. . . . There were no fruit or flowers in evidence, but from the brief description of the plant given in Gray's Manual, I felt sure I had discovered a new

colony of box huckleberry. I sent the specimens of the plant to the New York Botanical Garden, to the Gray Herbarium and to the Dept. of Agriculture at Washington. In a few days I received replies from each of these authorities, verifying my determination. . . . Dr. Frederick V. Covill and Dr. Edgar T. Wherry from Washington, and Dr. John K. Small from the New York Botanical Garden made several trips to the colony and were much impressed with its extent.

In recent years, the Parks Department has offered to relieve the Doyle family of their post as caretakers of the clone and convert part of their property into parkland, but Mr. Doyle—who has been quite generous in granting access to researchers—showed no sign of being tempted by the offer to make it a permanent arrangement. There's a saying that the best time to plant a tree was ten years ago, and the next-best time is today. The same could be said of conserving what we have while we still have the opportunity: much of the once hundred-acre, mile-long colony was destroyed in 1963 by the rebuilding of Routes 22 and 322. More still was destroyed by a fire.

In the years since my visit to the site, science has forged forward, and questions have arisen regarding the 13,000-year age determination. Conflicted glaciation data, as well as some questions about genetic drift and mutation, now points toward the Doyle's huckleberry as being closer to 8,000 years old. Not that 8,000 years is anything to scoff at.

Palmer's Oak

AGE
13,000 years

LOCATION
Riverside, California, USA

NICKNAME
Jurupa Hills oak

COMMON NAME
Palmer's oak

LATIN NAME
Quercus palmeri

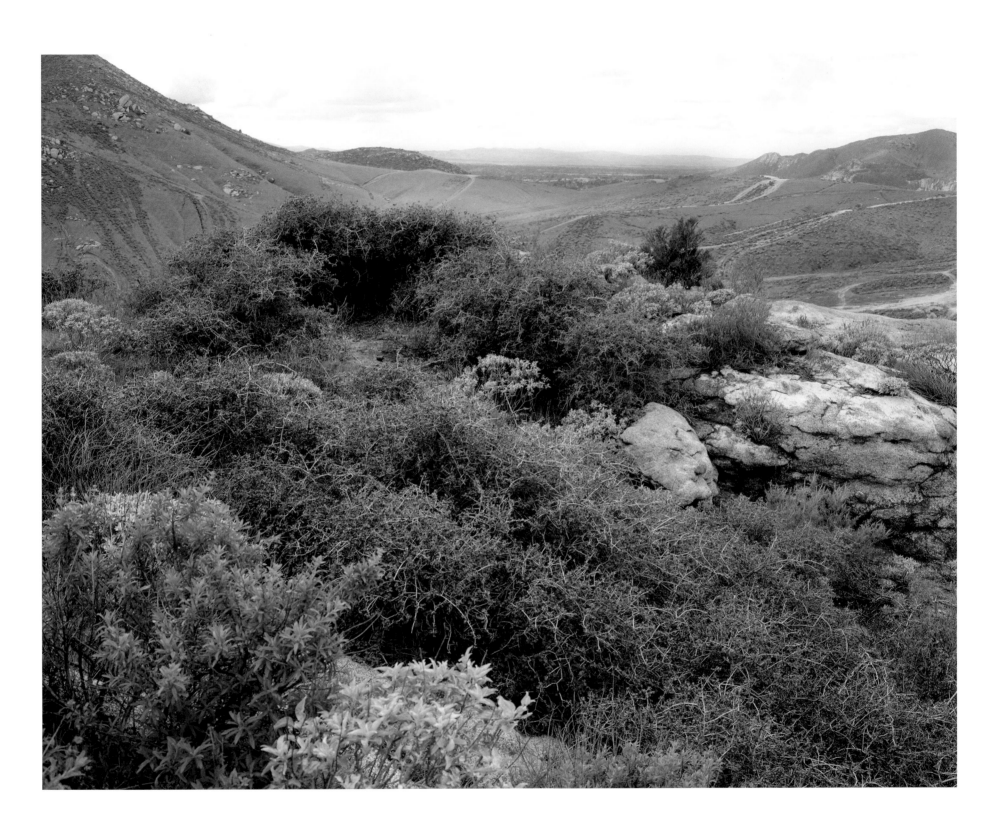

Palmer's Oak #0311-0514 (13,000 years old)

RIVERSIDE, CALIFORNIA

It was gratifying to receive an e-mail from biologist Jeffrey Ross-Ibarra telling me about a discovery he and his colleagues had confirmed. The organism in question was a clonal scrub oak, *Quercus palmeri*, at least 13,000 years old and perhaps more than twice that. The species itself was first described and in turn named for Edward Palmer, an autodidact botanist (and archeologist, to boot) who explored the American West and parts of Mexico under the employ of the US Department of Agriculture in 1891. But this ancient individual in Riverside, California, was discovered by Mitchell Provance, a local resident and then-fledgling botanist, just over one hundred years later—a discovery that validated his winding path to science.

I drove from Los Angeles out to the Inland Empire city, whose primary claim to fame is as the originator of the California citrus industry, its commencement marked by the planting of three naval orange trees from Brazil in 1874. I met up with Provance and Andy Sanders, master of the University of California, Riverside, Herbarium, who had helped Provance confirm his hunch. Provance took his first field botany class in the winter of 1996, just two years before he discovered the oak. Although he'd had leanings toward the sciences since he was little, he was always encouraged toward the arts. Provance told me over e-mail that he spent a summer as a child reading a text on mammal classification on his own volition. I can't help but make the connection of his autodidacticism with that of Palmer before him. Andy Sanders had been one of the first "plant hunters" (a term Provance uses affectionately, but that some botanists view as derogatory) he had met, and Sanders encouraged Provance to conduct a flora survey in the Jurupa Hills. On one such walkabout Provance happened upon the oak and immediately recognized it as something special. Over a decade later, the paper Provance coauthored with Sanders, Ross-Ibarra, and two of their other colleagues was published, confirming the tree's minimum age of 13,000 years. It may be significantly older.

If you were expecting something akin to the *Giving Tree* or on the massive scale of the giant sequoias, think again. Like many clonal organisms, you might walk right by this oak never knowing you'd come so close to such exceptional longevity. In fact, you might not know you were even in the presence of an oak. The leaves are tough with sharp, holly-like points, though Palmer's oak and holly are not related.

As the Pleistocene era drew to a close the area become more arid, and the once

Garbage at the base of the Palmer's Oak site #0311-0964

RIVERSIDE, CALIFORNIA

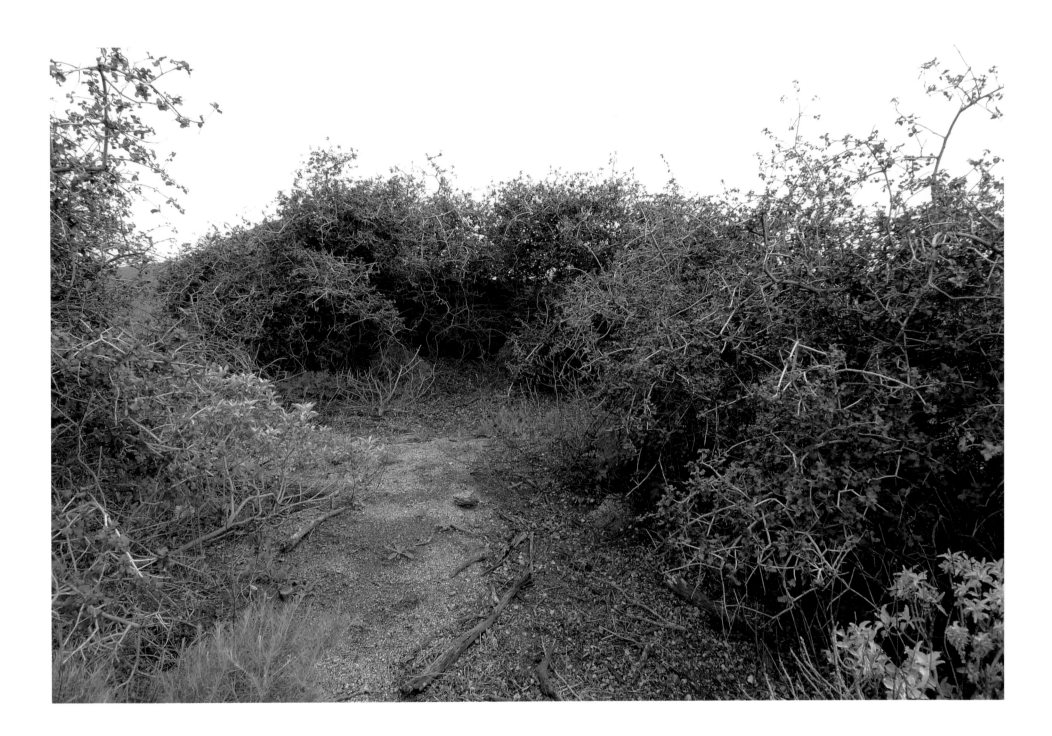

Palmer's Oak # 0311 - 0921 (13,000 years old)

RIVERSIDE, CALIFORNIA

extensive range that could support the Palmer's oak literally dried up. It is a relic of an ecosystem that no longer exists, having found a purchase on this steep hillside at a time when mastodons and camels still roamed the area. I was surprised to learn that camels actually originated in North America, some wandering south to become alpacas and llamas, others crossing the Bering Straight into Asia. The oak has quietly persisted ever since, even as housing developments, a cement factory, containers filled with modular home components, and the traffic of off-road vehicles became its new neighbors. Detritus from former meth labs and abandoned furniture now litter the lower slopes of the hill. It's a tricky climb to the top, especially when dividing one's attention between maintaining footing and safely transporting camera equipment, but that's probably precisely what afforded the oak the obscurity that allowed it to survive into the present. In fact, it lives on private property—clearly breeched by many an interloper—and it's likely that not even owner knows that it's there. Its steep and rocky perch keeps it out of the probable path of fires, as well.

I recently checked in with Sanders for the current status on the oak's health. He happily reported that despite the severe drought the area is suffering, the tree's various stems are exhibiting new growth and an abundance of flowers. However, he went on to say, "if this area dries over the long term, as some of the climate models predict, then the oaks will be stressed and perhaps significantly threatened. . . . I imagine it wouldn't take a lot of additional stress to cause mortality."

Sanders had actually been up for a visit for another reason. He took some mycologists to conduct field research on the "mycorrhizal fungi associates growing on the oak's fine roots and playing a major role in nutrient uptake." But this fungus isn't a threat like the *Armillaria*. "The fungi that produce truffles in Europe are an example of this [mycorrhizal fungi]. It's just too bad that none of the local ones produce top-notch truffles. I've not heard of people looking for truffles under Palmer's oaks, but maybe they should."

In the meantime, Provance has been hard at work as well. In fact, he's just discovered a new species of morning glory unique to Southern California.

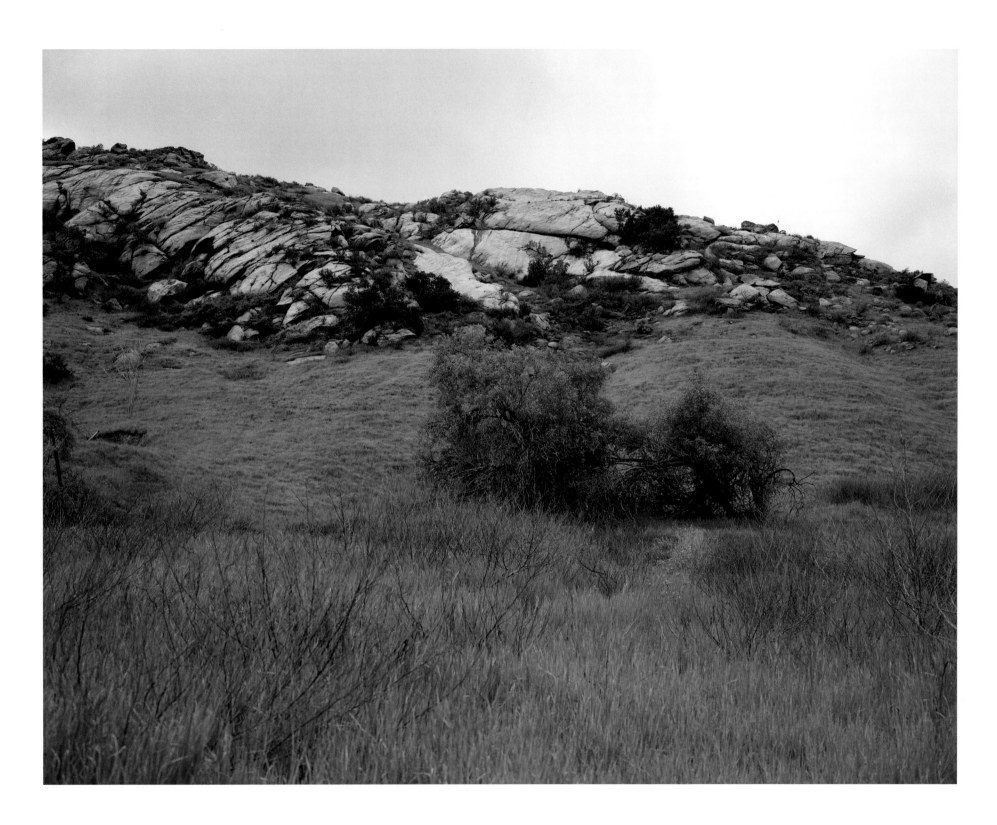

Lower slope leading to Palmer's Oak #0311-0828 (13,000 years old)

RIVERSIDE, CALIFORNIA

Pando

AGE
80,000 years

LOCATION
Fish Lake, Utah, USA

NICKNAME
Pando, the Trembling Giant

COMMON NAME
Quaking aspen

LATIN NAME
Populus tremuloides

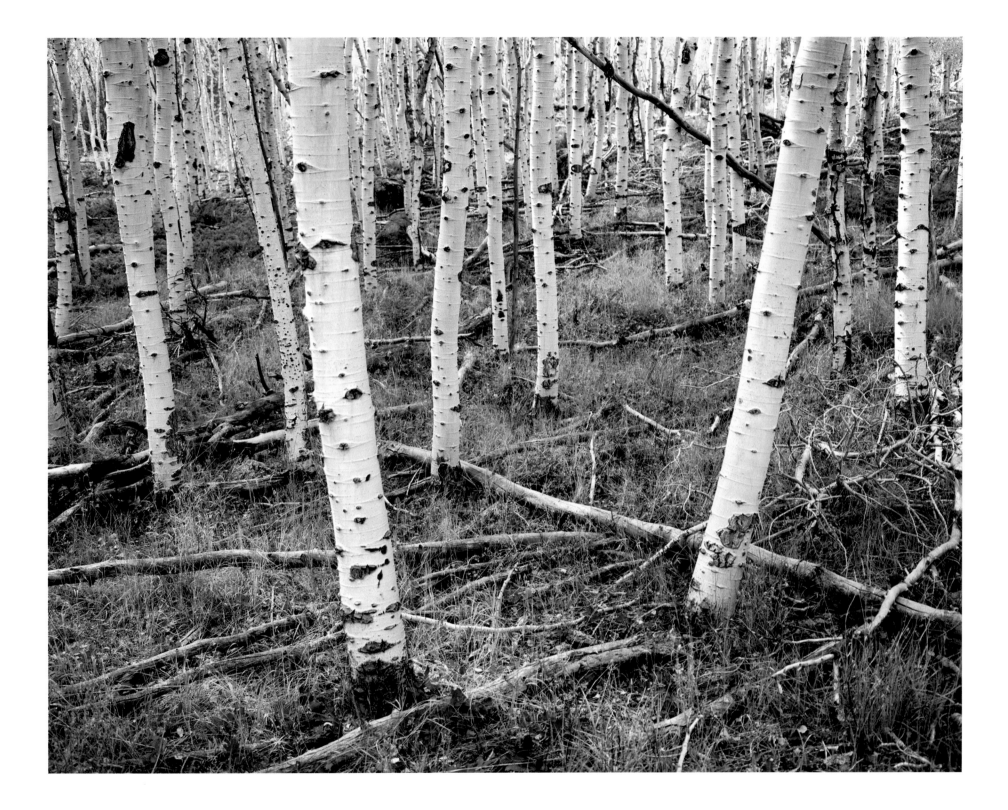

Pando, Clonal Colony of Quaking Aspen #0906-4317 (80,000 years old)

FISH LAKE, UTAH

What looks like a forest is, in a sense, a single tree.

Pando, a clonal colony of quaking aspen, comprises a massive root system, and each tree—all 47,000 of them—is a stem coming up from that single system, making it one giant, genetically identical, 106-acre individual. Quaking aspen have very wide distribution across North America, and this root suckering, or self-propagation, is not at all uncommon. Pando has just been doing it the longest.

Latin for "I spread," Pando is generally thought to be around 80,000 years old. However, Burton Barnes, who first indentified the clone in the 1970s, estimated that it could be as old as *700,000 years*. The truth is that both numbers are conjectures. While recent molecular work has defined Pando's boundaries with more accuracy than ever before, there are simply no reliable tools to pinpoint its exact age. Instead, factors such as growth rates and climate data were used to formulate educated guesses.

In 1992, Michael Grant, professor of ecology and evolutionary biology at the University of Colorado, expanded on Burton's work, calculating Pando's extraordinary mass. In fact, when I spoke with him again recently over e-mail, Grant told me that he was inspired by a story on National Public Radio about the *Armillaria* fungus, at the time reported to be the largest organism in the world, and thought to himself, "No, no, we can have a much more lovely image for the 'largest' organism in the world" and went on to conduct the research and nominate Pando.

The stands are quite sophisticated systems. Areas rich in nutrients and available water ferry these resources to poorer areas in need, and what's more, the colony as a whole can migrate toward more favorable conditions should the environmental circumstances change—albeit quite slowly. According to Grant, Pando's "immense spread [and probable immense age] have to do with an appropriate combination of enough fire frequency to keep the conifers from taking over, but not so frequent that aspen doesn't thrive, plus sufficient soil moisture for high water needs, but not so much it swamps [them out]."

However, human interference has already caused substantial damage to Pando. Roads, cabins, and campgrounds have breached its boundaries. (Or "his" boundaries, you could say—there are male and female quaking aspens; Pando happens to

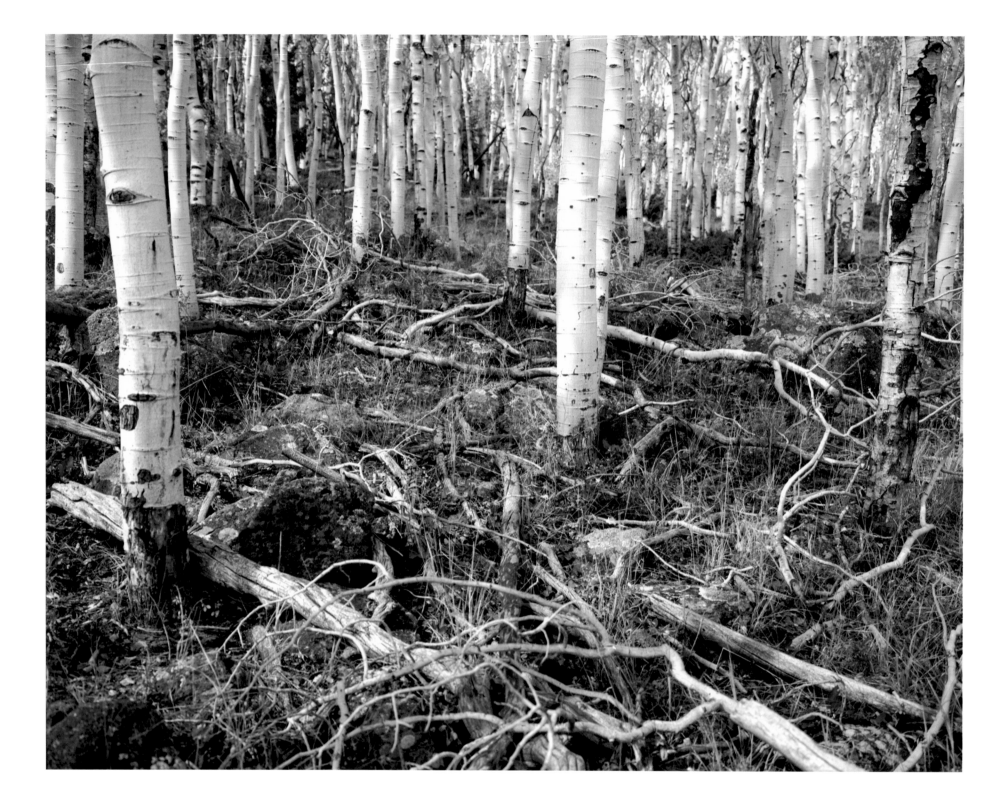

Pando, clonal colony of Quaking Aspen #0906- 4711 (80,000 years old)

FISH LAKE, UTAH

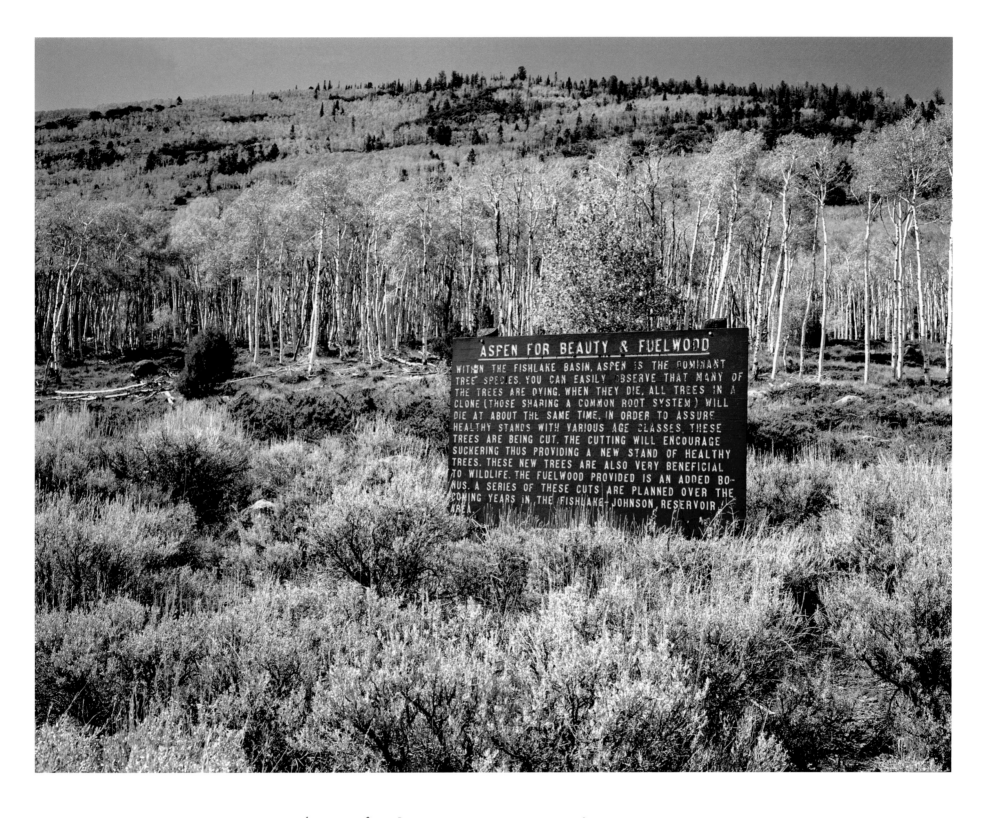

The sign in the photograph reads:

ASPEN FOR BEAUTY & FUELWOOD

WITHIN THE FISHLAKE BASIN, ASPEN IS THE DOMINANT TREE SPECIES. YOU CAN EASILY OBSERVE THAT MANY OF THE TREES ARE DYING. WHEN THEY DIE, ALL TREES IN A CLONE (THOSE SHARING A COMMON ROOT SYSTEM) WILL DIE AT ABOUT THE SAME TIME. IN ORDER TO ASSURE HEALTHY STANDS WITH VARIOUS AGE CLASSES, THESE TREES ARE BEING CUT. THE CUTTING WILL ENCOURAGE SUCKERING THUS PROVIDING A NEW STAND OF HEALTHY TREES. THESE NEW TREES ARE ALSO VERY BENEFICIAL TO WILDLIFE. THE FUELWOOD PROVIDED IS AN ADDED BO-NUS. A SERIES OF THESE CUTS ARE PLANNED OVER THE COMING YEARS IN THE FISHLAKE-JOHNSON RESERVOIR AREA.

Aspen for Beauty and Fuelwood #0906-5033

FISH LAKE, UTAH

Pando clear-cut #0906-4717 (80,000 years old)

FISH LAKE, UTAH

be male.) Worse still, the Fish Lake Forest Service clear-cut a large swath from its center, ostensibly to stimulate new growth in lieu of the necessary fires. At one cut site, deer ate all the new saplings, so the Forest Service chopped down even more, this time putting up a fence. Unfortunately those cuts were made at the heart of the grove, irreparably scaring Pando's previously pristine form. Ironically, the discarded timber was destined to encounter fire after all: as free firewood for anyone who wanted to haul it away.

Pando had fifteen minutes of fame in 2006 as a postage stamp in the US Postal Service "Wonders of America, Land of Superlatives" series. (*Fastest Bird! Largest Frog! Longest Covered Bridge!* And Pando, *Largest Plant.* In all fairness, the bristlecones made the list, too.) But perhaps it was because this discovery didn't capture the imagination of the world to a degree befitting its significance that I couldn't help but feel that the stamp was something of a comedown, like putting the discovery of one of the grandest living organisms on the planet on an "And all I got was this lousy t-shirt" souvenir. When we spoke again recently, Grant told me that while he has not seen Pando in person for about a decade, he has heard reports that its health is in decline.

Mistakes have been made in the management and preservation of this astoundingly large, ancient, complex, and beautiful organism. Pando needs an immediate intervention—its current management is missing the bigger picture. I'd like to nominate Pando, and all organisms over 2,000 years old, for UNESCO recognition and protection.

The Senator

AGE
3,500 years (deceased)

LOCATION
Florida, USA

NICKNAME
The Senator

COMMON NAME
Pond cypress

LATIN NAME
Taxodium ascendens

Charred remains of the Senator Tree, Bald Cypress #0212-0149 Killed Jan 16, 2012 (3,500 years old)

SEMINOLE CO., FLORIDA

The Senator Tree, Bald Cypress # 0907-0107 (3,500 years old; Seminole Co., Florida) DECEASED

SEMINOLE CO., FLORIDA

The tree had been on fire for over a week before anyone noticed. On January 16, 2012, the Senator, one of the oldest cypress trees in the world, collapsed and died, engulfed in flames. It was 3,500 years old.

It was my second visit to the tree, the first being in 2007—a trip that had failed to ignite my imagination after I had just returned from some serious adventures in Africa. The Senator was the primary attraction at the aptly named Big Tree Park, just twenty minutes' worth of strip malls away from downtown Orlando. In fact, it was the original Orlando attraction, BD ("Before Disney," if you will), visited via horse and carriage. I drove there with a friend in her family car. We parked in an orderly lot, walked a quarter mile on a planked path through the once swampy woodland, and arrived at the tree, just like that. Named for senator M. O. Overstreet in 1927, it was impressively tall and robust while not overly gnarly, and it kept company with Lady Liberty, which at 2,000 years and with a noticeably svelter silhouette—save for a knotty eye-level north-side bustle—made for a May-December pairing. Families with cameras looked up and strolled between the two, the children quickly bored and retreating to the playground.

I snapped a digital shot, out of proximity rather than expertise, for a couple who asked that I take their picture in front of the tree. I then took out my medium-format film camera and made some photographs of my own. When I got the film back I knew I had missed my mark: there were some interesting compositions, but I hadn't captured the spirit of this remarkable being.

I decided to return to the Senator when opportunity allowed. In the intervening years I traveled to Greenland, Chile, all over Australia, Tasmania, and elsewhere in search of other old individuals. But in those five years, even despite having visited Florida a couple of times to see family, I did not make it back to the Senator. It was too easy. (An older cypress tree in Iran, however, seemed too difficult, or rather, too dangerous.) The Senator would always be there. Surely, if it had been around for 3,500 years, it was going to be around for 3,505.

But it wasn't.

Extreme longevity can lull us into a false sense of permanence. We fall into a quotid-

ian reality devoid of long-term thinking, certain that things which have been here "forever" will remain, unchanging. But being old is not the same as being immortal. Even second chances have expiration dates. The comparative ease of access and the seeming lack of urgency bred a complacency in my return to the Senator.

On February 8, 2012, just days before I was to ship out for Antarctica in search of the 5,500-year-old moss, I returned to what remained of the ancient tree. I met Jim Duby, program manager of the Seminole County Natural Lands Program, at the locked gate of the park. Jim had been to the site every day since the fire. At the time, the cause of the fire had not yet been determined, and natural causes, like a lightning strike, were still on the table. After speaking with him, it was hard for me to consider the cause of death to be anything but human intention. There was no lightning recorded in the area during the weeks in question, and the tree had been newly fitted with a lightning rod. Another idea that it had spontaneously combusted under its own auspices simply seemed absurd. On the other hand, the tree had been visibly hollow before the fire, and an opening at the base of the trunk, once filled with concrete, had become large enough for a person to squeeze through and stand inside. Or to drop a match into, and run. The Senator was likely spared the long-ago ax of the logging industry because it was hollow, but the very same defect ultimately sparked its death.

So what did kill the Senator? Some kids in their early twenties who snuck into the park and climbed inside the tree, high on methamphetamine. They lit matches or a lighter to "see the drugs better," and just like that the Senator's hollow trunk was transformed into a towering chimney and fuel source in one.

For the Senator, there is a chance at a second life: clippings from the tree were taken years ago and successfully propagated in a nursery. In February 2013, after a careful root-stabilization process, a forty-foot grafted tree was successfully transplanted back into the Senator's original spot and has already sprouted fresh growth and gained in height. Four artisans and several institutions were selected to make works honoring the Senator's legacy. The stump has been incorporated into the playground area.

Seminole County held a contest to name the newly planted clone.

The community chose "The Phoenix."

Map Lichens

AGE
3,000–5,000 years

LOCATION
Greenland

NICKNAME
N/A

COMMON NAME
Map lichens

LATIN NAME
Rhizocarpon geographicum

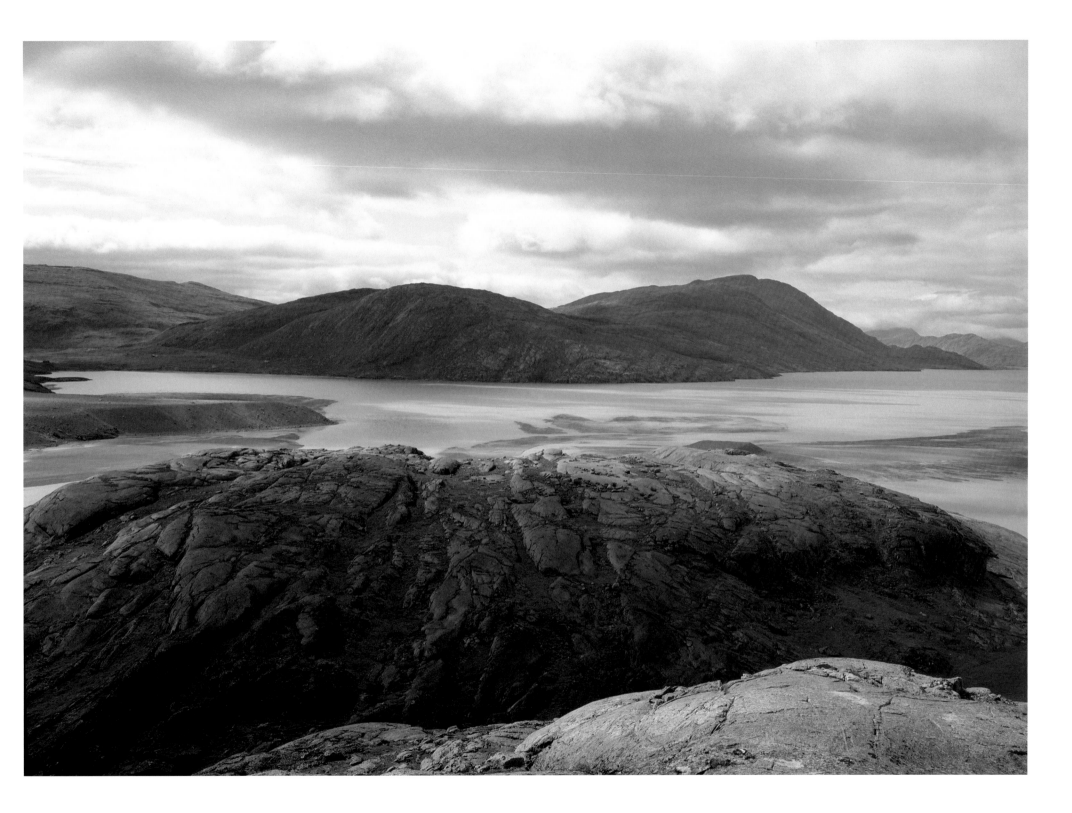

Untitled

IGALIKU FJORD, GREENLAND

Map lichen R. Geographicum #0808-04A05 (3,000 years old)

SOUTHERN GREENLAND

Norse grave site

IGALIKU, GREENLAND

If you miss the flight to Narsarsuaq, Greenland, from Reykjavik, Iceland, you have to wait a whole week for the next one. One August Thursday in 2008, I hurriedly packed up my studio at the Bard College MFA summer program in upstate New York, forgoing the end-of-semester party, rushed back to Brooklyn, packed a new set of bags, and flew to Iceland. Landing in Reykjavik, I had less than an hour to make it to the other airport and catch my connection to Narsarsuaq. My first helicopter ride followed shortly thereafter, eyes glued to the window at the primal landscape and "inland ice" that dominates most of Greenland's landmass.

I first met evolutionary biologist Martin Bay Hebsgaard at a cafe on a canal in Copenhagen in the summer of 2007 while imaging the Siberian Actinobacteria. Hebsgaard mentioned some ancient lichens in Greenland thought to be upward of 5,000 years old and invited me to join him on his expedition supporting some Danish archeologists with "lichenometry" —the measure of lichen growth on surfaces—to help confirm their own estimations of ages of Norse ruins. It's also a useful tool in measuring glacial movement.

Our search for *Rhizocarpon geographicum*, commonly known as map lichen, was a little haphazard. While generally in the correct vicinity, we didn't have exact coordinates. Nor was there any reason to believe the oldest lichen has actually been found. We hiked out of Qaqortoq, in the last throes of its short summer, one day to the north, the next to the south, icebergs floating in the bay and a metallic gray sky overhead. The ground was luxuriantly soft with springy cushions of moss, and lichens of all different colors painted the rocks: reindeer lichens with bright red noses, yellow streaks like brush strokes across rock canvases, purple, red, green, orange. Gray and black lichen fields closer to town were occluded with names and dates and phone numbers—lichen graffiti (or scratchiti, more accurately). I felt simultaneously lighthearted and serious, trying to find the world's oldest lichen in this manner; a little absurd, yet the chances were just as good as not of finding an ancient life that had never been pondered by another living soul before.

Though often classified as a fungus, lichens are in fact symbiotic amalgams of a fungus with a photosynthetic collaborator such as green algae (a plant) or cyanobacteria. They require low-pollution environments, though they can also thrive in extremely adverse conditions. In fact, some *R. geographicum* took part in an experiment hypothesizing the successful transport of microorganisms to Earth via meteorites. It,

Assorted young Map and other lichens # 0808 — 3383

SOUTHERN GREENLAND

Rock #0808-03A01

SOUTHERN GREENLAND

along with two other lichen species, was actually exposed to outer space for ten days and returned to Earth alive and well, deemed "quite resistant to outer space conditions." In Greenland, map lichens grow *one centimeter every hundred years*. Entire continents are drifting away from one another at a rate at least a hundred times that. Or imagine it in human terms: *an entire lifetime spent growing a single centimeter.*

There was never a moment when we declared the largest found; rather, we searched for the largest specimens for the duration of the time we had. Later in the week I was to continue my lichen hunt in the company of the aforementioned archeologists, and Hebsgaard was to fly to Singapore. Not direct. After we received a message via satellite phone that the archeologists' boat was broken, Hebsgaard suggested that I should make my way there on my own and helped me hire a local with a powerboat. As I walked him to the helipad, he assured me I had the correct directions, told me to "look for the yellow house," and chuckled at my slight concern over the logistics of finding them on the other side. I bid him bon voyage and headed down to the harbor.

The cliff sides viewed from the boat were mesmerizing. About an hour up the fjord we hung a right, entering an inlet that looked much like any other, and the captain proclaimed us arrived.

So this was Sodre Igaliku. (That's a bit of "Danelandic" patois—Danish and Greenlandic, mixed.) After climbing across the rocks and through antagonistically sticky glacial mud, I spotted one of the vivid orange Arctic water safety suits, telltale in that they're used exclusively by nonnatives. Sure enough, up the dirt road—the only option aside from back into the mud—was the yellow house. There, I was given a few parting words by the boat's owner, whose name I never learned, in halting English: there might be a sheep farm if I needed help. For a moment I considered returning to Qaqortoq, but didn't.

I hoisted my camping backpack onto my back, my camera bag onto my front, and made my way up the hill to the house. The door stuck, but was unlocked. People had been there, but weren't staying there now. I looked for a note, but didn't find one. It was probably 4 or 5 p.m. A tattered doll from a low-rent horror movie stared at me from the corner. The gravity of the situation came into sharp focus: I was, in fact, alone in the middle of nowhere. No means to call anyone. No supplies. Not sure of

Shed # 0808 — 15B 33

QAQORTOQ, GREENLAND

where to look for anyone, unsure if they knew I was coming, or when they might return. I ditched all but the cameras and started up the road.

I'd never in my life been so alone, the quiet so palpable I felt its pressure on my eardrums and my heart beat loud in my chest.

There were a few other structures near the yellow house, all in varying degrees of neglect. A decaying shack with a sign reading "snack bar" sat ridiculously by the shore, eliciting a smirk even in my distress. As I headed up the incline, there was, in fact, a working farm. A dog barked as I hesitantly ascended some steep stairs. I knocked and waited. I knocked again. Finally, a man opened the door, in his late forties, thin and expressionless, not in the least bit bewildered at a lone woman on his wilderness doorstep. He spoke no English, and I no Greenlandic. I shaded my eyes and squinted into a false distance, to mime searching. Nothing. I mimed digging, in hopes that might translate to "archeologists." Nothing. I suddenly remembered some digital photos of the crew I'd taken in Qaqortoq the previous week, and pulled out my camera. With little more than an indecipherable nod, he pointed down the road. The only word I caught was something sounding like "kilometers." Then he shut the door.

I am not going to die wandering the Arctic steppes because I wandered too far afield looking for old lichens, unprepared.

I returned to the yellow house and prepared the one proper meal's worth of food I had with me—you know, just in case—on the gas stove. There was no running water, but there was a jug in the kitchen, probably from the river. Though it would still be hours before it got dark, I lit candles and put them in the windows in hopes someone would spot them. I was uneasy, but tried to coach myself into settling in for the night. I avoided making eye contact with the doll.

A couple hours later, still far from sleep, I heard a truck. I exhaled deeply as a woman and her husband walked up to the door. The cabin was theirs. Apparently the archeologists had split up and gone to two new dig sites, one group on the far side of the yawning inlet, the others a few miles down the road. I stuffed my things back into my pack, and climbed into their pickup, flooded with relief.

It was dark when we drove up to the little schoolhouse, but as I knocked and entered a TV was on. This half of the team was made up of three City University of New York graduate students, and they were watching *Pirates of the Caribbean*. They offered me a much-needed drink, and were amused—if not all that surprised—that I'd found them. It was perfect in its absurdity. Later, I was a little miffed that someone hadn't at least thought to leave me a note. On the other hand, I'll never so much as entertain the notion of wandering into the wilderness unprepared and alone again.

All told, I probably wasn't lost for more than eight hours, but it strikes me now what a rare thing it is to be truly alone; a lone organism separated from all others of its kind. Yet, in looking for these lichens, I stumbled into a lesson in humility and the visceral vastness of a how long a few disconnected hours can feel, let alone a few thousand years.

I found the oldest map lichen of my expedition the following day.

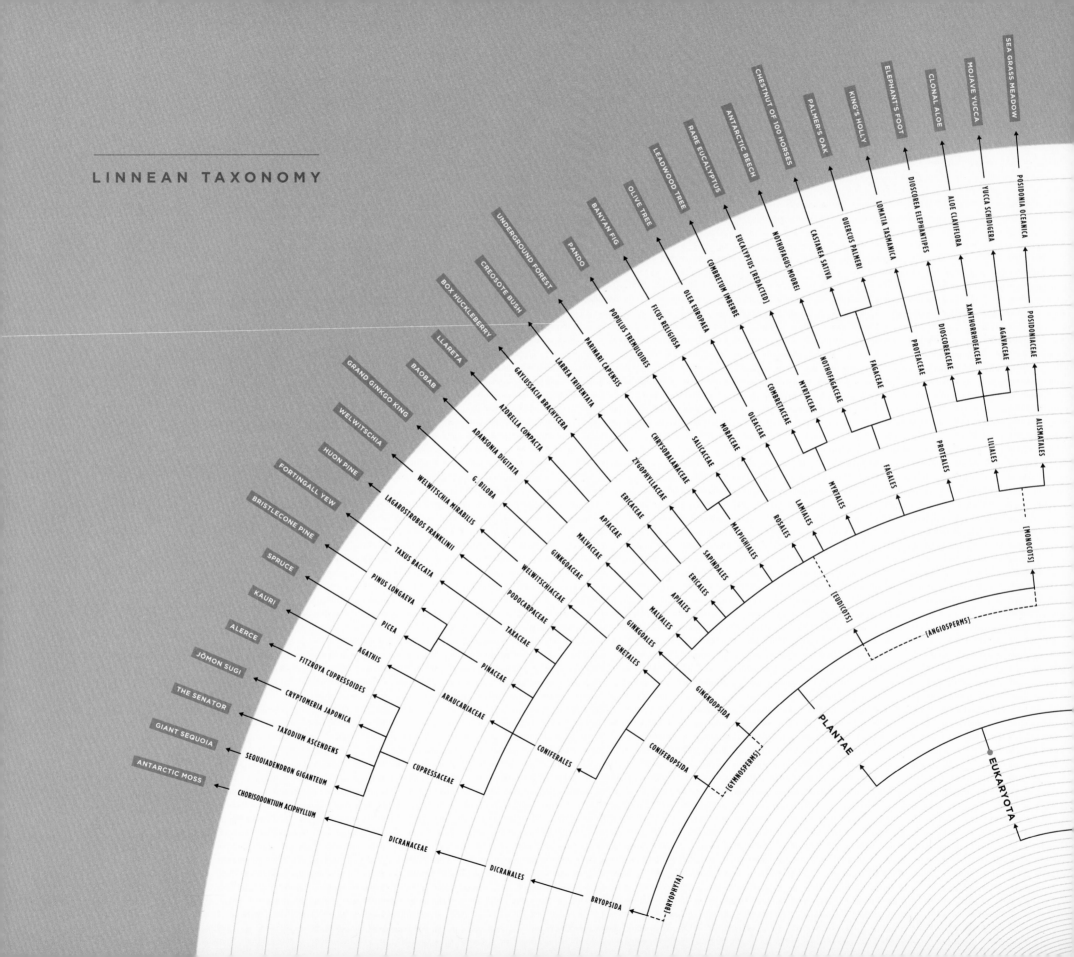

LINNEAN TAXONOMY

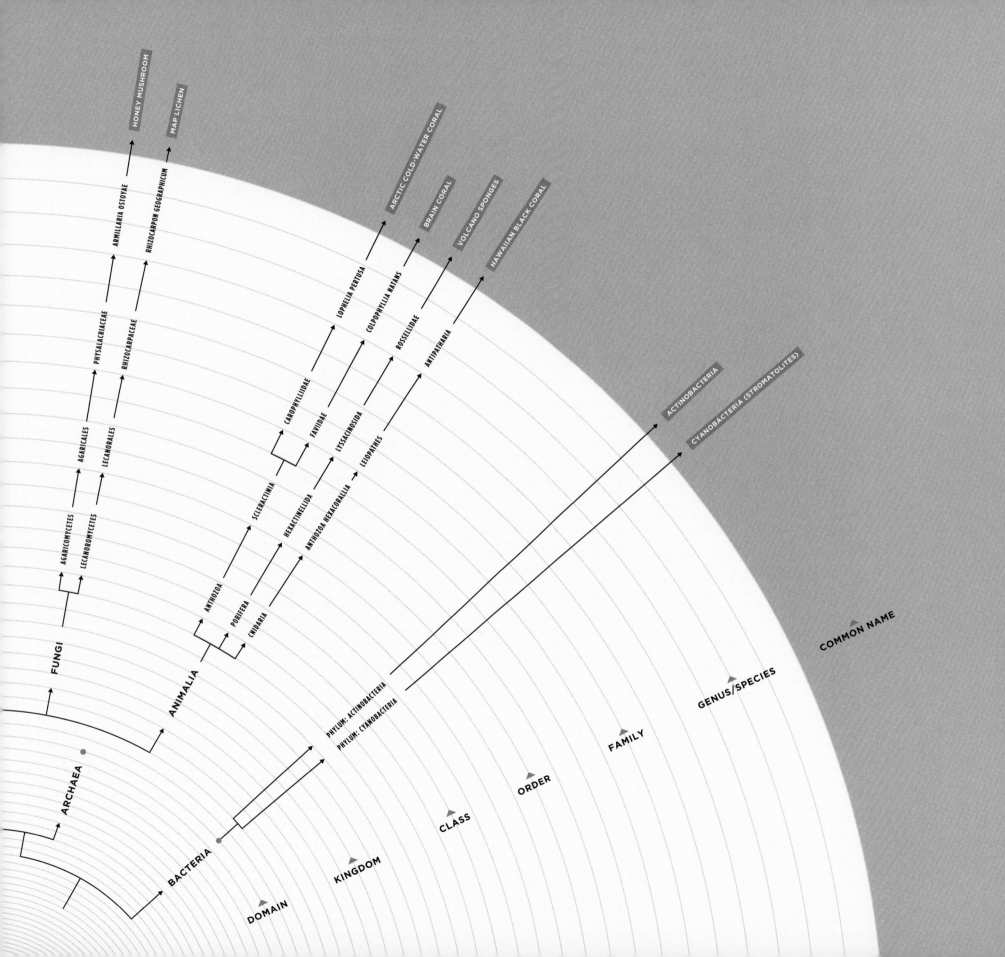

HONEY MUSHROOM

MAP LICHEN

ARCTIC COLD-WATER CORAL

BRAIN CORAL

VOLCANO SPONGES

HAWAIIAN BLACK CORAL

ARMILLARIA OSTOYAE

RHIZOCARPON GEOGRAPHICUM

ACTINOBACTERIA

CYANOBACTERIA (STROMATOLITES)

PHYSALACRIACEAE

RHIZOCARPACEAE

LOPHELIA PERTUSA

COLPOPHYLLIA NATANS

ROSSELLIDAE

ANTIPATHARIA

AGARICALES

LECANORALES

CARDPHYLLIDAE

FAVIIDAE

LYSSACINOSIDA

LEIOPATHES

AGARICOMYCETES

LECANOROMYCETES

SCLERACTINIA

HEXACTINELLIDA

ANTHOZOA HEXACORALLIA

ANTHOZOA

PORIFERA

CNIDARIA

COMMON NAME

FUNGI

GENUS/SPECIES

ANIMALIA

FAMILY

PHYLUM: ACTINOBACTERIA

PHYLUM: CYANOBACTERIA

ORDER

ARCHAEA

CLASS

BACTERIA

KINGDOM

DOMAIN

SOUTH AMERICA

Llareta

AGE
3,000 years

LOCATION
Atacama Desert, Chile

NICKNAME
N/A

COMMON NAME
Llareta

LATIN NAME
Azorella compacta

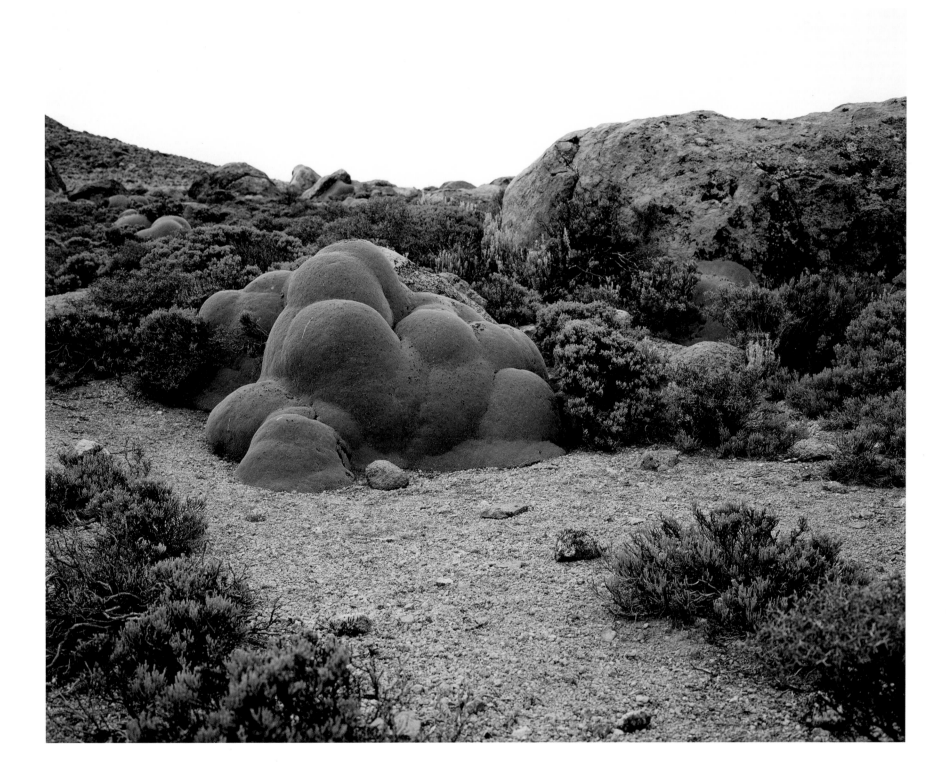

La Llareta #0308-23B26 (up to 3,000 years old)

ATACAMA DESERT, CHILE

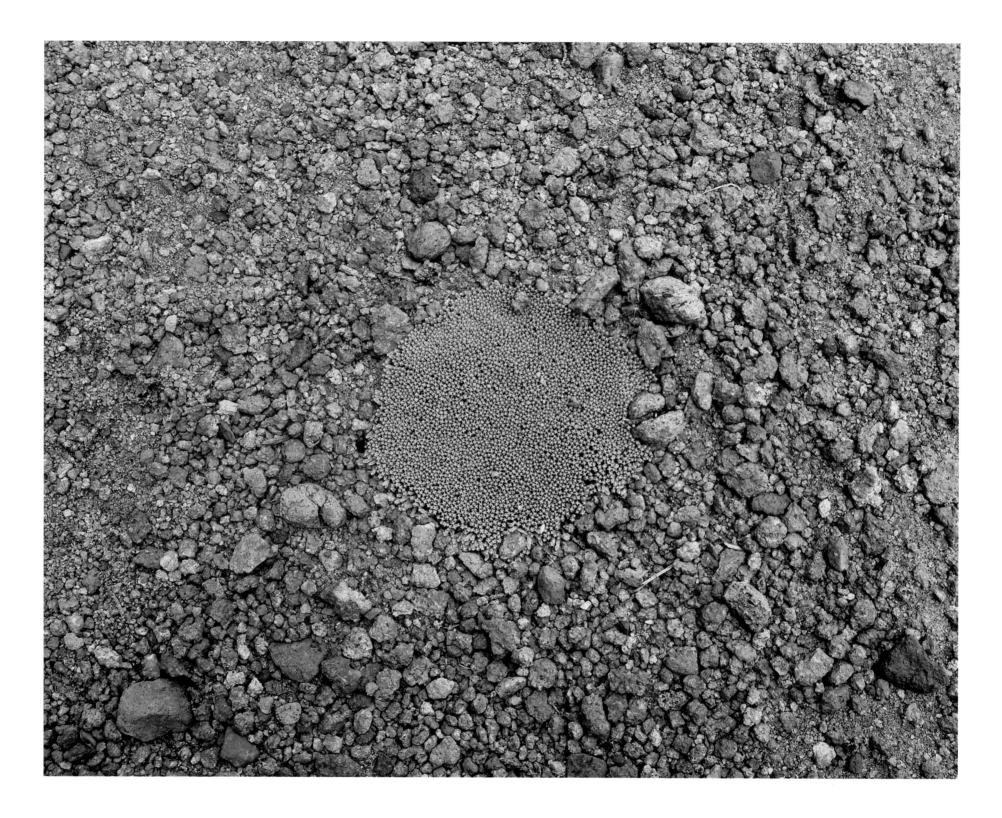

Baby llareta # 0308 -2539

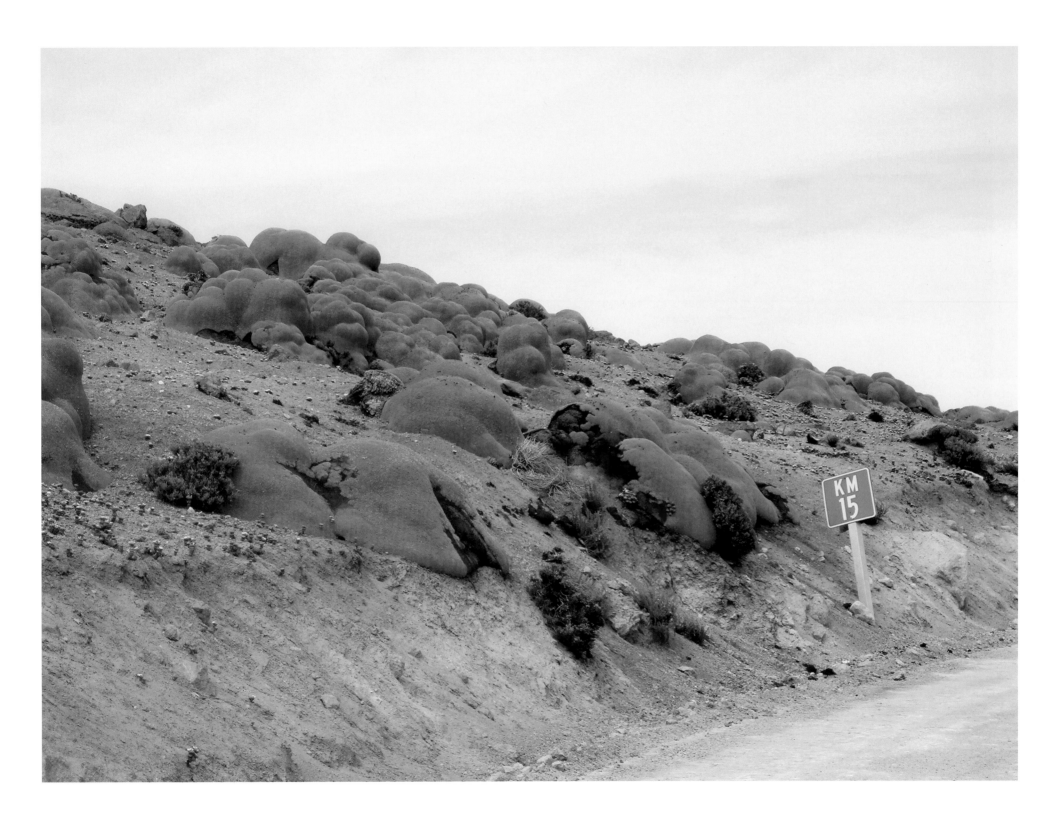

Llareta field or "llaretal" # 0308 - 2519

ATACAMA DESERT, CHILE

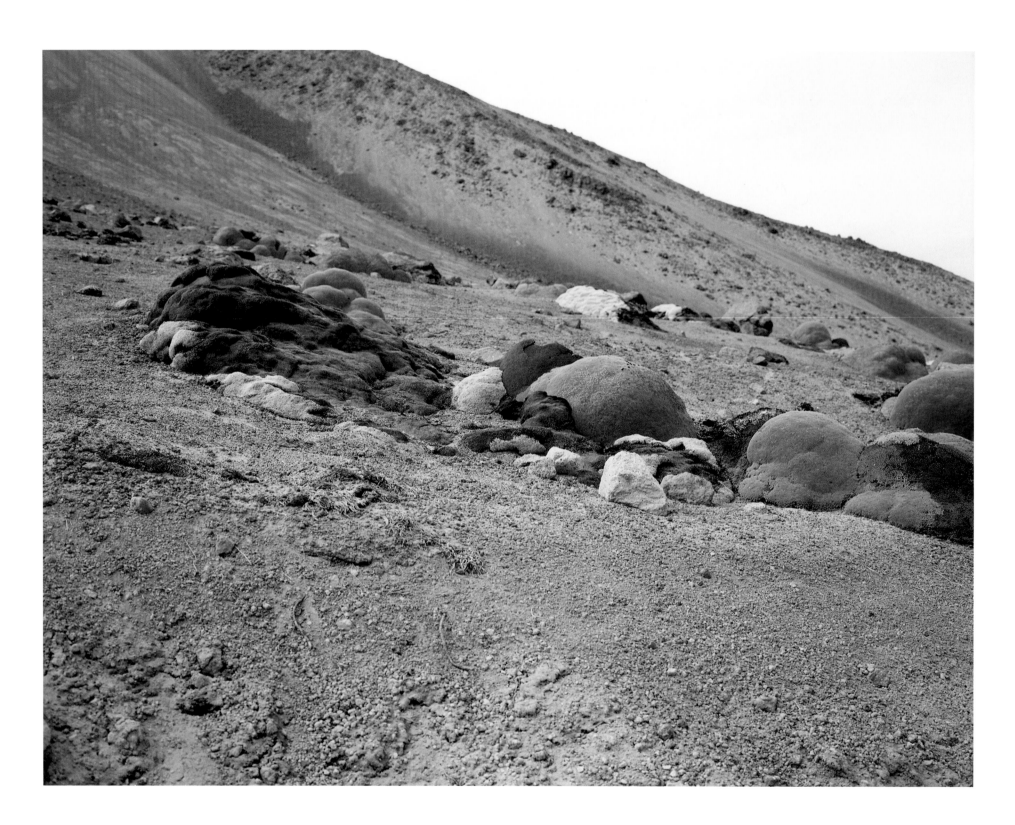

Dying llareta # 0308 - 2B29

The Llareta (or Yareta) calls home one of the most arid places on earth, the Atacama Desert, parts of which are referred to as "absolute desert" (which I can't help associating with the notion of "absolute elsewhere," used in physics to reference a point (or person's) relative position in space-time; a topic that can easily redirect a conversation toward the philosophic). Some segments of the Atacama have not seen a *single drop* of rain since record keeping began—and perhaps for millions of years before that. Admittedly, human record keeping is shallow in the grand scheme of things. But lest we get too philosophical, the absurd comes to the rescue: the llareta is a member of the *Apiaceae* family, making it a cousin of parsley, carrots, celery, fennel, and a whole host of common aromatic plants you may well have eaten already today. Llaretas live in the higher altitudes of the Atacama, beyond the absolute desert, in areas where marine fog and a few drops of rain sometimes fall.

I first heard about the llareta from a note from someone on Flickr whom I'd never met, but had read a blog post about my upcoming trip to Chile. I quite liked the idea of going to the absolute desert to find some 3,000-year-old parsley.

Botanist Eliana Belmonte borrowed a *camioneta* from the University of Tarapaca, in Arica, where she teaches, and we started the steep ascent from the coast up into the *altiplano*. Belmonte is a friend of my dear friend Tonia Steed's stepmother. In fact, Tonia had planned to join me for part of this expedition, but was unable to come because of a passport snafu. Nonetheless I stayed with her stepbrother and his wife, who live in Santiago. They were gracious hosts, and invited me back at the close of my trip. Belmonte, whose primary research is on the queñua trees—the only trees growing in the highlands—is knowledgeable about a wide range of local flora. She suggested that I hire her regular driver, Marisol, to take us through the difficult terrain over the next several days, and off we went, away from the coast and up into the bone-dry mountains.

Our first stop out of Arica was for tea and oxygen. Some friends of Belmonte´s run a sort of DIY desert tour and education program. The outside of their in-home tour center looked a bit like a bright hippie compound, and inside there were all sorts of treasures—fossils, arrowheads, old pottery, celestial maps, a picture of Einstein, and what at first looked like a dialysis machine but was actually the oxygen. We were already at 10,000 feet, and I could feel my heart pumping faster than usual. They led us in a breathing exercise:

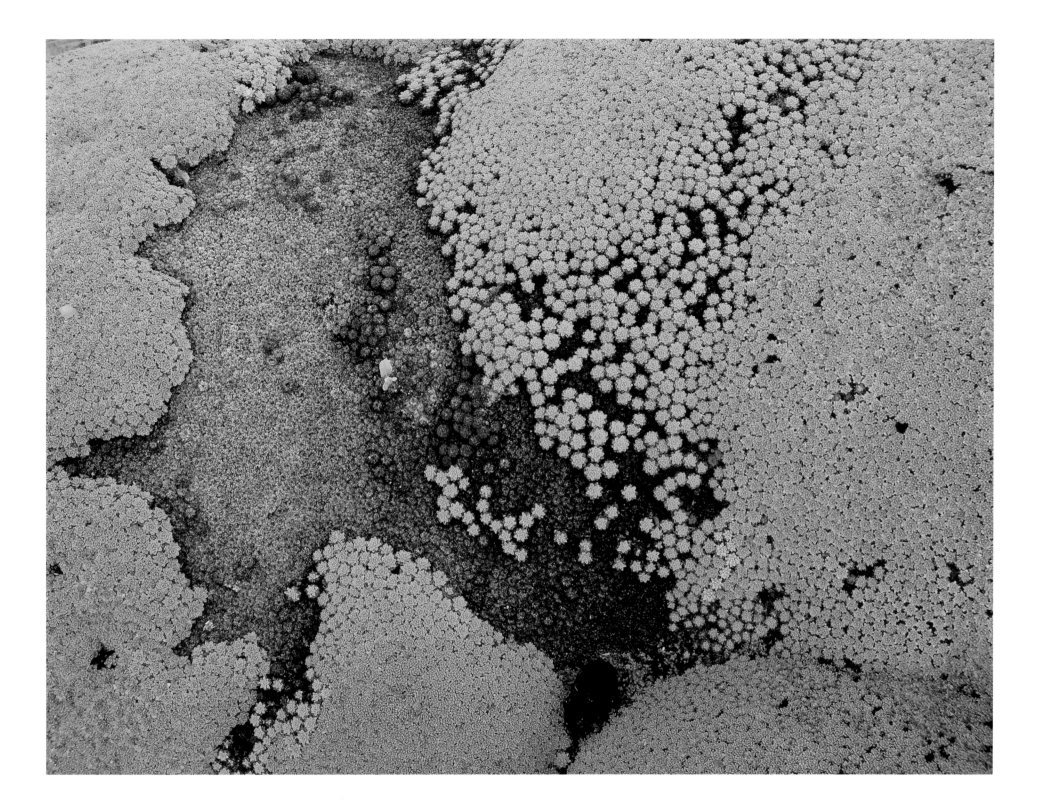

Llareta leaf clusters #0308 - 2498

ATACAMA DESERT, CHILE

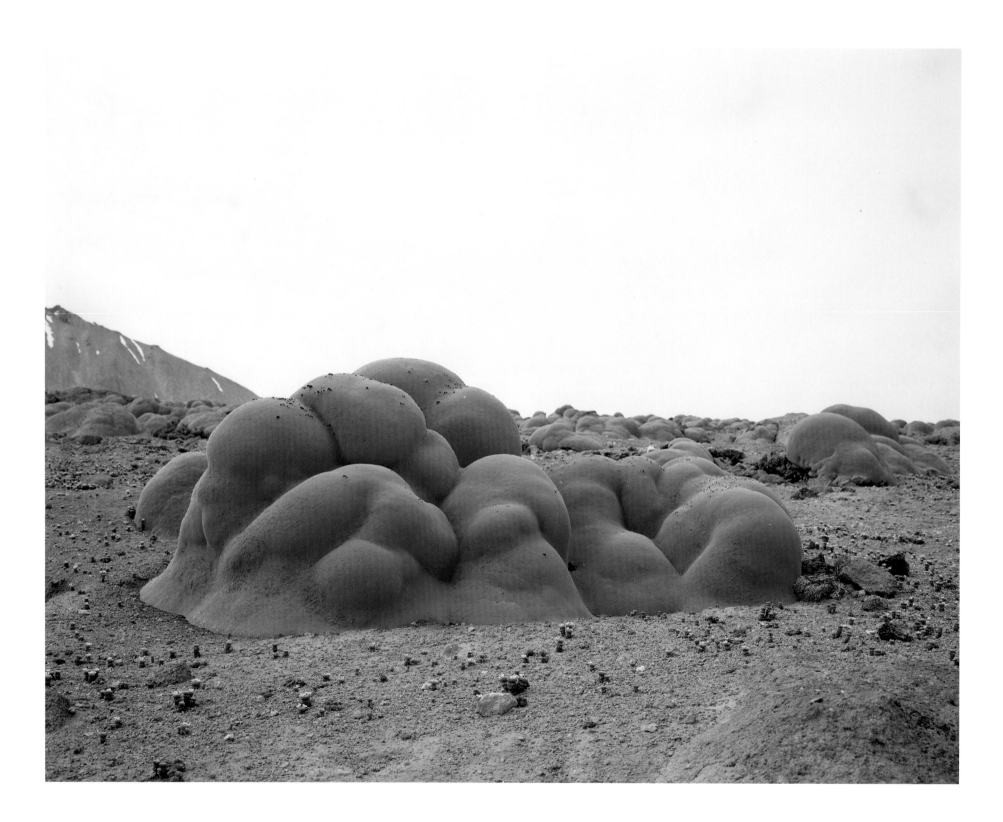

Llareta # 0308 - 2B31 (2,000+ years old)

Parque Lauca #0308 - 13B05

1. Take one hand, cross it in front of you, and hold the opposite nostril shut.
2. Breathe deeply.
3. Switch hands/nostrils and breathe deeply again.
4. Repeat 10 times.

After all that breathing, a turn with the oxygen mask, and tea prepared from coca leaves and various twigs from plants retrieved by their children directly outside the door, I was feeling well adjusted.

That afternoon we made it to Putre, a little town even higher in the *altiplano*, to acclimate before heading further up and out in search of the llareta. After walking around town a bit in the long late-afternoon light, we headed to La Paloma for dinner, the kind of place that has one thing on the menu for the day, and since I don't eat meat, this posed a bit of a problem. I asked if they could fix me some vegetables, to which they reluctantly agreed. Belmonte suggested they make some pasta as well—*verduras con fideos*. What I got was a plate of boiled spaghetti noodles—period. I added whatever condiments were on the table—salt, *salsa picante*—but there's only so much you can do with naked noodles. Once back in Santiago I learned that the proprietors of La Paloma own all sorts of businesses in Putre: the restaurant, the hotel and store, a postal service . . . but their primary focus is drug running over the nearby Bolivian border. Hence their lack of concern over my dinner.

The next day we started searching for the largest llaretas we could find. What looks like moss covering rocks is actually a shrub made up of thousands of branches with clusters of tiny leaves at the end. They are so densely packed together that you could actually stand on top of them. Not that I would recommend it; I was dizzy as I photographed, now at 15,000 feet. The llareta produces yellow flowers in the spring, though it was not in bloom at the time. Because it is dry and dense, the llareta burns efficiently, like peat. Its utility as fuel is actually endangering its survival, as even park rangers charged with protecting it have been known to burn it to keep warm on cold nights. The llareta grows no more than a centimeter a year, so using it for fuel is an entirely unsustainable enterprise.

We would depart this llaretal (a field of multiple llaretas) to seek out others growing in the Parque Lauca. Although we did not find any older individuals, the higher we

went, the richer the landscape became, in stark contrast to the seemingly lifeless desert below. As we entered the park, snowcapped mountains more than 20,000 feet above sea level were ringed by lakes filled with strolling flamingos. Primitive-looking birds waded around the far side, adding to the Mesozoic-esque tableau, oblivious that the world had changed so much around them. Every once in a while you see something so ludicrously beautiful that all you can do is laugh.

LLARETA

Alerce

AGE
2,200 years

LOCATION
Patagonia, Chile

NICKNAME
Alerce Milenario, El Tata

COMMON NAME
Alerce; Patagonian cypress

LATIN NAME
Fitzroya cupressoides

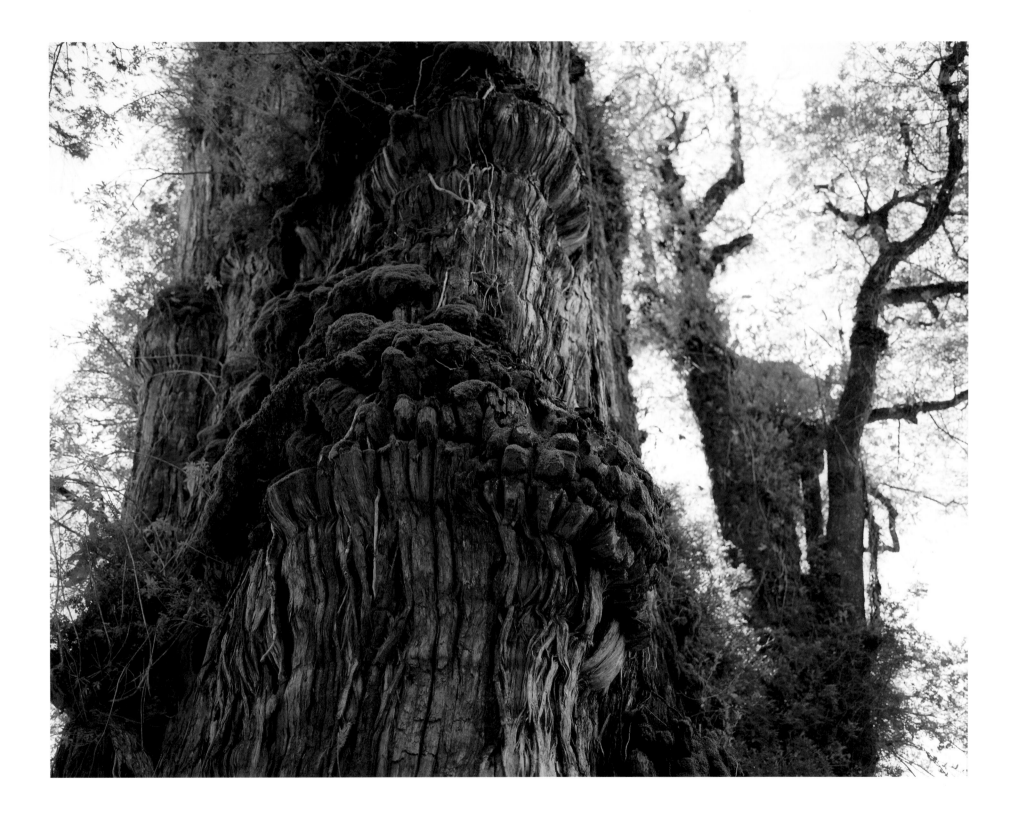

Alerce Milanaria Patagonian Cypress #0308-4A17 (2,200 years old)

ALERCE COSTERO NATIONAL MONUMENT, CHILE

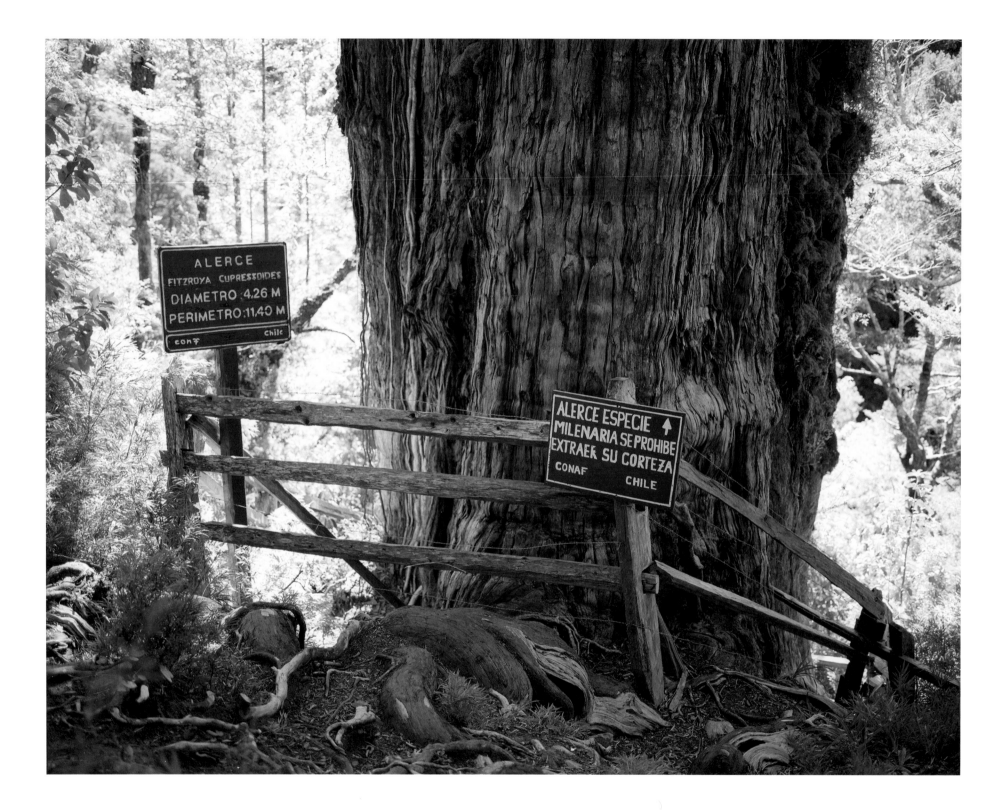

Alerce Milenario Patagonian Cypress # 0308-17B37 (2,200 years old)

ALERCE COSTERO NATIONAL MONUMENT, CHILE

Alerce bite, Patagonian Cypress #0308-16B22

ALERCE ANDINO NATIONAL FOREST, CHILE

A country road, a pig

ALERCE COSTERO, CHILE

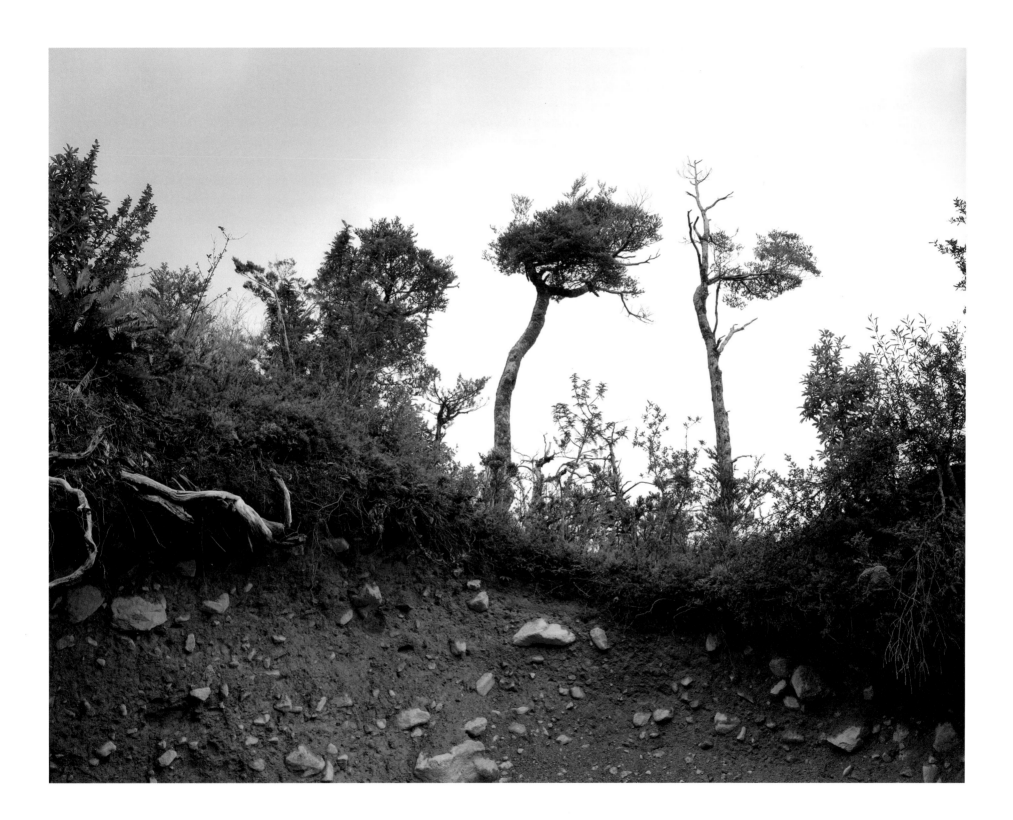

Alerce Andino National Forest #0308-9B35

The thought of driving alone on the Pan-American Highway made me uneasy. Despite assurances from my local contacts that it was quite safe, I still imagined a scenario where everyone's placations would turn out to be misplaced. What I was really afraid of, of course, was the unknown.

I flew down to Region X nonetheless. Concerns aside, I loved the misterioso, Bermuda triangle quality of that, though learned that the Roman numeral has been replaced with the aptly descriptive "Lakes Region." After a week in the Atacama Desert, the lakes and rivers looked downright indulgent, even when accounting for the brushfires still smoldering across the countryside. At my insistence, and after some confused looks, I received an automatic transmission 4×4 (I've learned many things during the course of my adventures, but driving stick isn't one of them). I was on my way. The road was newly paved. The weather was gorgeous. I turned on the radio and the Pixies—a favorite band from my teenage years—were playing. I smiled all the way to Valdivia, so pleased that my fears were unfounded, and relaxed into the next stage of my journey.

I had corresponded with preeminent alerce expert Antonio Lara at the Universidad Austral de Chile, a connection forged by Nate Stephenson at Kings Canyon National Park. The alerce, like the North American giant sequoias, are in the family Cupressaceae, so it's no coincidence that these researchers are personally acquainted. (This is not always the case, however. Many scientists whom I met with doing related work had never heard of each other's subjects, let alone being personally acquainted. I try to remedy that whenever possible.) When I arrived, Lara was unavailable to meet with me, but Jonathan Barichivich, a young student who happened to have grown up in the forest, was my able guide. In fact, his brother is the ranger at Alerce Costero Natural Monument, which has since been designated a national park.

The paved road ended long before we arrived at the park, and much of the dirt road washed out to deeply uneven rock, hence my need for the 4×4. If the Girl Scouts had an off-roading badge, I certainly would have earned it that day, the terrain worthy of the most macho of truck ads. Logging has long since destroyed much of the old-growth forest in the Valdivia region—and sure enough, the Alerce Costero bore few signs of old-growth grandeur. The Barichivich brothers and I hiked in, spotting a large tree here or there; then, after we rounded a bend and started down a steep incline, there was the *Alerce Milenario* in the afternoon light. While its exact age is

still not known, it is certain to be older than 2,200 years; the coring bit used to date it was not long enough to breach its full radius down to the pith, leaving its innermost growth rings uncounted.

When we returned from our hike, the ranger and his wife brought us into their home, perched on the outer edge of the park, and served bread still warm from the antique iron oven, homemade preserves, and eggs freshly collected from the yard. Everything was exquisite in its simplicity. I've always felt a pull toward having a more meaningful relationship with our place in the food chain and knowing the origins of what we eat. I grow a terrace garden in Brooklyn, though, despite their recently legalized status within the bounds of New York City, I have no plans to keep chickens.

Later, when I went back over the alerce research papers, it struck me that even the business of seemingly pure facts and figures can be misleading. From what I gleaned, lay reports of a 3,620-year-old alerce are actually a misrepresentation of a published scientific paper detailing a tree-ring *chronology* compiled for purposes of creating a linear temperature record. That record is composed of data from at the very least several distinct trees, not a single, 3,620-year-old individual. It's easy to see how misinformation spreads so easily: someone only need get it wrong once, and someone else repeat it.

Further south in Patagonia, in the Alerce Andino forest, another ancient tree was spared an untimely death, although it didn't emerge uninjured: according to my guide from the in-park lodge, saws had been taken to its trunk, but when the loggers realized it was hollow at its center, they abandoned their work and let it stand. It just wasn't worth the effort.

It's not the only time that a physical flaw ended up being the very thing that saved a life.

Brain Coral

AGE
2,000 years

LOCATION
Speyside, Tobago

NICKNAME
N/A

COMMON NAME
Brain coral

LATIN NAME
Colpophyllia natans

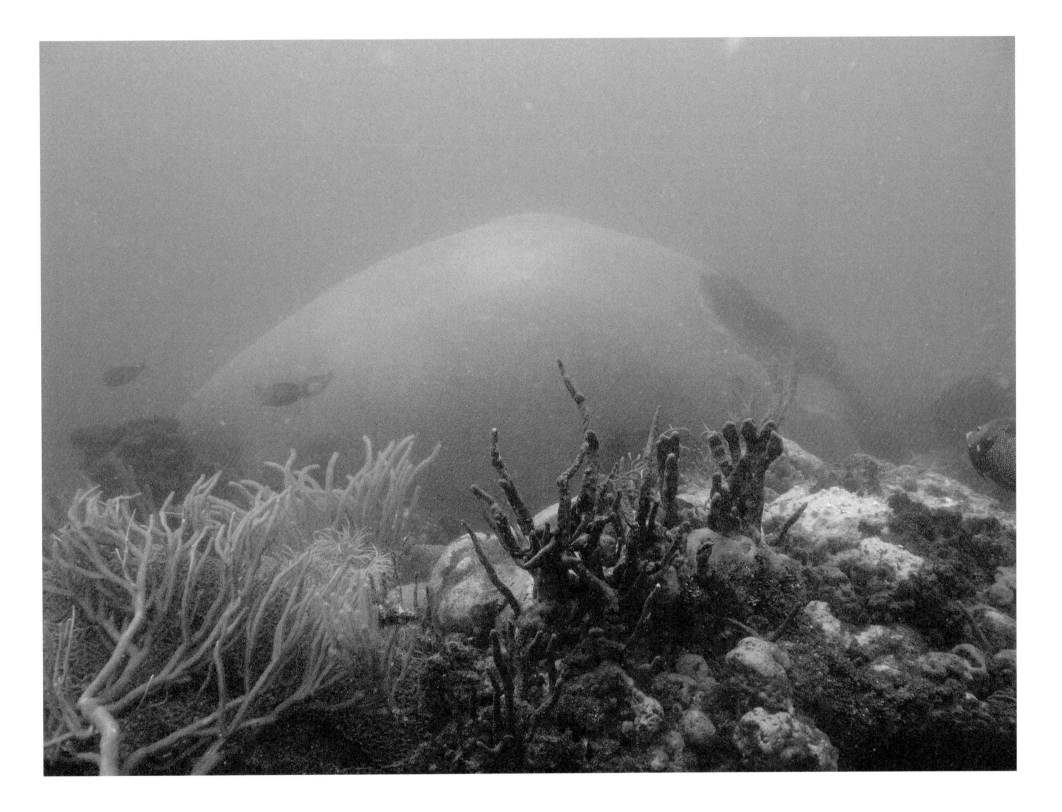

Brain Coral #0210 – 4540 (2,000 years old)

SPEYSIDE, TOBAGO

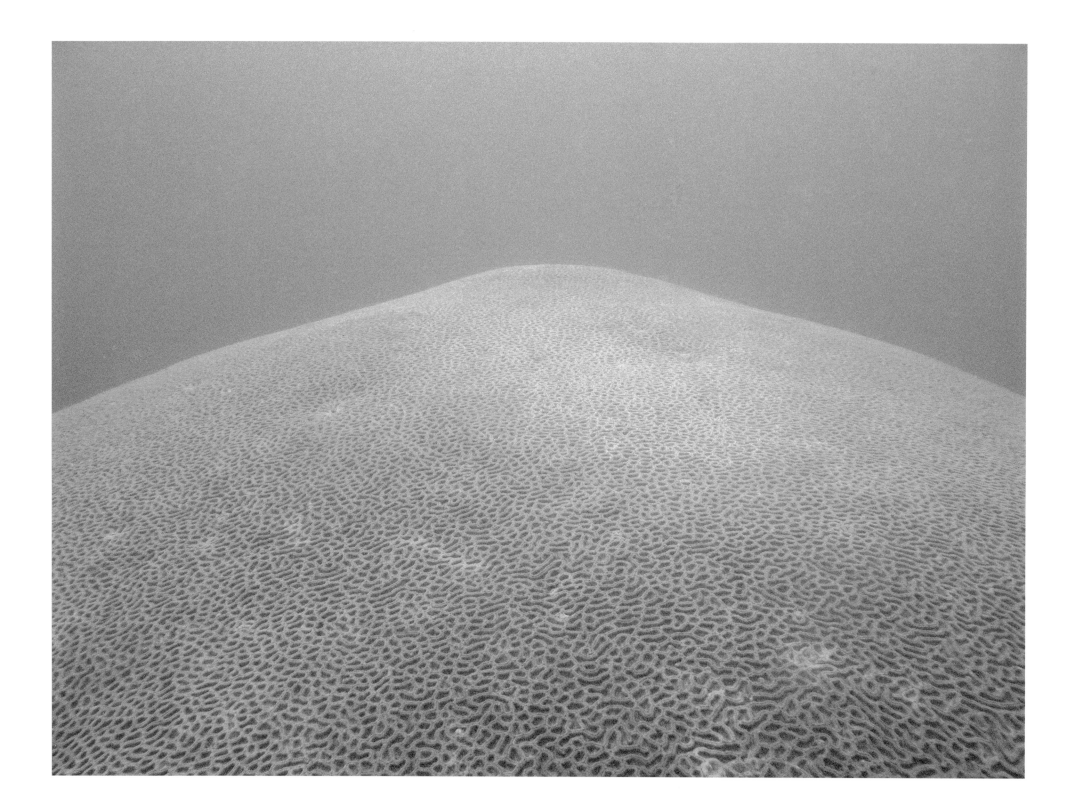

Brain Coral; crest #0210-4805 (2,000 years old)

SPEYSIDE, TOBAGO

Sea grass near coral site # 0210-4939

SPEYSIDE, TOBAGO

One dark winter's night in London I was chatting with a biologist at a cocktail reception at the Linnean Society. We got to talking about old things in short order, and he recalled seeing a brain coral thought to be 2,000 years old on a family holiday to Trinidad and Tobago. Corals. Corals are *animals.* It was a stirring moment, as I hadn't thought there would be any animals at all in this project, given that the oldest tortoise only made it up to 188 years; the oldest whales may be 200; and then there's the sad story of the 507-year-old clam in the North Atlantic that died in the lab . . . while scientists were trying to determine how old it was. There are also the so-called immortal jellyfish, which can revert back to the polyp state after already having achieved full-blown maturity. As much as we might hope they'll help unlock the secrets of immortality, there is no reason to think that any individual jellyfish would actually survive that long in the wild with so many predators about.

The brain coral was the first member of the animal kingdom I'd encountered that surpassed the 2,000-year mark.

This meant I was going to have to learn to scuba dive—something that involved getting over a bit of fear of deep water and existential discomfort at the vastness and dangers of the ocean. So another dark winter's night a year later, I was in a midtown Manhattan swimming pool so cold it made my teeth chatter. (I thought of the people I'd spotted on the train on the way into the city taking part in the No Pants Subway Ride, but this was certainly far more uncomfortable.) I signed the medical waver indicating I was perfectly healthy, but in fact I had been in a fair amount of pain for some time from a herniated disk in my lower spine. When it came time to lift and carry the heavy oxygen tank, my sister Lisa (the lessons a gift to us both from my then boyfriend R.) stealthily helped me, like a couple of schoolkids sharing answers on a test.

A month later I was at the far eastern point of Tobago at a beautiful, sheltered beach simultaneously getting my Open Water Certification, learning to photograph underwater, and trying to capture a new subject. And trying to manage what was going on between R. and me. Though we had started dating many years prior, this was the first time he'd joined me for one of my expeditions, and we were not in a great place. We arrived to find our names spelled out in flower petals on one of the past-its-prime beach motel beds; I would end up sleeping in one, he in the other.

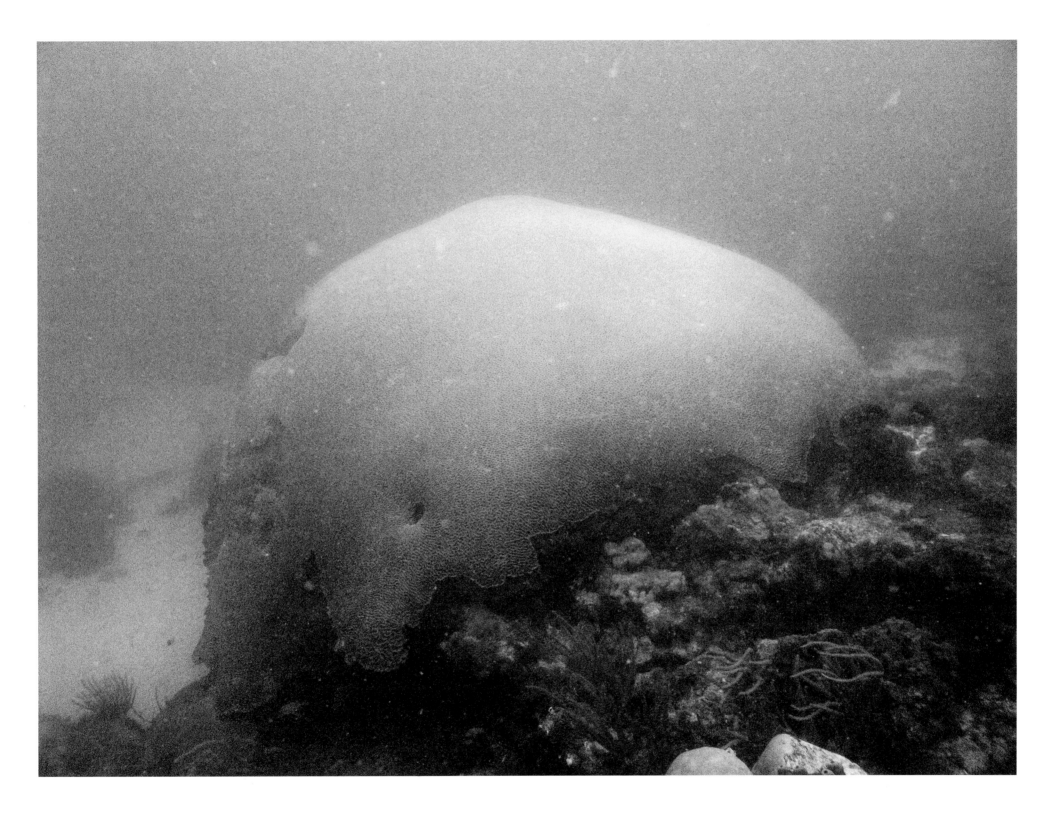

Brain Coral #0210-4501 (2,000 years old)

SPEYSIDE, TOBAGO

But I was there to jump in with both feet and get to work. Well, more like waddle awkwardly on the shore in flippers, and later tip over the side of the motorboat backward at the dive site proper. I'm told my eyes were wide as saucers when I made that first descent into deep water. This was not surprising, as I was glued to the side of the dive master almost the entire time, but I eventually relaxed a bit when I started to actually look around. When we finally got to the coral, it took my breath away. It's at a depth of about sixty feet, and at eighteen feet across it's both the oldest and largest known individual brain coral. It looked like something out of an old science-fiction film; a battered old moon or meteor.

Corals are spineless (that's not a euphemism; they're invertebrates) and construct their own exoskeletons out of calcium carbonate extracted from seawater. In the case of brain corals, the genetically identical individual polyps work in concert to form the overarching brain-like form of the colony. Each polyp has its own set of tentacles surrounding a single opening that's both its mouth and anus. (In other words, it does in fact shit where it eats.) To add to their science-fictional mystique, brain corals extend their stinging tentacles out at night to capture passing prey.

But there was no way I was prepared to try a night dive.

I did get more comfortable with each subsequent submersion, yet the dive conditions deteriorated with equal and opposite vigor. The weather grew stormy, which wouldn't be a problem underwater if it weren't also for the lunar cycle kicking up additional silt and severely hampering visibility. By the time I'd gotten more confident diving, the visibility was down to practically nothing.

In subsequent years I learned that there are two corals substantially older than this brain coral. A deep and very cold-water coral off the Norwegian shelf in the Arctic that's 6,000 years old is from the same class and order as the brain coral, but they part ways at the family level. The *Leiopathes* coral, with no immediate relation, in substantially deeper waters off the Hawaiian archipelago clocks in at 4,270. Both are best viewed in a submarine or with a remotely operated vehicle (ROV). An older animal still is something called the barrel or volcano sponge, the oldest of which is thought to be around 15,000 years old. This was reported off the McMurdo ice shelf in Antarctica, discovered using an ROV built specifically for under-ice navigation.

BRAIN CORAL

These are all quite recent discoveries, and I can't help think of the needle-in-the-haystack type luck that still plays a role in discovery, especially on the vast sea floor.

In recent years the Speyside brain coral was attacked by a school of feeding parrot fish, causing some damage, but they lost interest before killing it outright. Likewise, it was far enough from the 2010 Deepwater Horizon oil spill that it wasn't directly affected, but that was just luck. In 2013, multiple oil spills hit far closer to home in neighboring Trinidad. Luck, while wonderful when on one's side, is not a great long-term survival strategy.

On my very last dive, something stung my knee. I hadn't really noticed at the time, but my skin burned as I got out of the water. By the time I was back home in Brooklyn, angry red bumps were accompanied by enough swelling on both my knee and face to send me to the doctor. The inflammation subsided with medication, but not the aggravation on my knee: it seemed likely that I'd been stung by fire coral, which was now embedded under my skin, quite content to live there for many months to come. It's an interesting evolutionary tactic, to be sure: if you or some other sea creature dares brush against it . . . it's coming with you.

EUROPE

Fortingall Yew

AGE
Between 2,000–5,000 years

LOCATION
Fortingall, Scotland

NICKNAME
Fortingall yew

COMMON NAME
Yew; English or European yew

LATIN NAME
Taxus baccata

The Yew #0707-10332 (2,000 - 5,000 years old)

PERTHSHIRE, SCOTLAND

Fortingall Yew # 0707-09919 (2,000-5,000 years old)

PERTHSHIRE, SCOTLAND

Old yew trees are far from uncommon in churchyards in the UK—in fact there are as many as 500 of them, the trees all older than the buildings that adjoin them. In other words, first came the yews, then came the churches. There are a number of theories in this regard, the yew's symbolism running the gamut between dark prophesy through to immortality, with many shades of practical and mythical interpretation in between. In all likelihood, the trees held some sort of special status in pagan culture, the imagery of which was redirected toward the Christian over time. The Fortinagall yew in Scotland and the Llangernyw yew in Wales both safely surpass the 2000-year mark, preceding Christianity entirely.

Relatively speaking, the Fortingall yew has a rather large margin of error in its age estimate: it's thought to be anywhere between 2,000 and 5,000 years old. There's no longer a central trunk from which to take a core sample, as it has long since split into a number of smaller, disparate stems. (This is also true of the Llangernyw yew.) It is thought that some young men held bonfires within the hollows of the once intact trunk, hastening its breakdown. Apparently as far back as the 1830s people had taken so many souvenirs off the tree that a thick stone wall was erected for its own protection.

By the time I arrived in Edinburgh, I'd been on the road for six or seven weeks already, having just returned to the northern hemisphere from southern Africa. I drove north out of the city and booked a spare bedroom in a family home in Aberfeldy (best known for its Dewar's distillery), a town only slightly larger than Fortingall. It was a charming place, but I was thoroughly road-weary. I was lucky to have had a precipitation-free afternoon to photograph, but then the rain set in—and the electricity out. So instead of retreating to my room, I sat up that night with my hosts, talking by candlelight with a glass of local scotch (though I'm partial to peaty Islays, myself; they remind me of the things I photograph) at their kitchen table. They talked about how J. K. Rowling owned the house next door, and how there are as few as seven hours of daylight in the winter. The husband was part of cycling group that goes out equipped with headlamps in middle of the afternoon to combat the oppressive winter darkness. I was starting to see how all these yew stories emerged.

In the case of the Llangernyw yew, Welsh legend has it that the churchyard is haunted twice a year by the Angelystor, some sort of spirit or disembodied voice that

115

FORTINGALL
YEW

Clearcut Mountainside

FORTINGALL, SCOTLAND

recounts the names of those in the parish who will perish that year. One naysayer went to the church to prove everyone wrong, only to hear his own name called. . . . and sure enough died within the year.

Or so the story goes.

FORTINGALL
YEW

Chestnut of 100 Horses

AGE
3,000 years

LOCATION
Sant'Alfio, Sicily

NICKNAME
Castagno dei Cento Cavalli (Chestnut of 100 Horses)

COMMON NAME
Sweet chestnut, marron

LATIN NAME
Castanea sativa

Chestnut of 100 Horses with fresh lava #0412-1031 (3,000 years old)

SANT'ALFIO, SICILY

Legend would have it that the Queen of Aragon (a medieval Spanish kingdom that also ruled over Sicily) got caught in a severe thunderstorm en route to Mount Etna. She and one hundred of her knights—and, presumably, their horses—all took shelter under the expansive canopy of a chestnut tree. As ill advised as it is to stand under a tree during an electrical storm (though in fairness this took place sometime between 1035 and 1715, and it wasn't until 1752 that Ben Franklin famously flew a key attached to a kite in a storm), it is nonetheless the namesake tale of the Castagno dei Cento Cavalli, or Chestnut of 100 Horses.

In September 2010 I visited the Castagno for the first time. It was still the height of Mediterranean summer, overripe, really, and the Castagno was no exception. Its half-dome canopy was so thick with foliage and heavy with chestnuts that one could barely see the branches for the leaves. Because the trunk is split into a number of divergent sections, there is no central girth where a dendrochronological count would yield an accurate result, making the tree tricky to date. While I've seen claims ranging from 2,000 to 4,000 years, it's most likely right in the middle. Several references to studies conducted at the University of Catania place it at 3,000 years, though I wasn't able to track down the original research. I made some photos, but came away thinking that while the lush growth was impressive, it is the structure of its multi-pronged trunk, spread out under that impressive canopy, that really tells the story of what it's like to be alive for 3,000 years. I returned in the spring chill two years later.

I drove into Sant'Alfio in the dark. I was slightly better prepared for the chaos that is driving in Sicily, since this was my second visit. On my previous trip, motorcycles whipped by from all directions; pedestrians crossed the Catanian streets whenever and wherever they saw fit; cars pushed their way toward/into/in front of wherever they were trying to go. Only about one out of every five streets seemed to have a sign. I had laughed aloud driving up a busy, narrow, two-lane street when the scooters scooting contentedly past the cars, well over the yellow line into the oncoming traffic, were suddenly joined by an older woman in a motorized wheelchair just as a bus barreled toward them all from the opposite direction. Good thing I'm not a nervous driver. In 2012, better prepared, I wound my mercifully tiny Smart Car through the narrow, steep-walled switchbacks and up an unsigned one-way street—which I then had to back down. Once safely tucked in at my favorite *agroturismo* (a cluster of old stone buildings, a former monastery and still-working farm), a thunderstorm settled in, hail pelting down in loud, if brief, intervals, stirring up the yard dogs out

Chestnut of 100 Horses #0412-0512 (3,000 years old)

Chestnut of 100 Horses #0412 - 0424 (3,000 years old)

SANT'ALFIO, SICILY

Chestnut of 100 Horses #0412-0548 (3,000 years old)

SANT'ALFIO, SICILY

in the plum orchard. In the morning, a layer of perfectly round ice pellets covered the ground, contrasting bright white against the rough-hewn lava spit down from Mount Etna the previous week. (I was quite sorry to have missed that.)

By the time I reached the Castagno, the hail had already melted, and I could see through the mist that it had knocked a few tender leaves from the chestnut's branches during the night. I welled up with tears at the sight of the enormous tree's bare branches just barely flecked with green, at the beauty of its form, and also in relief for not having come all this way for naught. I'd received mixed advice on when the tree was likely to green up again, and discovering that the chestnut leaves in the southern German town of Baden Baden, where I had come from, were already out in full force made me nervous that I'd missed my window. I'd forgotten to take into account that the high altitude slows the coming of spring.

The weather changed every few minutes, the clouds rolling in and rolling right back out again. I explored the perimeter and the adjacent hazelnut orchard. Later in the day I returned to the tree once more to meet Alfio, a gatekeeper of the tree here in Sant'Alfio who had kindly held an umbrella over my head in 2010 while I photographed. Over the years Alfio has found all sorts of faces and animal forms in the gnarls of the trunk, like shapes in clouds, albeit unchanging, which he was quite keen to point out. The clouds persisted, but the precipitation did not, and I was able to see much more this time than last. I saw the heavy sections of the trunk and new suckers pushing forth, connected below the surface by what must be a formidable root system. I saw the details of gnarled and moss-covered swirls of bark. And I saw the deep charcoal of one section that I had overlooked previously:

"Fire," I asked?

"Yes," said Alfio.

Apparently some genius had tried to grill sausages *inside the tree*, and had nearly burnt it down.

The fence has been up ever since.

Chestnut of 100 Horses #0412-1226 (3,000 years old)

SANT'ALFIO, SICILY

Posidonia *Sea Grass*

AGE
100,000 years

LOCATION
Balearic Islands, Spain

NICKNAME
N/A

COMMON NAME
Neptune grass, Mediterranean tapeweed

LATIN NAME
Posidonia oceanica

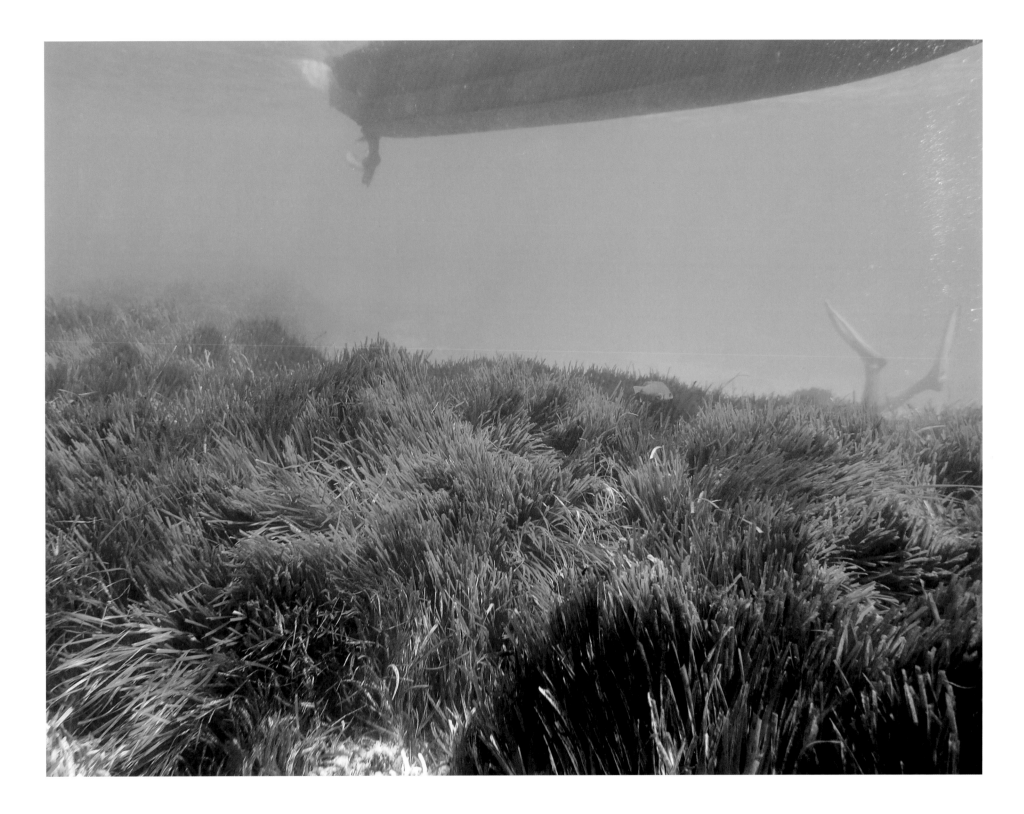

Sea grass with dive boat # 0910 - 0775 (100,000 years old)

BALEARIC ISLANDS, SPAIN

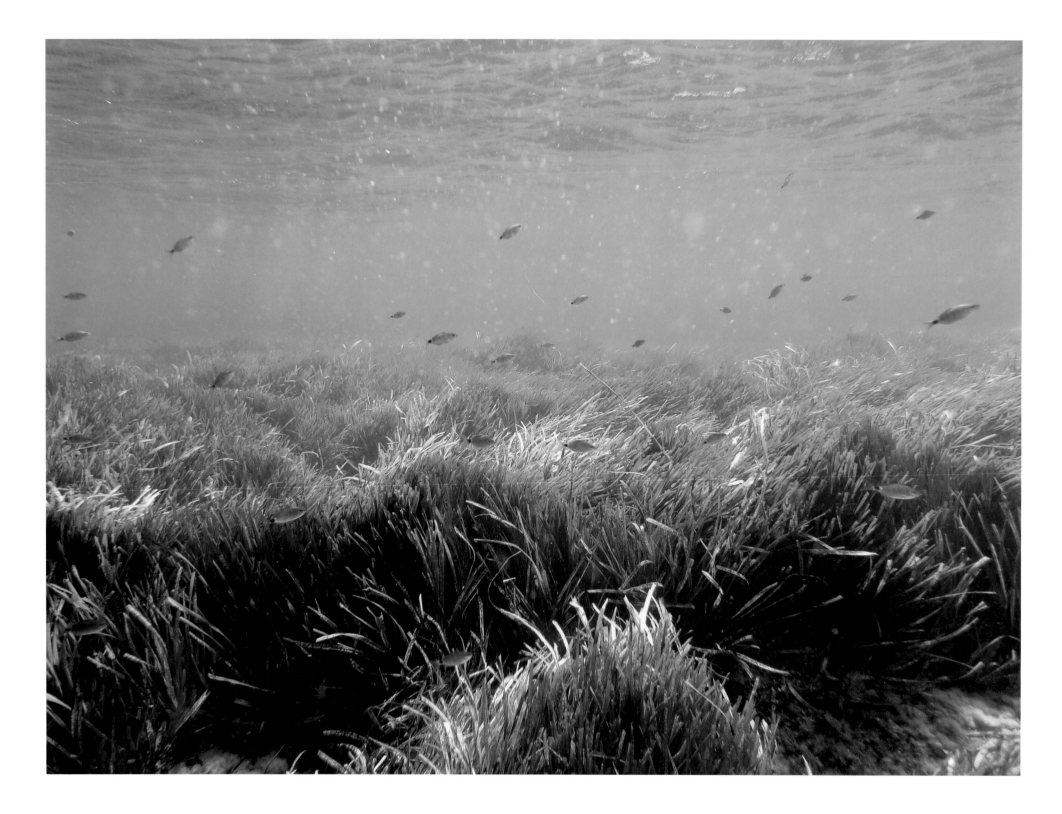

Posidonia Oceanica Seagrass #0910-0753 (100,000 years old)

BALEARIC ISLANDS, SPAIN

Posidonia Sea Grass Seed Pods #0910-0083

BALEARIC ISLANDS, SPAIN

Ibiza's reputation typically precedes it. Its club scene, parties, and music festivals draw inebriated crowds from all over the world. Yet it's far from common knowledge that one of the very oldest living things on the planet lives in the waterway stretching between Ibiza and Formentera. At 100,000 years old, the *Posidonia* sea grass meadow was first taking root at the same time some of our earliest ancestors were creating the first known "art studio" (that is, the tools and compounds used in the mixing of pigments) discovered in 2011 in South Africa.

I stumbled upon the *Posidonia oceanica* on an Ibiza tourist site and a local newspaper article, both free of verifiable references, though the latter included a tantalizing photo of a tangle of dead grass and seedpods that looked like the world's largest hairball. It was long before a peer-reviewed journal article was published, but every once in a while, rumors are true: a couple of years later I found a scientific paper about the meadows with the names and affiliations of the marine biologists conducting the long-term research, and I got in touch.

This research team had been studying the sea grass meadows spread between the Balearic Islands for over a decade. Long before its ancient age was ever fathomed, UNESCO natural heritage status was granted for "the dense prairies of oceanic *Posidonia* (sea grass), an important endemic species found only in the Mediterranean basin, [that] contain and support a diversity of marine life." Each year, Núria Marbà and her colleagues return to selected areas of the meadow and carefully count the number of stems to determine the health and growth rates of the sea grass. Back in the lab, they came across something unexpected: tests of the genetic makeup of disparate plots, quite far removed from one another, revealed that they were in fact identical; in other words, the same individual. Like many great discoveries, no one had set out with the idea that this meadow was a single, ancient individual, but once the possibility emerged, they set to work to prove it.

I had come to Ibiza by way of the Chestnut of 100 Horses in Sicily. R. arrived first and met me on a narrow street down by the harbor where we had a late-night snack and a glass of wine. We had separated for a while not long after the brain coral trip, but were giving it another go. The next morning we boarded the ferry to Formentera, where we would meet up with Marbà and the rest of the team.

Posidonia Sea Grass Seed Pods # 0910-12B23

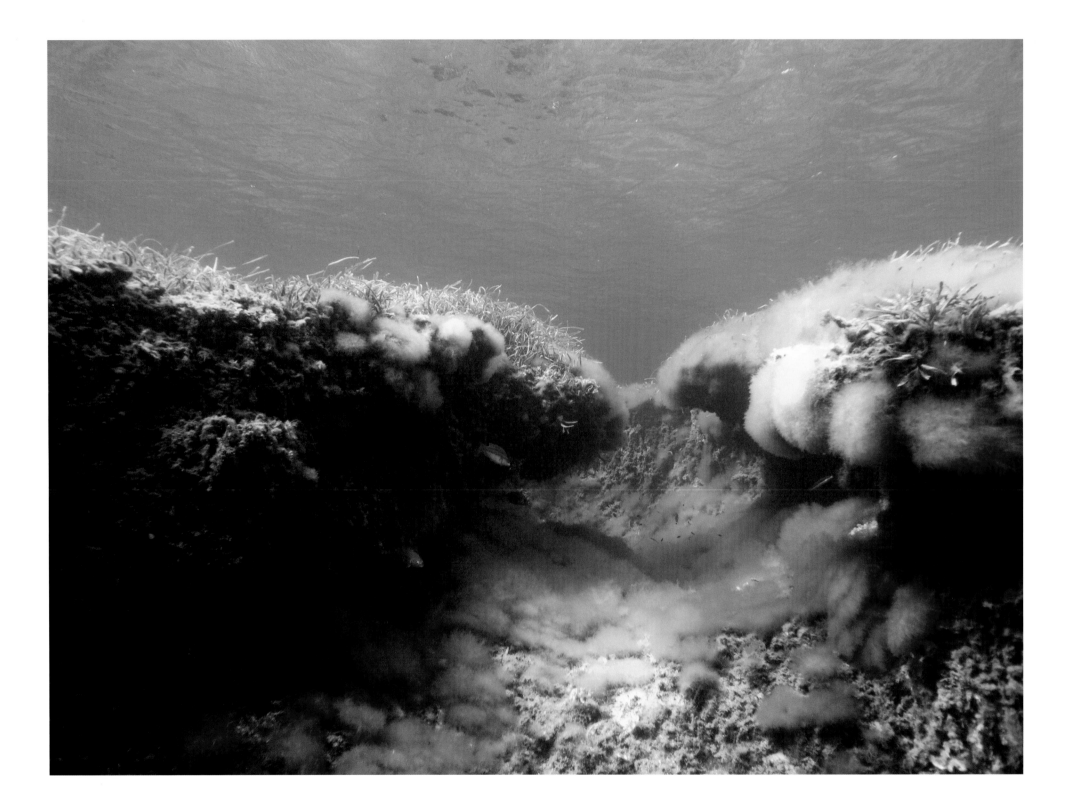

Invasive Algae on the Posidonia Meadow # 0910 - 0938

BALEARIC ISLANDS, SPAIN

The fieldwork is conducted underwater, of course, and this would be my second foray into diving (the first being for the brain coral in Tobago). R. had a week's more dive time under his belt than me, having learned on a previous trip to Mexico. We were both open-water certified, but that has a more advanced ring to it than it actually signifies. We laughed, if a bit nervously, when Marbà and her colleagues casually cautioned that we should try not to get lost underwater while they worked. Good idea.

The sea grass was beautiful, stretching out in all directions in varying concentrations as far as you could see. The biologists went to work at their respective plots about sixty feet down, meticulously counting individual shoots and writing notes on underwater whiteboards tethered to their dive tanks. R. and I did not get lost, but I had one technical problem after another with my cameras. The underwater housing for my digital camera wasn't as responsive as one might hope at such depths, and I had trouble adjusting the white balance. Luckily a sufficient portion of the color spectrum penetrated the shallower waters. The 35mm-film Nikonos camera that I had just purchased in New York before the trip was broken entirely.

Despite the UNESCO protections, a fair amount of ship traffic is allowed to pass through these waterways. Invasive algae, stowaways on the rudders of cruise ships and the like from foreign ports, now threaten the ecosystem. After diving at a couple of pristine sites, Marbà took us to another, right off one of the Formentera beaches, where the algae could be seen in murky yellow tufts browning the grass and covering it in sickly beige fuzz. It then opened out again into healthy meadow, but it wasn't hard to imagine it tipping over into a dystopian takeover.

The diving done for the day, I was captivated with the mountains of seedpods from the grass, washed up on the shore. I looked around at all those beachgoers sunbathing next to what must have been millions of seedpods, and a hundred thousand years of history, completely unaware that they were in the presence of—and connected to—something so thoroughly marvelous.

Olive

AGE
3,000 years

LOCATION
Ano Vouves, Crete, Greece

NICKNAME
N/A

COMMON NAME
Olive

LATIN NAME
Olea europaea

Fallen Olives #0910-0335 (3,000 years old)

ANO VOUVES, CRETE

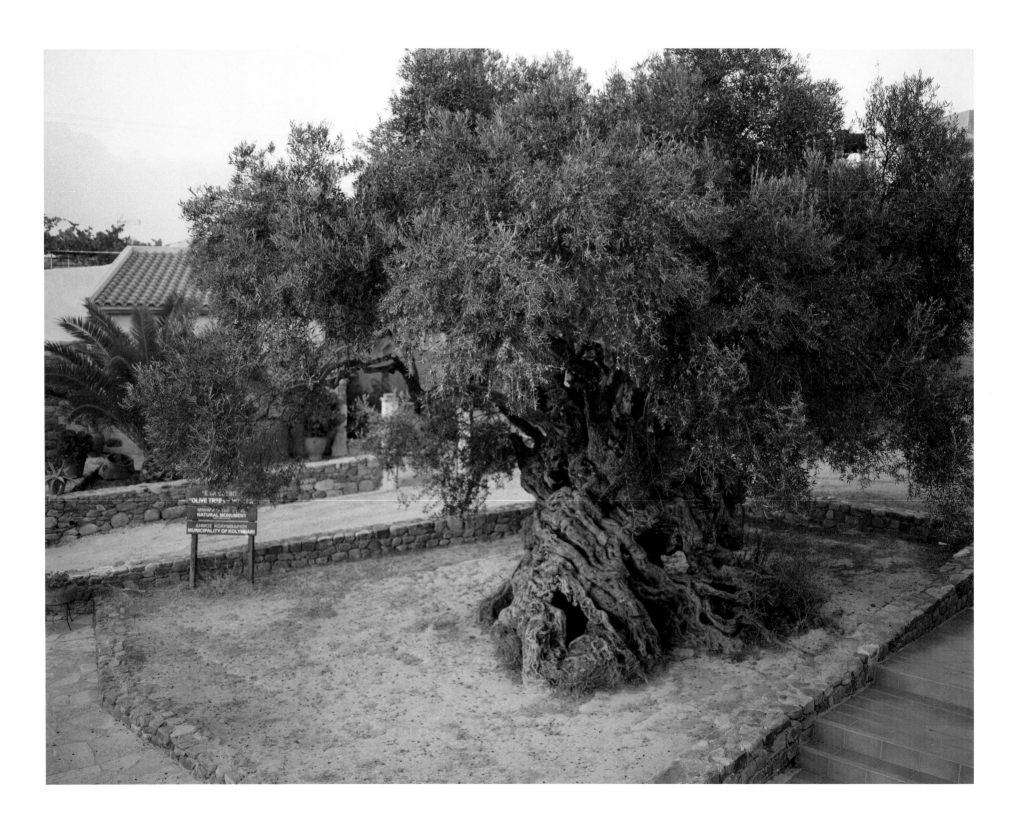

Olive # 0910 - 4A04 (3,000 years old)

ANO VOUVES, CRETE

An olive tree thought to have germinated back in the Greek Dark Ages still lives on the far western side of the long, narrow island of Crete. It was turning out to be a bit of a dark age for me, too. Despite the brightly flawless Mediterranean skies, storm clouds thickened and settled in around my boyfriend and me. We left Ibiza and headed for Ano Vouves. Things between us only got worse when we reached an otherwise charming B&B situated less than a mile from the ancient olive. The next morning, I gathered up some film, my camera, tripod, and drinking water, and set out alone on foot along the narrow, orchard-lined rural road, tears streaming down my cheeks.

I rounded a bend and merged into an incongruously wide driveway that was drawing in tour buses like a sightseeing river delta. A hedgerow shaped like the Olympic insignia grew proudly on the lawn, a small but well-appointed museum stood on the left. *Buenos dias. Buongiorno.* No: *Καλημέρα*. I forgot what to say in Greek as I pulled myself together and tried to bid good morning to the women seated in the open-air café situated off the tree's right flank.

The olive is the pride of Crete, a living witness of an ancient culture so significant it is considered the very bedrock of modern Western civilization. What's more, the tree connects the sleepy little town of Ano Vouves with the world at large: branches are culled from it every four years to make wreathes worn in the Olympic Games ceremonies; hence the hedges. The first Olympics were thought to have been held in Greece in 776 BCE. The tree is completely hollow inside, so a core sample to determine its precise age would be fruitless. But if this tree is in fact 3,000 years old, it would have already been over 200 at the time of the lighting of the first torch. Both the athletes and the tree itself certainly have the gift of endurance in common, if on wholly different timescales.

As dignified as all that sounds, the tree probably has some chickens to thank for the fact that it still stands. When other olives of its age were being cut down, it was put to the rather inglorious task of serving as a chicken coop. Like the alerce and Senator trees, it was the flaw of being hollow that likely spared its life. And much like the ancient chestnut I had just visited in Sicily a few weeks prior, it was brimming with fruit, challenging the notion of age as a definitive marker in the decline of fertility. (Although I tried without success to sprout some of the olives back home in a soil-lined baking pan, I imagine that was due to my lack of expertise or ideal conditions.)

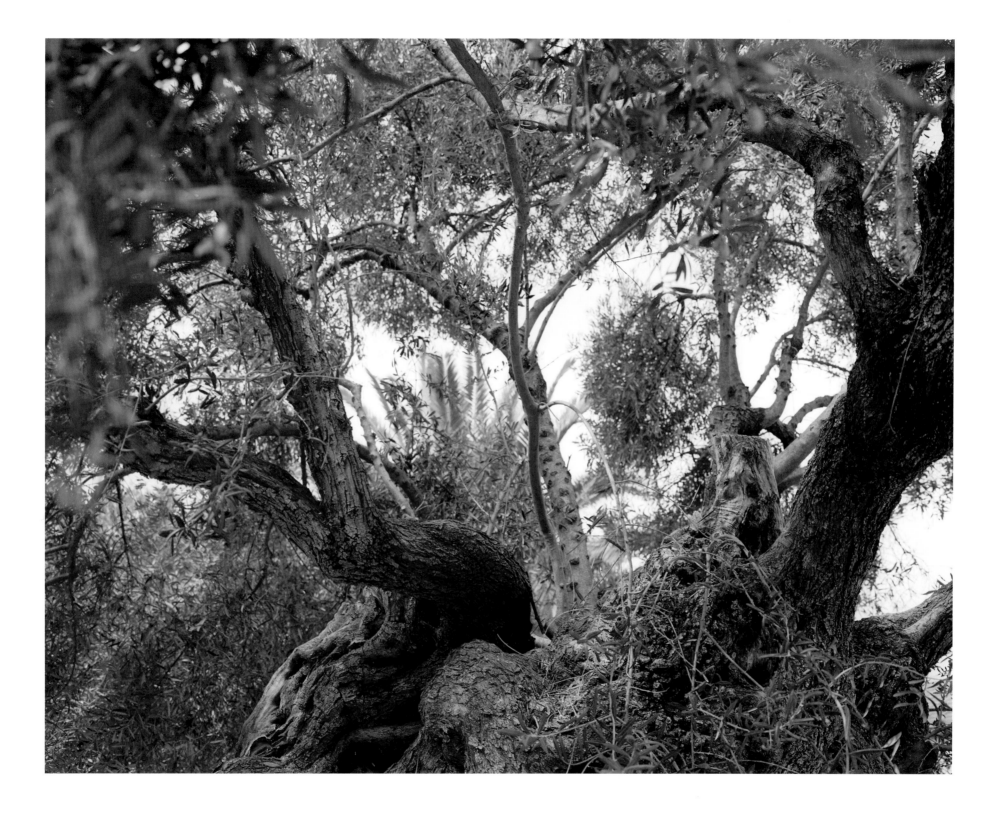

Olive Branches #0910-13B26 (3,000 years old)

ANO VOUVES, CRETE

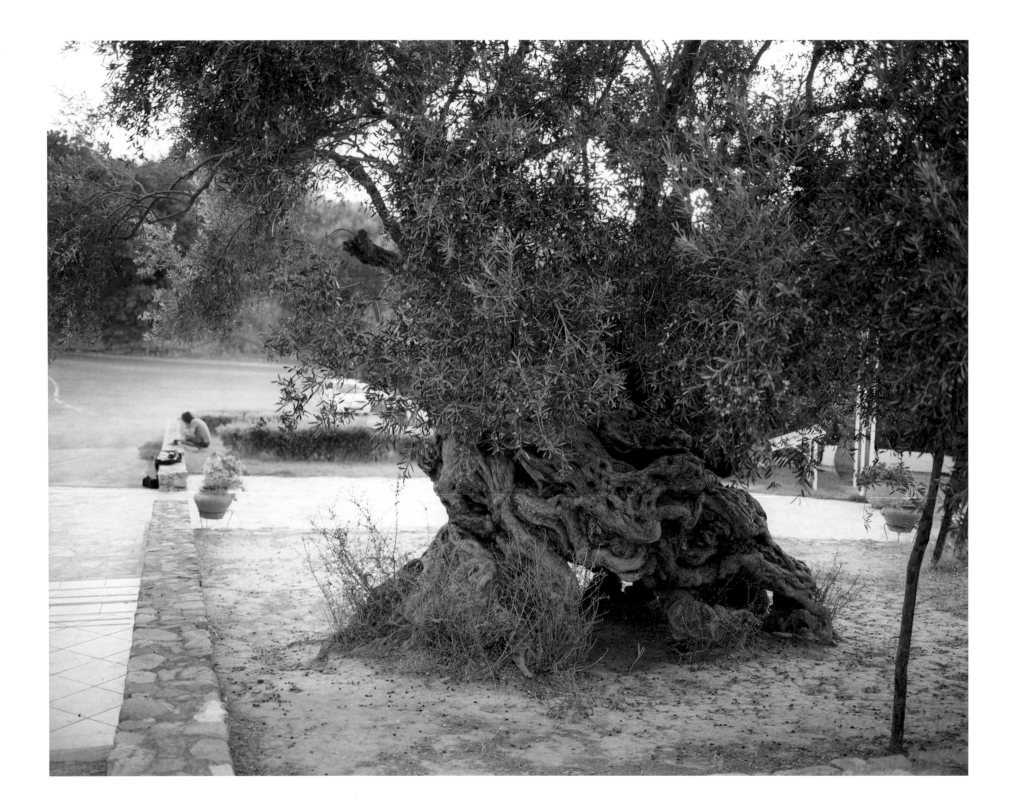

Olive Sunset #0910-4A06 (3,000 years old)

ANO VOUVES, CRETE

Olive trees in Israel, Palestine, and Portugal also lay claim to the title of oldest, indicative of both the lack of faithful measurements to set the record straight, as well as local pride prone to colloquial exaggeration.

I circled the tree to get to know it, perched myself on the balcony of the adjoining building for a higher angle, and shimmied inside the hollow trunk, making photos as I went. I took it in the best I could, but as I stood in front of this ancient tree, my mind was elsewhere, weighted down in emotion. I returned, reserved, with R. that afternoon and again in the evening, looking for the right light. I made more photographs and we chatted with the women, who had not moved since the morning. One said it was dogs, not chickens, which were kept inside the tree. Someone else claimed that it was 5,000 years old, not 3,000. We signed the guest book, and left.

I don't remember now if we stopped at the tree or not the next morning before setting out for other parts of the island. By the afternoon R. and I had driven many steep and windy miles, olive orchards everywhere, their leaves glinting hard silver in the sun. At the apex of a hillside overlooking a gloriously blue sea, I found myself sobbing on the side of the road, overcome with the depth of our discord and finally understood, clear as day, that after six erratic years, R. and I should no longer be together. I was heartbroken and resolved.

While all of these organisms connect us to deep time, we are still bound by (and made up of) our perceptions, thoughts, and emotions—utterly transient in comparison. When a tree sustains an injury, whether at its branch, trunk, or roots, it's called a wound. Every four years, young branches are sheared from the olive of Ano Vouves to adorn the most athletic among us. The most effective way for a tree to heal a wound is to compartmentalize it, sealing it off so that nothing else can work its way in. That might not be the best strategy for humans. But one thing we do share: as long as a wound isn't too deep, we can—and do—heal.

{ 18 }

Spruce

AGE
9,550 years

LOCATION
Dalarna, Sweden

NICKNAME
Old Tjikko

COMMON NAME
Spruce Gran *Picea*

LATIN NAME
Picea sp.

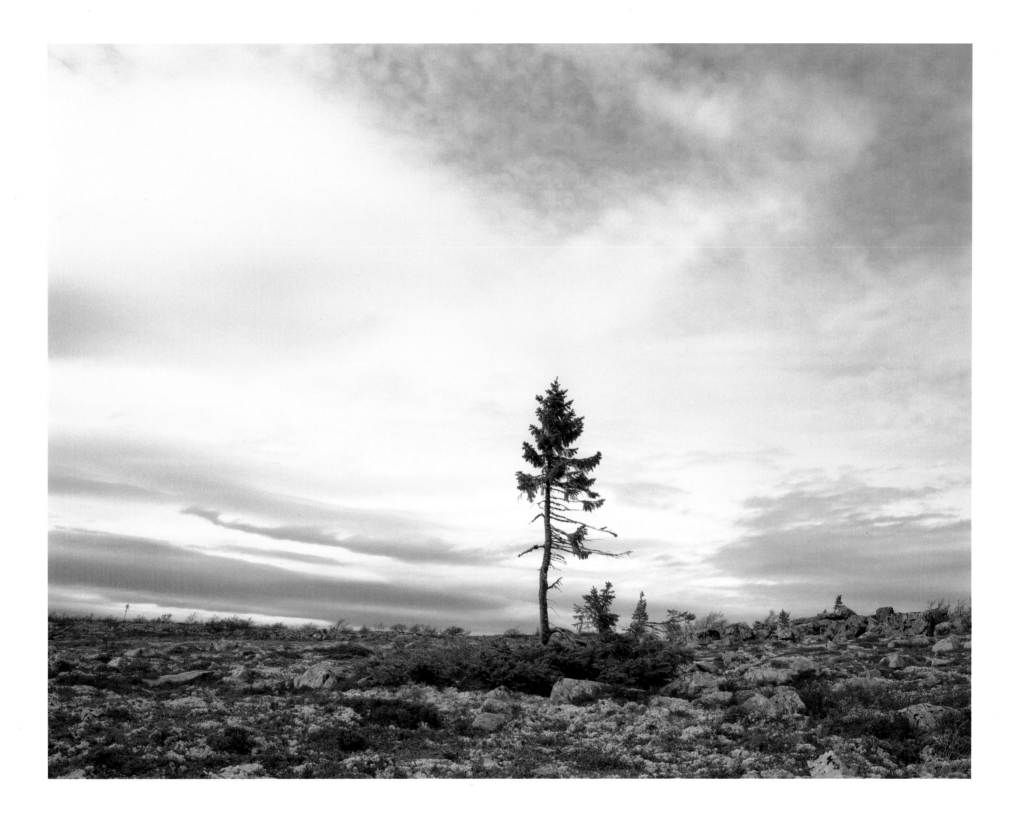

Spruce Gran Picea #0909-11A07 (9,550 years old)

A cross-country trip in Sweden takes only around six hours. It's another story, tip to tail, but the tree I was after lives on the southwestern edge of the country, a couple hundred miles south of the Arctic Circle in a mountainous park whose boundary breaches Norway. My youngest sister Lisa joined me for the expedition. (She never did finish her scuba certification, but her hiking abilities and good humor—like our shared amusement at little cultural peculiarities like an Uppsala hotel's suggestion of taking sausages into the sauna—were all that were required for this trip.) It was September and the weather was gorgeous.

It was late in the day when we arrived in the Dalarna province. The next morning we headed to Mount Fulufjället with water and lunch and my photo gear divvied up between us. There were only a few visitors despite the superb weather; some were headed to the thoroughly appealing *naturcentrum*, tucked in like a duck blind from one approach, floor-to-ceiling glass windows looking out on an untouched meadow from its far end. Others were headed out on the scenic waterfall hike. As we headed deeper into the park proper, *Rhizocarpon geographicum*, which I'd sought in Greenland, were among the riot of mosses and lichen and shrubby flora rusting in the autumn air. It was almost amusing to see such large specimens of map lichens clinging so casually to pathside rocks after all I'd gone through to find them in Greenland. But it made sense: it was warmer here, so they grow at a much faster rate. Though larger than their Greenlandic brethren, they were younger.

The relaxed woodland ramble became a steeper, more exposed climb, and it grew colder and windier as we worked our way up the mountain toward the spruce. If you came upon this particular Spruce Gran *Picea* without a particular knowledge of it, there'd be a slim chance you'd find it to be remarkable. In fact, even when Lisa and I made it up to the plateau it calls home, we had trouble finding it at all. Its precise location is kept secret from the public for its own protection, but even with directions from Leif Kullman, who discovered it, we ended up hiking all the way back down to the *naturcentrum* to ask for guidance.

It turned out we'd been quite close on our first attempt, but had missed the mark. Clouds rolled in and out, and I plunged my hands into my pockets between photographs to ward off the cold.

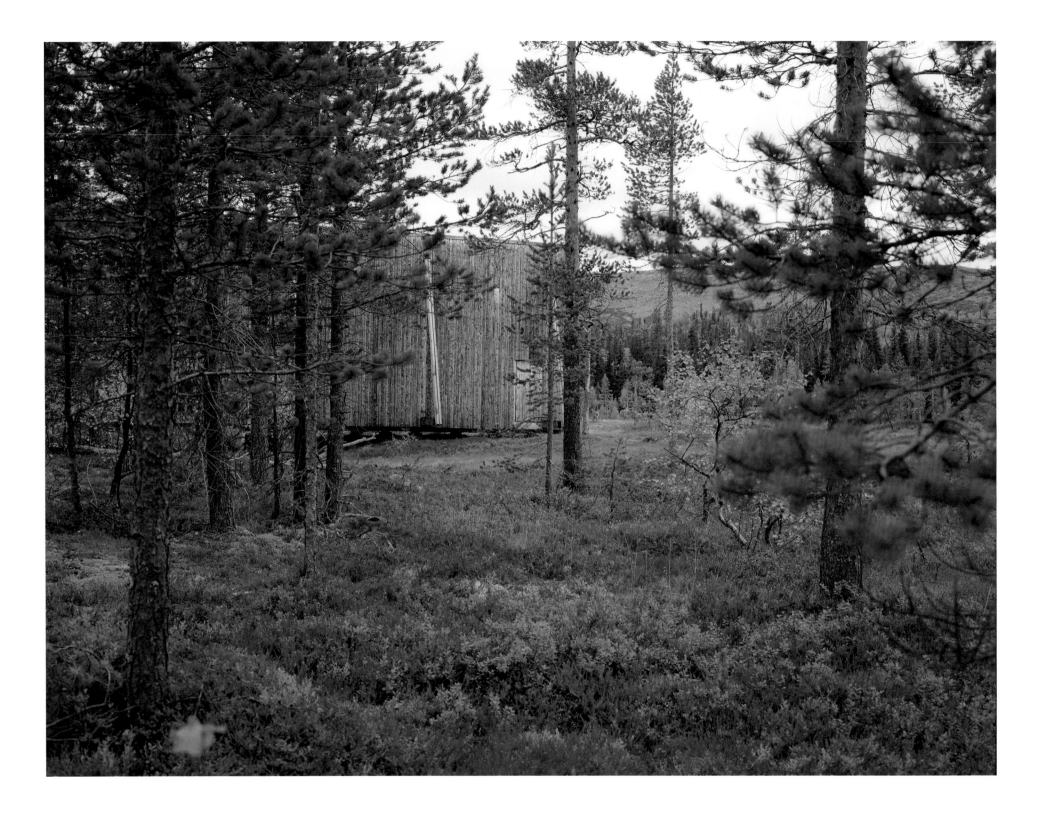

Fulufjället Naturcentrum #0909-9A05

DALARNA, SWEDEN

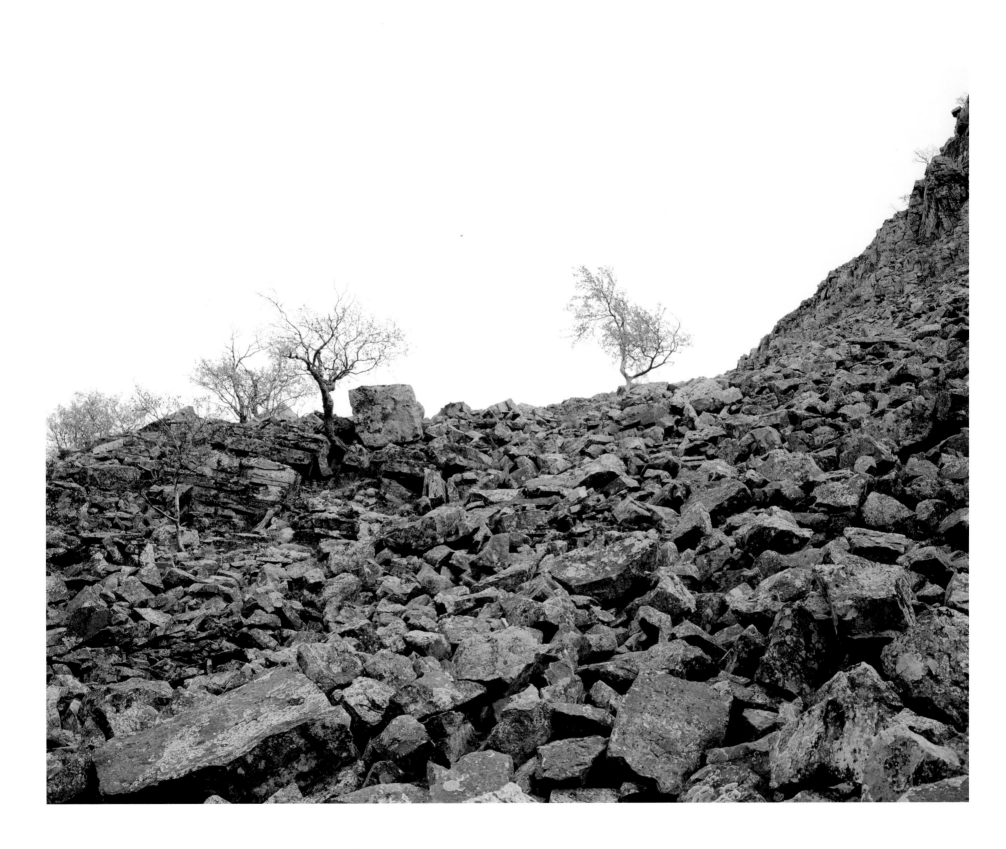

Fulufjället National Park #0909 - 8B26

DALARNA, SWEDEN

Radiocarbon dating was used to determine the tree's age, as well as the ages of around twenty other Scandinavian spruces found to surpass 8,000 years, covering a range of nearly of over 700 miles through the Swedish mountains and up into Finland. Kullman told me over e-mail that almost all of these ancient spruces exhibit the same growth characteristics as Old Tjikko, which he described as "a dense basal skirt of branches up to the snow surface. Above this level, there are one or a few erect stems, 2–4 m high."

What Kullman is describing, this shrub-like mass of clonal branches with a spindly taller trunk in the middle, is essentially a living portrait of climate change. For the first 9,500 of Old Tjikko's years, the low-lying branching would have been all you would have seen. Its strategy: should one trunk or branch die in a harsh winter, it can always produce another. That was a far better bet than depending on a single trunk to survive. But in the late 1940s things started to change. It began to get warmer on that mountaintop plateau, causing the vegetation zone to shift skyward. So instead of remaining close to the ground near the snow line, the spruce now has a spindly central trunk around sixteen feet tall. While studying the individual tree is important, Kullman and his students are also talking a wider view in investigating the changing "position and structure of the alpine tree line as an indicator and 'early warning' of ecologically important climate change."

Why "Old Tjikko"? Kullman named the tree in memory of his dog. I suppose that makes the spruce 69,650 in dog years.

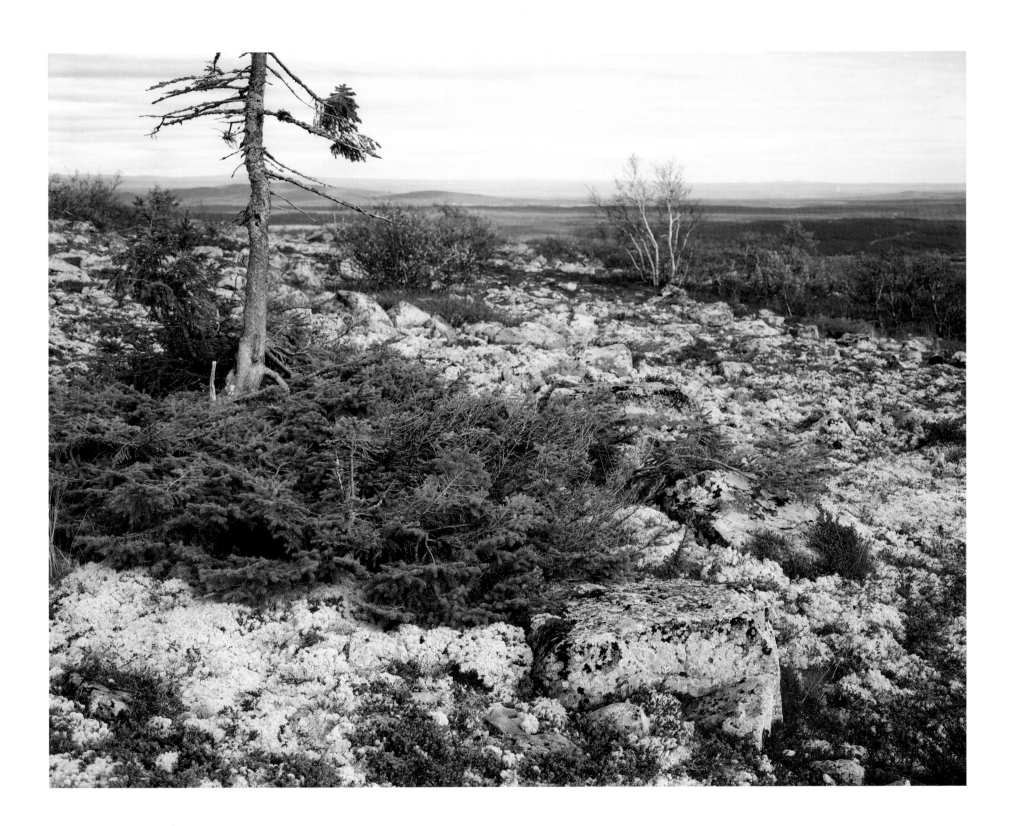

Spruce Gran Picea # 0909-7A01 (9,550 years old)

DEEP TIMELINE

Top axis markers (left to right):

13.75 BYA · 4.6 BYA · 3.8 BYA · 3.5 BYA · 3.0 BYA · 2.4 BYA · 1.5 BYA · 1.1 BYA · 750 MYA · 650 MYA · 600 MYA · 575 MYA · 545 MYA · 500 MYA · 450 MYA · 440 MYA · 410 MYA · 360 MYA

Labels:

CLOSED SPHERICAL SPACETIME OF ZERO RADIUS

BIG BANG

EARTH FORMS

LATE HEAVY BOMBARDMENT ENDS; DISPROPORTIONATELY LARGE NUMBER OF ASTEROIDS MAY HAVE COLLIDED WITH EARTH

STROMATOLITES (BOUND CYANOBACTERIA) FORM START TO RELEASE FREE OXGEN INTO ATMOSPHERE

UR, THE FIRST CONTINENT ON EARTH FORMS

GREAT OXYGENATION EVENT; ENOUGH OXYGEN ACCUMULATES IN ATMOSPHERE TO CREATE SIGNIFICANT ENVIRONMENTAL CHANGE

ARCHAEA FUSES WITH EUBACTERIUM TO FORM FIRST ANCESTOR OF ALL EUKARYOTES, SETS THE STAGE FOR THE DEVELOPMENT OF BOTH PLANTS AND ANIMALS

SUPERCONTINENT RODINIA CONTAINS ALL OR MOST OF THE EARTH'S LANDMASS, BUT IS COMPLETELY BARREN

EARTH IS 4 BILLION YEARS OLD, BUT LIFE IS STILL LIMITED TO UNICELLULAR ORGANISMS

OZONE LAYER FORMS VIA THE ACCUMULATION OF OXYGEN IN THE ATMOSPHERE

EARLIEST KNOWN COMPLEX MULTICELLULAR ANIMALS EMERGE

CAMBRIAN EXPLOSION: EVOLUTION ACCELERATES BY AN ORDER OF MAGNITUDE, MOST LINEAGES APPEAR FIRST PREDATORS APPEAR

FIRST LAND PLANTS APPEAR MARINE FAUNA INCREASES FOUR FOLD; CORALS APPEAR AND SPREAD

MAJOR EXTINCTION EVENT: ORDOVICIAN-SILURIAN 27% OF ALL FAMILIES AND 57% OF ALL GENERA BECOME EXTINCT

DEVONIAN ERA: FISH, SEEDED PLANTS, FORESTS, INSECTS AND FOUR-LEGGED VERTEBRATES FIRST APPEAR

CARBONIFEROUS ERA BEGINS, MAJOR EXTINCTION EVENT CAUSED BY CHANGE IN CLIMATE REPTILES DIVERSIFY, CONIFERS DEVELOP, AMNIOTIC EGG INCUBATION STARTS

Bottom scale: 5 BYA ← → 1 BYA 750 MYA ←

Timeline

Top scale markers:

300 MYA · 252 MYA · 230 MYA · 200 MYA · 180 MYA · 65 MYA · 60 MYA – 55 MYA · 600,000 YA · 500,000 YA · 400,000 YA · 279,000 YA · 200,000 YA · 100,000 YA · 80,000 YA · 77,000 YA · 69,000 YA · 43,600 YA · 43,000 YA · 40,800 YA

Events:

- GONDWANA AND LAURASIA COMBINE TO FORM SUPERCONTINENT PANGAEA, SURROUNDED BY THE WORLD'S ONLY OCEAN, PANTHALASSA
- MAJOR EXTINCTION EVENT: PERMIAN-TRIASSIC, OR "THE GREAT DYING." 96% OF ALL MARINE SPECIES AND 70% OF TERRESTRIAL VERTEBRATE SPECIES BECOME EXTINCT
- DINOSAURS FIRST APPEAR
- ANTARCTIC BEECHES MIGRATE NORTH AS GONDWANA BREAKS APART AND THE SOUTH GROWS COLDER
- MAJOR EXTINCTION EVENT: CRETACEOUS-PALEOGENE; ABOUT 17% OF ALL FAMILIES, 50% OF ALL GENERA AND 75% OF SPECIES BECAME EXTINCT, MOST NOTABLY NONAVIAN DINOSAURS
- LAURASIA BREAKS INTO NORTH AND SOUTH AMERICA, COMPLETING PANGAEA'S BREAKUP
- ACTINOBACTERIA, SIBERIA
- WORLD'S OLDEST "HUT" STRUCTURE FOUND IN CHICHIBU, JAPAN, NORTH OF TOKYO
- EARLIEST KNOWN WEAPONS; STONE-TIPPED JAVELINS FOUND IN ETHIOPIA
- ANATOMICALLY MODERN HUMANS ORIGINATE IN AFRICA ABOUT 200,000 YEARS AGO, AND BEGIN TO SPREAD OUT FROM THERE BETWEEN 50,000 AND 100,000 YEARS AGO
- EARLIEST KNOWN ART STUDIO
- POSIDONIA SEA GRASS MEADOW, BALEARIC ISLANDS, SPAIN
- PANDO, CLONAL COLONY OF QUAKING ASPEN, UTAH, USA
- EXTENDED VOLCANIC WINTER CREATED BY TOBA SUPERERUPTION PERHAPS CAUSES BOTTLENECK IN HUMAN EVOLUTION REDUCING TOTAL POPULATION TO 10K, OR MAYBE AS FEW AS 1,000 PAIRS
- TASMANIAN LOMATIA, SOUTHWEST WILDERNESS, TASMANIA
- OLDEST CONFIRMED MUSICAL INSTRUMENTS, GEISSENKLÖSTERLE CAVE, GERMANY
- OLDEST CONFIRMED PAINTING – "RED DOT" BY A NEANDERTHAL ARTIST IN SPAIN

Bottom scale markers:

60 MYA · 600K YA · 100K YA · 80K YA · 40K YA

17,000 YA · 15,000 YA · 13,000 YA · 12,000 YA · 10,500 YA · 10,000 YA · 9,950 YA · 6,000 YA · 5,500 YA · 5,000 YA · 4,900 YA · 4,500 YA · 4,265 YA · 4,000 YA · 3,500 YA · 3,000 YA · 2,890 YA

HOMO FLORESIENSIS, WHAT MAY HAVE BEEN THE CLOSEST LATE RELATIVE TO MODERN HOMO SAPIENS, GOES EXTINCT

VOLCANO SPONGES, ANTARCTICA

UNDERGROUND FOREST, PRETORIA, SOUTH AFRICA (DECEASED)
RARE EUCALYPTUS, NEW SOUTH WALES, AUSTRALIA
PALMER'S OAK, RIVERSIDE, CALIFORNIA, USA
BOX HUCKLEBERRY, PENNSYLVANIA, USA
ANTARCTIC BEECH TREES, QUEENSLAND, AUSTRALIA
CREOSOTE BUSH, MOJAVE DESERT, CALIFORNIA, USA
MOJAVE YUCCA, MOJAVE DESERT, CALIFORNIA, USA
HUON PINE, MOUNT REED, TASMANIA
CLONAL ALOE, SOUTH AFRICA
SPRUCE GRAN PICEA, DALARNA, SWEDEN

EUCALYPTUS, WESTERN AUSTRALIA
COLD-WATER CORAL, NORWEGIAN SHELF
HUON PINE, MOUNT REED, TASMANIA
BRISTLECONE PINE, CALIFORNIA, USA
LEIOPATHES CORAL, HAWAII, USA
GINKGO, CHINA
CYPRESS OF ZOROASTER, IRAN
SENATOR TREE, FLORIDA (DECEASED)
MAP LICHENS, GREENLAND
CHESTNUT OF 100 HORSES, SICILY
LLARETA, ATACAMA DESERT, CHILE

GIANT SEQUOIA, CALIFORNIA, USA

STROMATOLITES, WESTERN AUSTRALIA
OLIVE TREE, CRETE
FORTINGALL YEW, SCOTLAND

ARMILLARIA FUNGUS, OREGON, USA

END OF THE PLEISTOCENE MEGAFAUNA DIE-OFF

HUMANS FIRST START FARMING AND HERDING ANIMALS

HISTORY STARTS:
FIRST USE OF WHEEL AND INVENTION OF WRITING IN MESOPOTAMIA
MAYAN CALENDAR STARTS
WORK STARTS ON STONEHENGE
FIRST EGYPTIAN HIEROGLYPHS
FIRST PYRAMIDS BUILT IN BRAZIL AND EGYPT

17K YA ← · → 3K YA · 2.89K YA ←

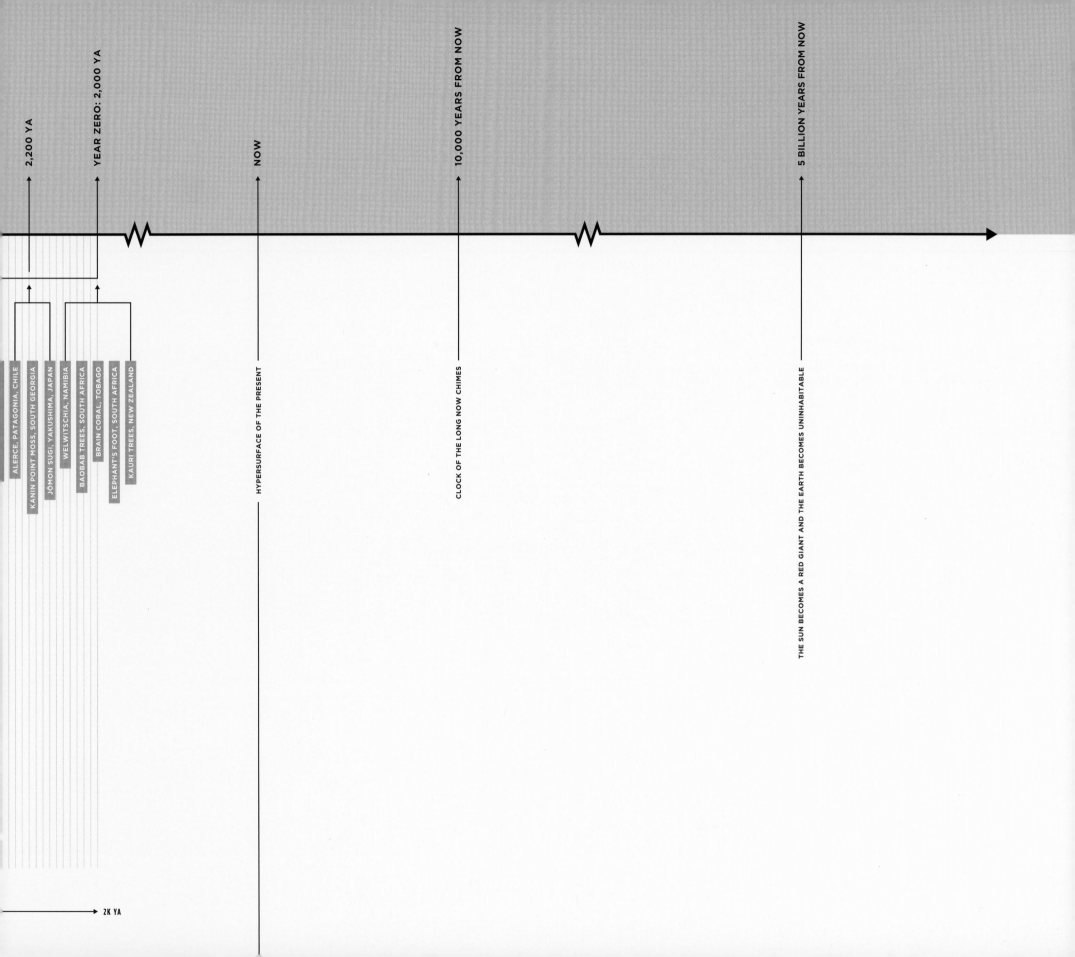

2,200 YA

YEAR ZERO: 2,000 YA

NOW

10,000 YEARS FROM NOW

5 BILLION YEARS FROM NOW

ALERCE, PATAGONIA, CHILE

KANIN POINT MOSS, SOUTH GEORGIA

JŌMON SUGI, YAKUSHIMA, JAPAN

WELWITSCHIA, NAMIBIA

BAOBAB TREES, SOUTH AFRICA

BRAIN CORAL, TOBAGO

ELEPHANT'S FOOT, SOUTH AFRICA

KAURI TREES, NEW ZEALAND

HYPERSURFACE OF THE PRESENT

CLOCK OF THE LONG NOW CHIMES

THE SUN BECOMES A RED GIANT AND THE EARTH BECOMES UNINHABITABLE

2K YA

ASIA

{ 19 }

Jōmon Sugi

AGE
2,180–7,000 years

LOCATION
Yakushima, Japan

NICKNAME
Jōmon Sugi

COMMON NAME
Japanese cedar

LATIN NAME
Cryptomeria japonica

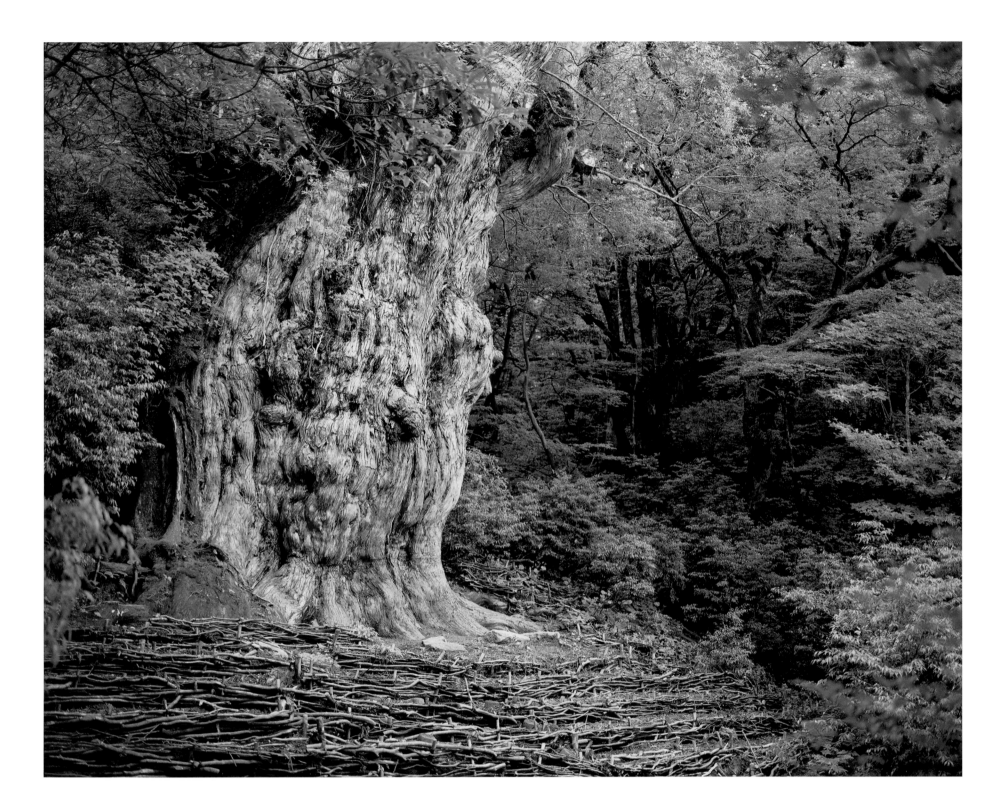

Jōmon Sugi, Japanese Cedar #0704-002 (2,180-7,000 years old)

YAKUSHIMA, JAPAN

I wiped the sweat from my brow as the big tree came into view, content with the weary satisfaction of vigorous hiking, and at the time more focused in the journey than the destination. I made a few photographs of Jōmon Sugi, but I had not yet gotten the idea for *The Oldest Living Things in the World* project. In fact, I just as easily might have never visited it all. Originally, I'd considered a different Japanese adventure entirely: a twenty-four-hour boat ride off the eastern coast of the country to a remote island technically part of Tokyo, to search out some intriguing sea salt. Clearly I was looking for *something*, I just didn't know what. While I was open to having an adventure, I was concerned that the ship to Ogasawara required a time commitment: should I arrive on the island and find that it wasn't the adventure I'd hoped, I'd have to wait an entire week to return to the mainland. Instead, I opted to buy some Ogasawara sea salt in the basement boutique of a Tokyo department store and left Tokyo without a clear itinerary in mind. Kyoto was my first stop—an uncomfortable one that would in turn impel me toward Yakushima in search of Jōmon Sugi.

There's a joke on the lush, subtropical island of Yakushima (*shima* means "island") that it rains thirty-five days a month. Abandoned track from a failed railroad wends its way partially up the Miyanoura-dake before being swallowed up by vegetation, but there is no record of any forestry on the mountain. Almost all of Yakushima's inhabitants live down by the coast, ringing the island. It's not hard to see how the dense vegetation was the inspiration for Hayao Miyazaki's environmental cautionary tale, *Princess Mononoke*, a fantasy battle between spirits of nature pitted against human interests.

Sugis are the national tree of Japan, and like yews in the UK, are often planted near shrines and temples. Although *sugi* translates to "cedar" in English, they are actually in the *Cupressaceae* family, or cypress. Just how old is Jōmon Sugi? Named for the Jōmon era in Japanese history, it has quite a noteworthy spread in this regard: from 2,180 years all the way up to 7,000 (the oldest it could be, following a massive volcano eruption wiping the slate clean), and any number of estimations in between. Like many older trees, it is partially hollow, making an accurate date difficult to ascertain. Jōmon Sugi lost a limb in 2005, and according to a local blogger, another one in November of 2012.

You can't help but want to make out contorted faces in the tree's knobby bark, the wide girth finally giving way to a tangle of limbs, high leafy bits like tufts of hair. But my gaze was immediately drawn down to the crosshatched blanket of branches at

its base, like a handwoven basket. It is meant to both discourage direct contact with the tree and to protect the root system from the persistent rain, but I was interested in the visual: human intervention in nature. Apparently, when the undergrowth was cut back to allow for a better view, it compromised the shallower roots. In a narrative similar to Pando, new seedlings were planted but were eaten by deer, so they planted more and put up a fence. The tree hasn't been immune from souvenir takers, either. Jōmon Sugi is now outfitted with a surveillance camera.

Sri Maha Bodhi

AGE
2,294 + years

LOCATION
Anuradhapura, Sri Lanka

NICKNAME
Sri Maha Bodhi

COMMON NAME
Banyan fig, bo tree, Bodhi tree

LATIN NAME
Ficus religiosa

Machine gun trained on the Indian Ocean

COLOMBO, SRI LANKA

The nurses were busily installing a morphine drip just as my anesthesia was wearing off. I'd spent the week looking for white clothing to wear to visit the Sri Maha Bodhi, a banyan fig tree linked to the historical Buddha, and the oldest planted tree on record. The tree lives inside the walls of a temple, and all-white attire is required in order to enter into its immediate presence. There had been an obscenely expensive white cotton dress at the hotel gift shop in Colombo, a white caftan three or four times too large en route to Anuradhapura, and finally resignation that I'd have to try my luck with the pale yellow pants I'd packed from home. But here I was, finally in all white—white sheets, white hospital gown, white plaster cast running from my awkwardly cocked wrist, digging into the flesh at the crook of my elbow.

The Sri Maha Bodhi is said to be a transplanted branch of the tree in Bodh Gaya, India under which Siddhārtha Gautama attained enlightenment. The historical Gautama perhaps lived from 563 BCE to 483 BCE, but the dates are disputed. Some scholars claim he died closer to 400 BCE. What we do know is that the living branch was brought to Sri Lanka in 288 BCE. This was done under specific instruction of the Buddha; perhaps a wish from his deathbed. How old is the Anuradhapura bo tree? We could add 2011 (the year of my visit) plus 288, but it's not quite so simple. First, there is the "year zero" question. It's not uncommon for numerical systems to skip from −1 to +1 without counting the zero; sort of like buildings that eschew a thirteenth floor. From a philosophical perspective, it's not surprising that the Buddhist calendar *does* include a year zero; however, the calendar itself begins somewhere between 554 and 483 BCE (per the dispute mentioned above); a seventy-one-year margin of error. More to the point: even if we could pinpoint the exact year that that *Ficus religiosa* branch crossed the Palk Strait, how old was the tree from which that branch was cut? That branch is a clone of the original tree: it is vegetative growth that does not incorporate any additional outside genetic material, and therefore, from a genetic perspective, the same tree, albeit a clonal one. We could reasonably claim that the tree is the current year plus 288 plus the age of the tree from which the branch was removed. If the original tree were still standing (and were it not considered sacred), a core sample could be taken and the rings counted. But the Bodhi tree standing in Bodh Gaya today is a clone from none other than the Anuradhapura tree, returned and rerooted (reincarnated?), the original having long since been killed. For a relatively immobile organism, this tree really gets around.

Unlike the majority of ancient organisms, it isn't so much the scientific community

that keeps tabs on it, but rather a religious one. It so happened that my first cousin Laura Bandara's husband is Sri Lankan and has direct connections to the temple in question. Widgitha reached out to the monks on my behalf, and Laura allayed my fears with regard to safety in a country so recently marred by civil war, though she also advised me to hire a driver. They introduced me to their friends Ian and Sujatha, who happened to be in Colombo visiting her parents.

I was also surprised to find I had Sri Lankan connections via someone else's family—Thilo Hoffman, the elderly uncle of my friend Tina Roth Eisenberg (more widely known as designer and blogger Swissmiss), just so happened to be a preeminent conservationist in Sri Lanka for decades. I e-mailed Uncle Thilo and received a delightful longhand fax via e-mail in response. A reminder that had I attempted to undertake this global project pre-Internet, I'd surely still just be scratching the surface.

My e-mails to one of the very few scientists allowed direct access to the tree went unanswered, but Samantha Suranjan Fernando, affiliated with the botanical garden in Kandy, picked up my cause. He suggested I write a letter to the temple requesting direct access to the tree, and kindly posted it from Sri Lanka so that it would arrive before I did. We met in the muggy lobby of a partially restored colonial hotel in Colombo. Fernando reminded me that I'd have to remove my shoes at the temple. For that, I was prepared with Japanese tabi socks, to protect against the scorching courtyard. It was then he told me I'd have to be dressed in all white to enter the temple.

That night I met Ian and Sujatha at the home of her parents, the Meegamas. My driver, Siva, was their regular driver. The next morning, as I was leaving the hotel, I exchanged smiles with a couple—two men, also departing—and went out into the diffusely bright, dense air. Inexplicably, it was cheaper to rent a van than a car, so Siva and I set out on the six-hour drive, several rows of empty seats behind us.

It was hard to pinpoint exactly where Colombo ended and the countryside began. Rows of shops selling car parts appeared. First, a shop selling only car seats, which pressed against display windows from both first and second floors. Next, a shop selling exclusively bumpers, then chassis, then car doors—as if you were meant to work your way down the road piecing together a custom vehicle. Fruit districts began to emerge: row upon row of roadside pineapple stands, then rambutan, then cashews.

Little handmade brooms. Then more car parts. Rice paddies disappeared into the penumbra of dense palm forest. We stopped for some luscious, ripe fruit, and then later for lunch at a restaurant famous for its cleanliness. As I sat down, I noticed the same couple I'd exchanged greetings with that morning. David and Iñaki were vacationing from Barcelona, and we happened to be headed to the same hotel. As travelers do, we made a plan to meet for dinner.

Searching for thirty different organisms in environments requiring demanding climbs, dives, and freezing temperatures in some of the last-left remote places, I was no stranger to flirting with some physical danger. But sometimes the most immediate danger lies in a single misstep.

The Palm Village Garden Hotel has the kind of architecture that would be illegal in the United States: stairs leading to steep drops, hidden impediments, no railings anywhere, slick tile covering everything. That night at dinner, I was walking through the multitiered restaurant with Iñaki. I stepped down onto the first stair, deep in conversation. As I stepped again, something was wrong. My right foot was not on a stair, but rather a slick tile ramp. I looked down at my foot, as it slid in slow motion, then a flash forward as I fell over the ledge, breaking my fall on my outstretched right palm.

The other diners stared as I lay on the floor, stunned. I summoned all my willpower not to pass out as a hot wave of nausea rolled through me. Water was brought out, and later charged to the dinner bill of my Spanish friends, one of whom happened to be a doctor. I asked someone to go find Siva. It was time to get me to a hospital. Iñaki and David were coming along, as was the receptionist, and another hotel employee who didn't speak English. Suddenly my frivolously large van was filled with passengers.

It was Saturday night, 9 or 10 p.m. The private hospital turned me away. The only other option was the open-air public hospital. I was checked in and wheeled down open, concrete corridors, past a sign that read "Morgue," then finally to some sort of ward where maybe forty patients in gurneys lay quietly, no expectation of going anywhere anytime soon. A single nurse-orderly sat behind a desk. Stray dogs and chickens strolled through as they pleased. The story kept changing, but what it came

down to was this: no painkiller, no x-ray; I would have to spend the night on a gurney with the dogs and chickens, untreated and in pain. They would put me under general anesthesia in the morning.

I had to get out of there.

We piled back in the van, my fractured wrist—still unset—wrapped in gauze and a useless layer of single-ply cardboard. My shift in circumstances was crystal clear. I was no longer in Sri Lanka to photograph the Tree of Enlightenment. Rather, after a sleepless night, and with help from the Meegamas, the minister of health of Sri Lanka, my brother (a doctor at Yale New Haven Hospital), the US consulate, and anyone else we thought could help, I endured a delirious six-hour car ride back to a hospital in Colombo.

Ian and Mr. Meegama were there to greet me. The walls and the air-conditioning were comforting. Ian, whose last name I didn't even know at the time, signed my surgical consent form. I was asked over and over again if I wanted to call my husband, as over and over again I said I didn't have one. I thought of texting my then ex-boyfriend R.—"In Sri Lanka / Broken wrist / Scared"—but thought better of it. I didn't need to be rescued; I needed to talk to the orthopedist. I agreed when the doctor recommended he would set the break here, and that I should fly back home for additional surgery. The anesthesiologist asked if my husband was apprised of my condition as I was instructed to keep my eyes open and count back from ten. The next morning a nurse came in and asked if I was "paining" and if I'd called my husband yet.

There are tigers and elephants in Sri Lanka, but I hadn't seen any. I hadn't seen the famously charming town of Kandy, or the Temple of the Tooth. And I hadn't seen the ancient banyan fig tree that was the entire purpose of my trip. Was I giving up? I thought about returning to Anuradhapura to photograph the tree, cast and all. Or was I not yet out of the woods? I received an e-mail from my estranged father—himself an erstwhile orthopedic surgeon—who said that if I did need surgery it should be done within a week of the injury, or the risk of permanent damage would be exponentially higher. I lay in the hospital bed, weighing the failure to achieve my immediate goal against my long-term physical well-being. That settled it: I was going home.

After a complicated game with the billing department, I was finally allowed to leave. I had dinner at the Meegamas that night, and Sujatha brushed out my exquisitely snarled hair and wove it into two braids for the long flights home.

I was ferried through the Colombo airport in a wheelchair around midnight; the delayed flight was called around 3 a.m. Another wheelchair awaited me in the glittering, coolly reassuring Dubai airport. Ten hours later I arrived at JFK, where Lindsey, my dear sister-in-law, was there to greet me.

As I left the airport it struck me that this was the very nature of exploration: you set out with the intention to do one thing, and something entirely different happens instead. Sometimes success is measured simply by being secure in the knowledge that things could have been worse, especially when viewed from the safety of the other side.

By the time I had my appointment in New Haven the following day, a rumor had circulated around the Yale hospital that "Scott's sister from Sri Lanka" had flown all the way to Connecticut to receive care. Later, the orthopedist laughed out loud at the enormous plaster cast and awkward position of my wrist, the technique having been abandoned in the States a decade ago. However, a few days later I returned to the ER because of excessive swelling inside my new fiberglass cast. I dutifully reanswered the string of standard questions.

"Where did this happen?" the attendant asked.

"Sri Lanka."

Another few questions went by, and he asked again:

"*Where* did this happen?"

"Sri Lanka," I replied again.

There was a long pause, and then: "Is that in New York or Connecticut?"

It was a woman who brought the Sri Maha Bodhi branch to Sri Lanka from India: Saṅghamittā Thera, daughter of Emperor Ashoka, who later founded an order of Buddhist nuns in Sri Lanka. The tree was planted by King Devanampiyatissa. The city itself was established around the tree and flourished for 1,300 years.

Over the years the Sri Maha Bodhi has lost a branch or two due to storms (and one to a "lunatic"), but it remains largely untouched within the temple walls. The last time Anuradhapura made history was in 1985, two years into Sri Lanka's twenty-seven-year civil war, when a massacre took place at the same temple. A number of people were killed.

The tree emerged unharmed.

Siberian Actinobacteria

AGE
400,000–600,000 years

LOCATION
Kolyma Lowlands, Siberia

NICKNAME
N/A

COMMON NAME
Siberian bacteria

LATIN NAME
Actinobacteria

Soil Sample containing Siberian Actinobacteria #0807-tV26 (400,000 – 600,000 years old)

NIELS BOHR INSTITUTE, COPENHAGEN

Half a million years ago, anatomically modern humans did not yet exist, though things were certainly leaning in that direction. Some of our pre-*Homo sapiens* ancestors in Japan were busy creating the earliest known hut structure. The Siberian Actinobacteria might have already been 100,000 years old. Even if the bacteria turn out to be at the lower end of its 400,000-to-600,000-year range, their closest neighbor—the *Posidonia* sea grass meadow—is still at least 300,000 years younger. Perhaps this isn't all that surprising, given that bacteria were among the very earliest forms of life on Earth.

I first learned about the Actinobacteria completely by chance, at a New Year's Eve party at an artist's house in Brooklyn, years before the first paper on the discovery was published. Sarah Stewart Johnson, one of the scientists from the team at Niels Bohr Institute in Copenhagen who discovered this ancient bacteria, happened to be among the guests. Johnson, who was a visiting fellow from MIT and based in the States by that time, connected me with Martin Bay Hebsgaard at the lab where the research was conducted and where the bacteria were being kept in the freezer. (I didn't get the chance to go to Siberia, unfortunately, as the fieldwork had already been completed.)

In 2005, a team of planetary biologists traveled to the Kolyma Lowlands in Russia, explicitly looking for clues to life on other planets by investigating one of the most inhospitable places on Earth. Other research expeditions were conducted in Antarctica and northwestern Canada, and different types of Actinobacteria can be found in soil and both salt and freshwater in many places throughout the world. But the team's discovery of this particular Siberian Actinobacteria is particularly remarkable in that they are doing DNA repair below freezing. This means that unlike other ancient bacteria that have been frozen in time in a state of suspended animation, Siberian Actinobacteria are in fact *not dormant*, but rather have been alive and slowly growing for half a million years. According to Johnson, after their visit the team spent nine months proving that the cells were still alive and breathing, and those results had to be duplicated in a separate clean lab. Their results were verified, and the paper was published in 2007.

Bacteria have their own domain, the others being Archaea and Eucaryota. But despite our human inclination to classify everything, there are still several competing systems at the domain and kingdom levels in use for determining taxonomic rank.

Bacteria are unicellular organisms, most of which reproduce asexually via binary fission: essentially, when a cell gets large enough, it splits in two, ad infinitum. They are prokaryotes, signifying that they do not have nuclei. It is not unheard of for a bacterium, along with Archaea, to be classified amongst the extremophiles: organisms that live and even thrive in conditions that would be unbearable for other forms of life. (Examples include iron-breathing microbes, life forms like the Pompeii worm, supported by deep-sea hydrothermal vents and withstanding temperatures up to 176°F (80°C), and a host of other organisms studied by astrobiologists looking at the nature of life in the universe.)

Hebsgaard (who later invited me to join him for the lichen hunting in Greenland), met with me in Copenhagen and walked me through the protocols of the lab. We donned protective suits (more to protect the samples from us than us from them). Hebsgaard pulled a metal canister containing the bacteria out of the freezer and carefully prepared some slides that just looked like dirt to the naked eye. The research conducted on the bacteria did not require the scientists to visualize them, so it seems that I became the first person to try to do so. Unfortunately, there was no scanning electron microscope on hand that would have allowed for magnification up to 500,000×, so I used the available single-lens microscope with 100× magnification. I made the digital optical microscopy images using a camera attachment affixed to the head of the microscope, which in turn was connected to a computer screen with a live feed of the slide. I adjusted the position of the slide and made digital captures.

Those scientists acted on a hunch that they would find something valuable buried in the permafrost, but the fact that they found the oldest continuously living thing on the planet was also good luck. It prompts the question: what else have we yet to discover? It also makes us wonder just what will happen to the Siberian Actinobacteria in the face of climate change. Microbial activity tends to increase with warming temperature, so it might not be the bacteria per se that we have to worry about, but rather all the by-products that the thawing permafrost will unleash. According to Johnson, "As temperatures continue to warm, permafrost will continue to thaw. Climate change is particularly insidious when it comes to permafrost, as organic carbon trapped in permafrost can be released into the atmosphere as carbon dioxide and methane, which in turn warms the climate even more."

AFRICA

Baobab

AGE
2,000 years

LOCATION
Limpopo, South Africa

NICKNAMES
Sagole, Pafuri, Glencoe, and Sunland trees

COMMON NAME
Baobab

LATIN NAME
Adansonia digitata

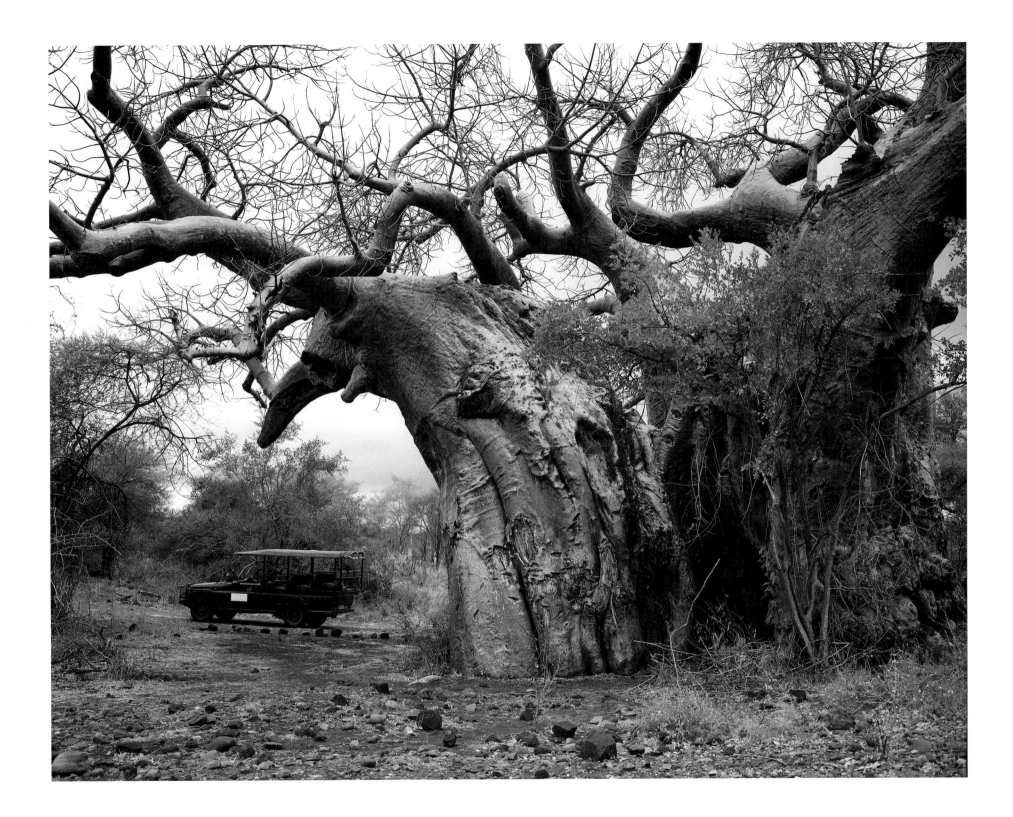

Pafuri Baobab # 0707 - 1335 (up to 2,000 years old)

KRUGER NATIONAL PARK, SOUTH AFRICA

Early morning on my first full day in Africa, Diana Mayne, a baobab expert, and Christine McLeavey (a mutual friend of Rachel Holstead, whom we'd meet later in Capetown) and I drove out from Johannesburg toward the northeasternmost part of the country. A chain of e-mail inquires had led me to Mayne, who was amenable to taking a baobab tour of the Limpopo. Our first stop was in the town of Louis Trichardt at the home of a friend of Mayne's, a forester creating a sustainable local business processing the oil from the baobabs, the uses for which range from soothing skin to dressing salads. Myths about the baobabs abound—for instance, that they used to uproot themselves and walk around, or that they had angered the gods and were planted upside down (the branches looking root-like as they do) as a punishment.

The Sagole may or may not be the oldest living baobab, but odds are in its favor. It was to be the first tree on our weeklong tour. I was doing most of the driving, gradually getting used to piloting from the right side of the car. More challenging still were the cows, donkeys, people, goats, and so on crossing the highway at their leisure and wherever they pleased, regardless of the exceptionally high speed limit. (Only the chaos of driving in Sicily springs to mind in comparison.) We left the so-called tar roads, turning onto the gravel of the tribal lands that are home to the Sagole. Regrettably, I was responsible for the loss of at least one mongoose, when a pack of them darted out in front of the car.

It was late afternoon by the time we reached the enormous tree, paying a small tourist fee to enter into its company. The just-discernible sounds of the nearby tribespeople and muted bells ringing from round the necks of grazing livestock floated over, lending an almost magical tenor to the late-day light. The Sagole's bark was very smooth (save for the deep graffiti cuts of names carved into its flesh) and the limbs steep. Winter is the dry season, and baobabs are deciduous—so this July day was a good time to see them, as their formidable branch structures are obscured when fully outfitted in summer leaves. Their odd shapes are a case of form following function: the trunks serve as their own water storage tanks for use in extended periods of drought.

Like the giant sequoias, baobabs are among the handful of oldest living things that are also supremely large. Baobabs get pulpy at their centers and tend to hollow out as they grow older, rendering them notoriously difficult to date. These hollows can

serve as natural shelters for animals, but have also been appropriated for some less scrupulous human uses: for instance, as a toilet, a prison, and even a bar, the last of which we'd visit later in the week.

The shadows were growing long as we lingered by the tree, the sun setting entirely as we drove back to the tar road, heading toward the Pafuri Gate of the Kruger National Park. We were platform-tent camping a stone's throw from the electrified fence of the Kruger's perimeter. The Kruger is filled with lions and leopards and cheetahs (oh my). I slept fitfully, the pitch-black woods filled with unfamiliar noises. In the middle of the night I was convinced that monkeys were just outside at the outdoor sink, eating the toothpaste I'd forgotten to bring in, but I wasn't about to get up in the darkness to find out. In the morning I was surprised to find it very much as I'd left it.

We awoke to cloudy skies, absolutely unheard of in the dry season, let alone the all-out rain coming down by the time we met up with the park rangers who would serve as our armed escorts to the Pafuri baobab. Visitors to the Kruger are not allowed off the main roads or even out of the car without an escort in most parts of the game preserve. Occasionally people are killed, but it is extremely rare, and it is usually those not following park rules, many of them poachers. (Illegal wildlife trade is comparable to the drug trade and human trafficking in terms of the amount of money it generates.) Attacks by lions, leopards, and crocodiles have caused injuries and deaths. But even trained park rangers are not immune to the dangers. A field ranger, out looking for illegal fishing nets, was trampled to death by an elephant when he startled her and her calf.

The Pafuri baobab is not as large as the Sagole, but still striking in form and larger by far than anything else growing in the preserve. Everyone milled around discussing the tree as I made photographs, the skies clearing then darkening again, rains starting and abating. Mayne took notes and made measurements, as she had the previous day with the Sagole.

A little further down the road is a grove of "fever trees," which have a delicately hued pale green bark. The name comes by association to malaria. The trees certainly don't cause malaria themselves, but they do require damper soil than most to grow, so naturally there are more mosquitoes around them. Just a little further down the path

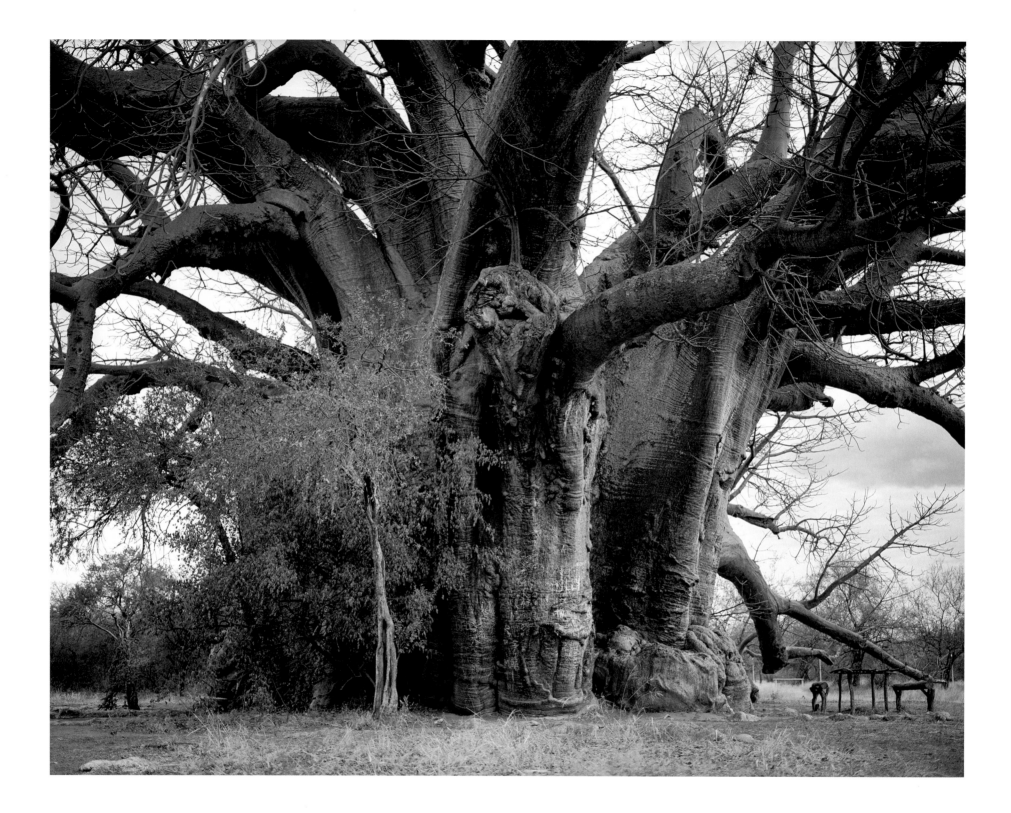

Sagole Baobab #0707-000505 (2,000 years old)

LIMPOPO PROVINCE, SOUTH AFRICA

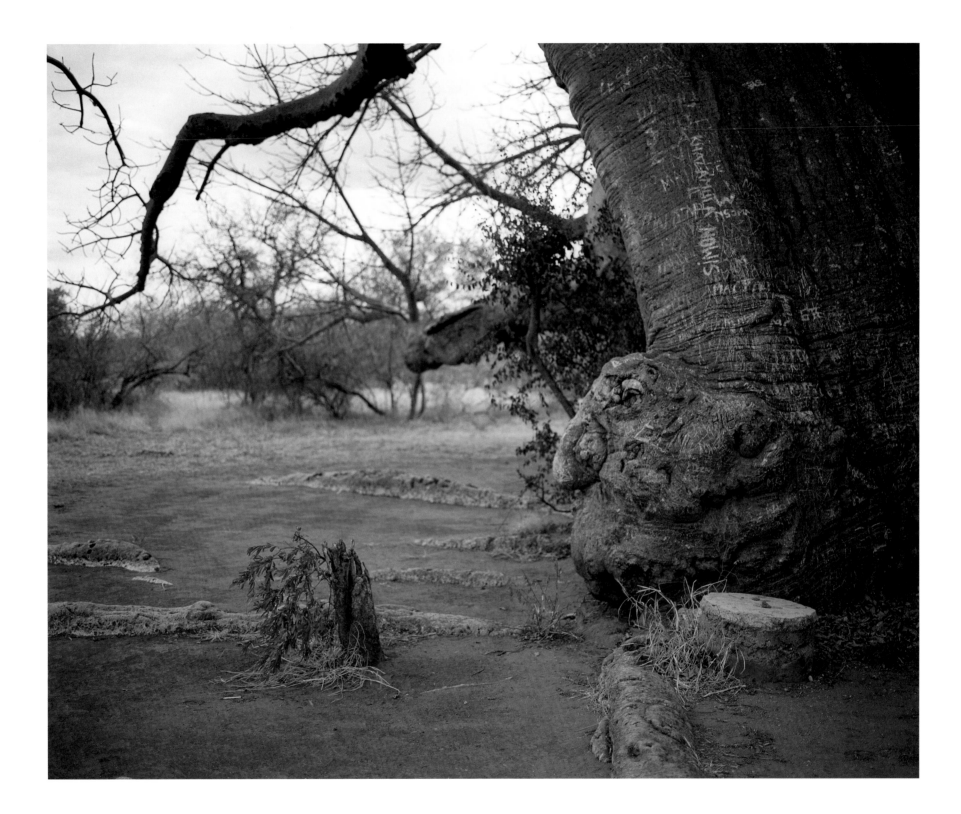

Sagole Baobab #0707-0824 (2,000 years old)

Sunland Baobab "Beer" #0707-2128 (up to 2,000 years old)

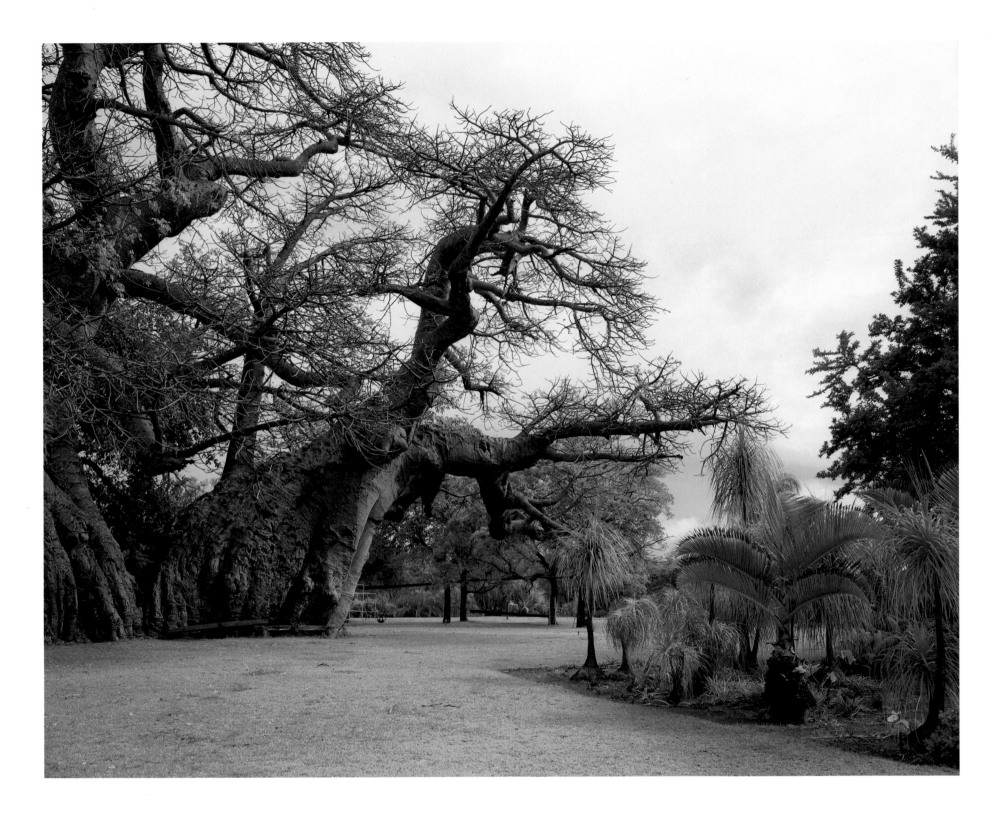

Sunland Baobab #0707-2303 (up to 2,000 years old)

LIMPOPO PROVINCE, SOUTH AFRICA

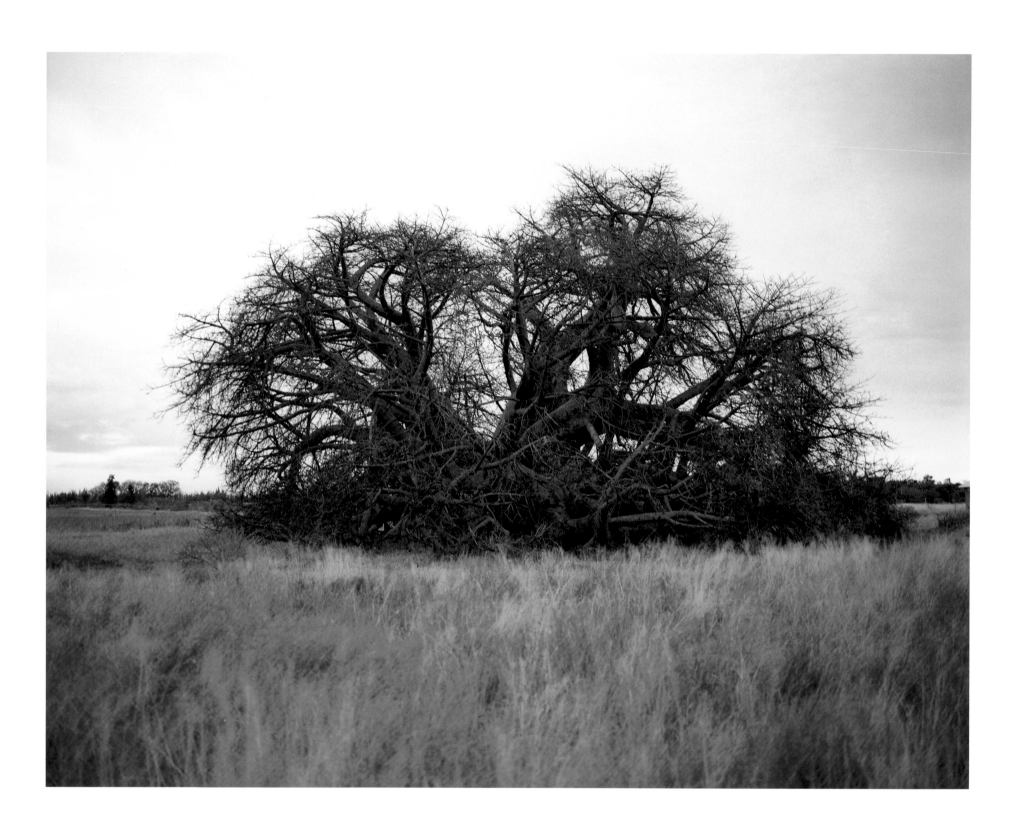

Glencoe Baobab # 0707 - 3305 (up to 2,000 years old)

LIMPOPO PROVINCE, SOUTH AFRICA

we arrived on the dry banks of the Limpopo River. On the far shore are Zimbabwe and Mozambique. There is no fence, but the open expanse is patrolled by lions. They tend to be indiscriminate in refusing entry.

After some conflicting opinions among my travel companions about how much time we should spend viewing wildlife, we decided to press on to the next tree. After a long and convoluted drive, we arrived at the Sunland baobab at dark. The Sunland's primary claim to fame is the not-quite-operational bar inside the belly of the tree. A sign reading "Beer" is affixed to its trunk, along with some outdoor lighting. Inside, saloon-style antiques fill the space, though no drinks were actually being served. It was hard not to feel bad for it—an elder worthy of respect turned into an amusing sideshow.

The last tree on our route was the Glencoe baobab on a private farm. Mayne had pre-arranged our visit with the owners, who'd happily obliged. The huge tree interrupted the otherwise flat expanse of the farm, sheer mountains not far in the distance. The Glencoe had been struck by lightning many years ago and knocked over on its side, half uprooted. Those exposed roots transformed themselves into branches, creating an unusually symmetrical silhouette for a baobab. As baobabs age they develop more and more distinct personalities.

We returned to Johannesburg after midnight; after ten-plus hours of hard driving and a car full of nerves frayed from hours in standstill traffic in an area Mayne had warned was not all that safe, I was completely spent. The next morning Christine and I would drive to Pretoria for the underground forests. Before we departed Johannesburg, Mayne's husband warned that there was a threat of "smash and grabs" that morning at precisely the intersection where we would exit the highway to the gardens. (The operation: smash a car window, grab what you can, and bolt.) He advised me to just keep driving, even through red lights, should we spot anyone skulking about at those particular intersections. We arrived at the garden without incident.

Underground Forests

AGE
13,000 years (Deceased; other individuals still living)

LOCATION
Pretoria, South Africa

NICKNAME
Underground forests

COMMON NAME
Dwarf mobola (and others)

LATIN NAME
Parinari capensis (and others)

Underground Forest #0707-10333 (+3,000 years old) DECEASED

PRETORIA, SOUTH AFRICA

While tracking down information on the baobabs, I happened upon one of the cleverest phenomena I've heard of to date: a growth strategy collectively referred to as the underground forests of Africa. Braam van Wyk, a botanist from the Pretoria National Botanical Garden, explained to me that several distinct species of woody plants that live in the arid, fire-prone bushveld ecoregion have adapted in a remarkable way. While other species have developed thick bark impermeable to fire, the underground forests instead migrated most of their mass underground, with just the equivalent of the crown of a tree peeping above the surface. The soil is employed as a natural firewall, protecting the bulk of the forests' extensive underground presence, so that when a fire rips through, it can only harm the leaves and twiggy annual growth, or ramets, off the top. The plant can easily recover. It's the equivalent of getting your eyebrows singed—they'll grow back.

The oldest individuals grow clonally and are thought to be 13,000 years old, and possibly significantly older. At that latitude, they have the additional advantage of not having had to overwinter an ice age.

Usually composed of both a central woody stem, sometimes referred to as a rhizome, and an extensive system of stems and roots, many underground forests can be found around Johannesburg and Pretoria and are robust throughout sub-Saharan Africa. Van Wyk suggests looking in almost any patch of undisturbed grassland: if it has never been ploughed or otherwise developed before, you might just find an underground forest. While no methodology has been developed to determine their exact ages (as is true with many clones), growth-rate analysis produces educated estimates.

The massive underground formations were discovered because of the nuisance they cause. Sometimes exposed by construction workers putting in roads, they are extremely difficult to unearth, and can likewise pose a problem to farmers, as some (but not all) of the species that grow in this manner are poisonous to livestock. Farmers have figured out a clever, if devious, way to remove them without digging up their pastures: they slice through some living branches and get the plant to draw water, as a flower would draw water in a vase. Once the stem is successfully taking up the water, the farmers switch the water out for poison, and the plant unwittingly drinks itself to death.

UNDERGROUND
FORESTS

As helpful as the austral winter was to get the best sense of the baobab, it was not an ideal time to see the full foliage of the underground forest clones, some of which are deciduous and therefore difficult to visualize in the off-season. The individual I photographed, however, was a bright green against the orange clay soil in an island relic of undisturbed grassland. Literally, a traffic island between the highway and the garden.

However, it is no more. Van Wyk informed me that it was killed during construction of a new traffic pattern outside the gates of the garden a few years after my visit. The good news is that there are many more; the bad news is that once gone, they are really gone—you can't replicate 13,000 years of growth in short order, and there is so very much that we don't yet know about them.

For as intriguing as they are, the underground forests are widely unknown, even to botanists.

Welwitschia

AGE
2,000 years

LOCATION
Namib-Naukluft Desert, Namibia

NICKNAME
N/A

COMMON NAME
Welwitschia

LATIN NAME
Welwitschia mirabilis

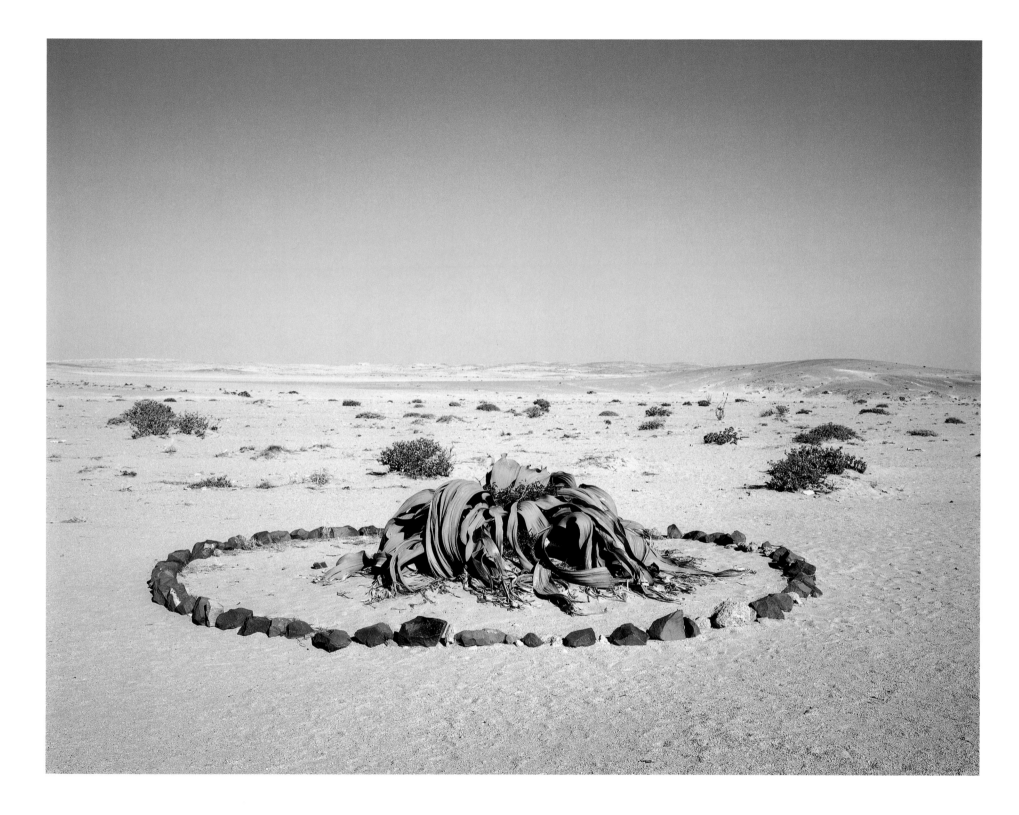

Welwitschia Mirabilis #0707- 6724 (Approx. 2,000 years old)

NAMIB-NAUKLUFT DESERT, NAMIBIA

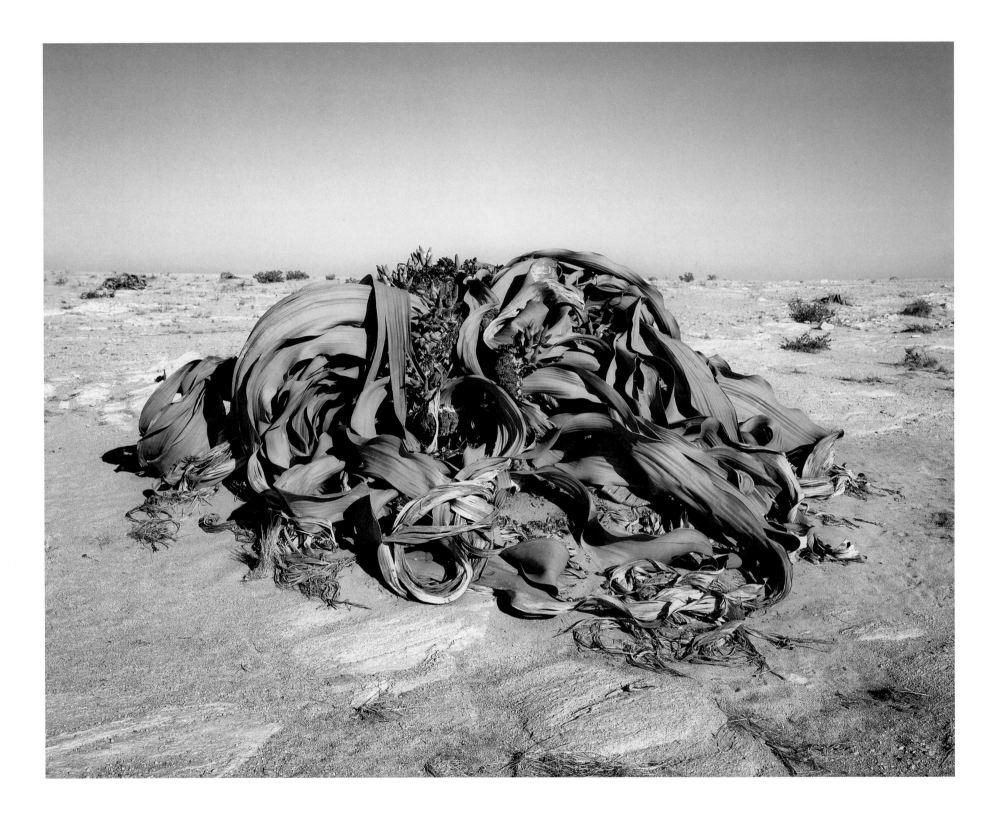

Welwitschia Mirabilis #0707-22411 (2,000 years old)

NAMIB-NAUKLUFT DESERT, NAMIBIA

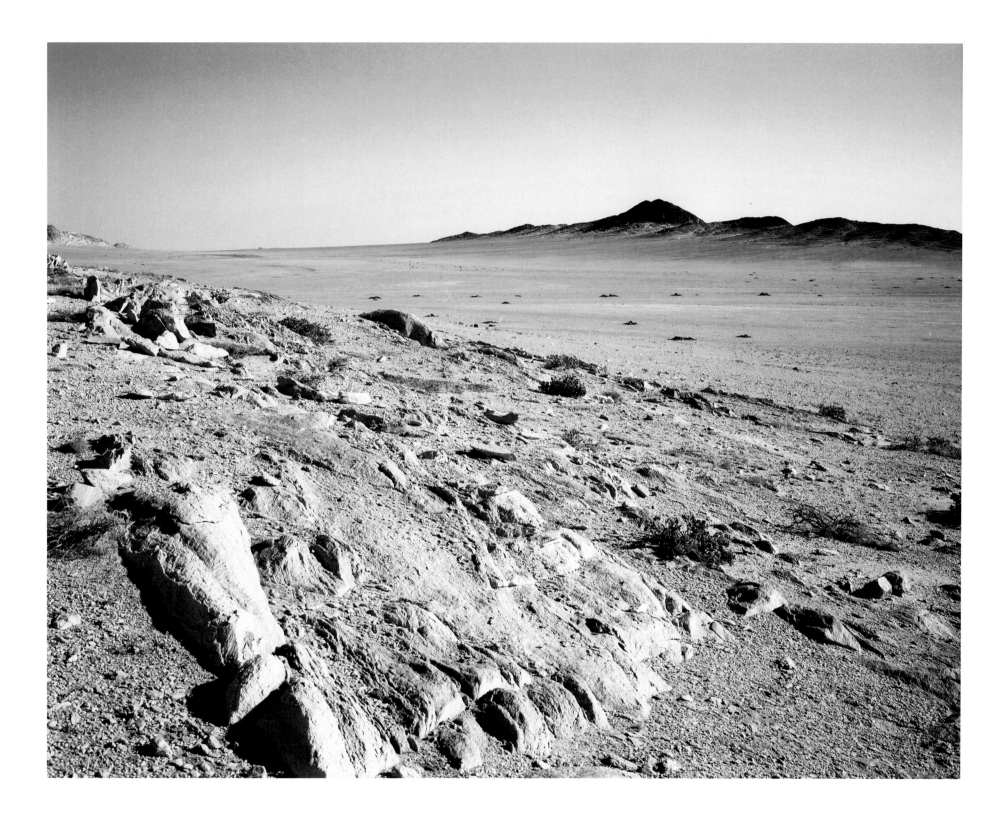

Welwitschias in the Namib-Naukluft # 0707- 06736

NAMIBIA

The *Welwitschia* is a truly strange and unique plant that lives only where the coastal fog and desert meet along the coasts of Namibia and Angola. Though you might not guess it from the looks of it, the *Welwitschia* is a tree, classified in the strange, anomalous, and still-disputed family Gnetophyta, thought to be a sister group to Pinaceae. As with many conifers in the Pinaceae family, the *Welwitschia* bears cones, albeit primitive ones. It has a long taproot, and above ground grows in an almost wavelike form (you can see annual growth rings, though they're too distorted for an accurate count), and unlike anything else in the plant kingdom, it grows only two leaves over the course of its entire life span. Technically they begin their lives with embryonic leaves, called cotyledons, which are developmentally distinct from the true, adult leaves. If you've ever grown plants from seed, you might have observed that the first leaves to sprout from the soil are different from the leaves of the mature plant. These are the cotyledons—sort of like baby teeth—and in the case of *Welwitschia*, are replaced by adult ones, which never fall out . . . and never stop growing. ("Long in the tooth," as they say?) In other words, what looks like two big piles of leaves on either side are actually those two individual ones, shredded up by the elements and piling on top of themselves over time.

There are many petrified forests in Namibia, yet no discernible trees. Ernst van Jaarsveld, chief horticulturalist at the Kirstenbosch National Botanical Garden, describes the *Welwitschia* as a living fossil, surviving—much like the Palmer's oak in California—in a remnant of an ancient ecosystem that has largely disappeared. Researcher Kathryn Jacobson hypothesizes that the *Welwitschia* had a vibrant population 105 million years ago, but then became increasingly more isolated by the change in climate. But the story deepens: van Jaarsveld told me recently over e-mail that "*Welwitschia*-like fossil plants have fairly recently been discovered in northern Brazil, which were dated at about 115 mm years ago when Africa was still connected to America."

When I met with van Jaarsveld in Cape Town, he described the *Welwitschia* as being arrested in its juvenile stage, bringing to mind a coniferous Peter Pan that is growing old without ever growing up. But how is it a tree? Strictly speaking, the *Welwitschia* has a trunk. When pressed for the defining attributes of a tree, van Jaarsveld replied with a smile: "You have to be able to climb it."

But back to the desert.

Rachel Holstead (the aforementioned Irish composer I'd befriended at the Mac-Dowell Colony), Christine McLeavey, and I were on a road trip from Cape Town up South Africa's west coast, and across the border into Namibia. I relaxed into the open expanses and was in love with the landscape: Fish River Canyon, second only in size to the Grand Canyon; landscapes casually strewn with boulders in the Giants Playground; quiver trees at dawn; the deep rusty red of the Sossusvlei dunes; and the Dead Vlei skeleton trees. The desert was entirely more beautiful and varied than I'd imagined. Still, this leg of the journey was not without its tribulations. I was thrown from a resentful horse—or rather vaulted off it at full speed, rolling up hard onto the side of the corral after he tried, unsuccessfully, to dislodge me against a tree. I was sore and covered in bruises, but thankfully nothing worse. (Pro tip: do not tell ranchers you're an experienced rider in unknown environs; you might end up with a horse that's barely saddle-broken.) Later in the trip and further north, our car was nearly trampled in the pitch-darkness by an enormous oryx while we were en route to a safari lodge. Thankfully, both parties came out unscathed. But by the time I visited Australia later in the project and was advised not to drive in the outback at night, I didn't need to be told twice.

The most pressing problem, however, was that the scientists at the Gobabeb Re-search & Training Centre, with whom I'd been corresponding for months and who were going to take me out to find the *Welwitschia*, turned out to be in Angola when I arrived, and offered no help as to alternatives. Luckily, a New York–based friend of a friend's neighbor's sister was a travel agent in Windhoek. Small world. Nicole Voland had helped plan and book our route (you don't just wing it in Namibia or you'd be likely to end up on your own in the middle of nowhere). She tracked down a contact in Swakopmund who in turn put me in touch with a self-taught naturalist, George, who agreed to take us out on a Namib-Naukluft tour. Swakopmund is an unusual place, founded in 1892 by the then German empire, and it still retains the flavor of a German beach town. I still regret having just missed a local high school production of *Grease*, just to add to the cultural incongruity.

The four of us took a jeep into the expansive desert park, featureless except for the newly laid pipelines carrying water away from the town and out into the bone-dry expanses. George explained that the Namibian government has leased out large por-tions of the park to international mining corporations. While they do bring in a few low-wage jobs for Namibian citizens, Namibia is not sharing in the profits from the

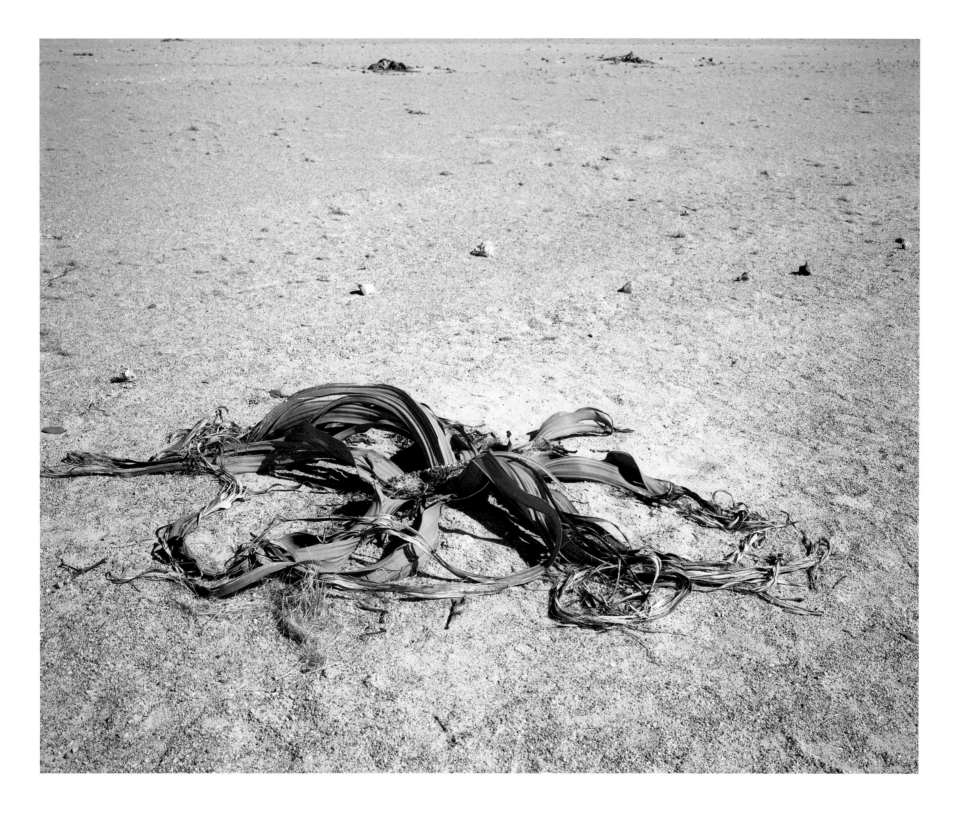

Young Welwitschia #0707- 06520

NAMIB-NAUKLUFT DESERT, NAMIBIA

mining of their natural resources. I began to wonder what weight the designation of "park" carried, as we passed sign after sign warning of restricted entrance, this one to "Swakop Uranium."

We started along the eponymous *Welwitschia* Route, a self-guided driving tour culminating with "the Big *Welwitschia*." It is aptly named, and a strange sight fenced off, complete with its own rickety viewing platform. A number of plants disrupted the surface of bare desert, some babies and others as large as the star specimen, drawing into question why that one had been singled out for special treatment. As with most plants, light, water, nutrients, pH, and other factors can affect growth rates, but in general the bigger the *Welwitschia*, the older the *Welwitschia*. We abandoned the tourist route and headed to what might be an even bigger—and unfenced—individual. George didn't quite have his facts straight, but that was all right: with his help, I found what I was looking for. Gazing at its monstrous form, it came as no surprise that when the children of Namibia misbehave, the *Welwitschia* will come and get them.

As the afternoon wore on we left the desert plains for the relative green of the canyon, an occasional ostrich zigzagging prehistorically out of the path of the jeep. I came away thinking of many things at once: the primitive and exceedingly improbable existence of the *Welwitschia*, the colonialist town likewise setting up its own improbable roots, and the future of the country (and continent, for that matter) whose natural resources are often viewed as there for the taking.

Somehow the *Welwitschia*—national plant of Namibia—perseveres in this unforgiving desert. It was born for it.

Road into the Namib-Naukluft from Swakopmund

AUSTRALIA

Antarctic Beech

AGE
6,000–12,000 years

LOCATION
Queensland, Australia

NICKNAME
N/A

COMMON NAME
Antarctic beech

LATIN NAME
Nothofagus moorei

Antarctic Beech # 1211-0367 (12,000 years old)

LAMINGTON NATIONAL PARK, QUEENSLAND, AUSTRALIA

Shortly after my TED talk went live in 2010, Rob Price, an innate naturalist and newly minted biologist living in Australia's Gold Coast, e-mailed to ask if I was familiar with the Antarctic beech trees there. I hadn't even known to look for them.

Having previously sported a dubiously chosen (read racist) nickname, the *Nothofagus moorei* are now commonly known as Antarctic beech, and although they now live in Queensland, they do in fact originally hail from Antarctica, albeit 180 million years ago. Antarctica's climate would certainly not support them nowadays, but the wet, high-altitude, and considerably warmer Lamington Plateau in the McPherson Range suits them just fine. The *Nothofagus moorei* are related to the *Nothofagus antarctica*, now found in South America, which happen to be the most southerly occurring trees on Earth, and just one example of evidence linking the Antarctic and Australian floristic kingdoms in the planet's deep history.

But back to the here and now. After a few days acclimating to the sixteen-hour time difference in Sydney (while my gracious host, Robert Todd, made sure to tutor me on all the possible type of poisonous snakes I might encounter out in the bush), Price picked me up from the low-key beach town airport. I was to stay in the bona fide hippie trailer in the front yard of the house he rented from some bona fide hippies. Price shared the ground floor with their tie-dye workshop, and the family lived upstairs. A pen confined quails (if not their odor) feet from my camper door. I was offered a tiny, delicious egg sandwich. By Price, not the quails. When I first met Joy, she had a flower painted on her cheek, having just returned from a goddess workshop. (The following day she returned with a book of photographs on the variety and glory that is the vagina.) Their daughter was an aspiring aerialist, and I a retired one. I was a gymnast as a child, but perhaps more unusual was that at the acrobatically old age of twenty-five I took it up again, along with static trapeze to ease the impact. I performed with filmmaker Kitao Sakurai in clubs around New York into my early thirties, at which time my body declared it was time to retire. We were quite the crew.

The next day Price and I departed the declining beach town and drove up to the Lamington National Park. The hike was moderately steep and many miles long. I was a little worse for wear, still in a wrist brace after the break and connective tissue tears that I'd sustained in Sri Lanka a few months prior, and still suffering chronic back pain, probably a result of all the aforementioned acrobatics, and surely made

worse by lugging camera equipment all over the planet. But I was *here*, and there was no sense in doing things halfway. I saw wallabies and fruit bats and flying foxes and rare birds. Price was so at home in the forest, it was as if he knew every woodland creature to say hello to by name. He was entirely unfazed by a poisonous snake in the path. (This reminded me of having joined the "Carolina Snake Bite Club" at the tender age of ten-ish, a camp activity of sorts. One was to place one's hand in a burlap sack occupied by a black snake until bitten. And voila! Membership attained. Different times, the eighties.) As we continued our climb, Price told me a story about a frog that gestates its young in its stomach. It stops producing stomach acid, swallows the fertilized eggs, and vomits them up when it's time to be born. While an interesting evolutionary tactic, to be sure, it was not all that surprising to learn it is now extinct. Though you do want to give it points for trying.

The forest was dense and primal, and the stresses of the long journey to Australia from Brooklyn fell away into the honest exhaustion of hiking. Huge tree ferns reminded me of Devonian illustrations from elementary school textbooks. We started spotting Antarctic beeches of varying ages, some with obvious multiple stems, or trunks, emerging from the same root system. We matched individuals to the research paper, verifying their ages, though in all likelihood most of the trees have never been studied. The oldest was at the pinnacle of our ascent: a 12,000-year-old fairy ring in one of the lushest parts of the forest.

On the drive back to the coast, I noticed a trickle of blood under my collarbone near my left shoulder. Leeches produce an anticoagulant that prevents your blood from clotting, and it did seem like an incongruous amount of blood for the size of the wound. The perpetrator was nowhere in sight, but Price identified the bite marks as leech-induced. I found a take-out napkin to stop the bleeding. I couldn't help but squirm with discomfort as I thought of the ancient medical bloodletting by leeching. In ancient Greece it was thought that bloodletting would realign the humors. While leeching is still used today in various parts of the world for any number of maladies, aligning the blood with the other "substances of the body"—black bile, yellow bile, and phlegm—is just plain silly to us now with the illuminations of modern medicine. But how many things that we are certain of today will be proven ridiculous tomorrow? And how many things did our ancient ancestors get right the first time?

Vines and Moss # 1112-0355

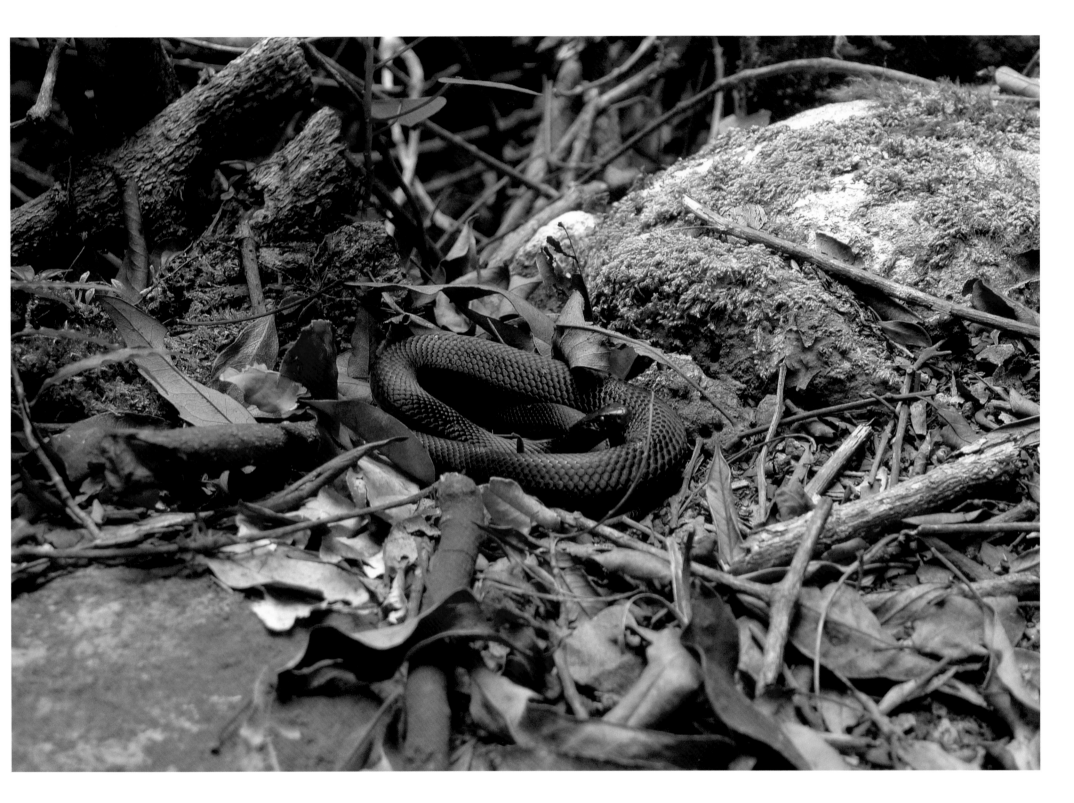

Red-bellied black snake in the path

LAMINGTON NATIONAL PARK, QUEENSLAND, AUSTRALIA

Antarctic Beech # 1211- 2717 (6,000 years old)

LAMINGTON NATIONAL PARK, AUSTRALIA

The following day the sun slipped behind some low cloud cover; then came mist, then all-out rain. Price and I drove up to a nearer section of park with a well-marked path and signage around another ancient fairy ring. I was leaving for "Melbin" (Melbourne, that is) the following day en route to Tasmania, so it was now or never: wielding the tripod with cold hands and poor visibility, I took photos while Price attempted to shield my camera from the rain.

ANTARCTIC
BEACH

Tasmanian Lomatia

AGE
43,600 years

LOCATIONS
Southwest Tasmania; Royal Tasmanian
Botanical Garden, Hobart

NICKNAMES
King's holly, king's lomatia

COMMON NAME
Tasmanian lomatia

LATIN NAME
Lomatia tasmanica

Lomatia Tasmanica #1211-0398 (43,600 years old; propagated clippings)

The *Lomatia tasmanica* is so critically endangered as to have only a *single individual* left to its name.

It flowers reddish pink, though rarely, and there are pollen and a stigma in each flower, but it's a triploid—a rare genetic anomaly—causing sterility. *Lomatia tasmanica* was first collected in 1934, but that particular population has since died out. Another was identified in 1967, and in 1991 its age was established by radiocarbon dating fragments of identical leaves found in its vicinity—it is at least 43,600 years old, and possibly more than twice that.

Tasmania was the only place in the world where I was not granted direct access to my subjects in the wild. This included the lomatia, living in southwestern Tasmania in an area with the rather literal-minded moniker of South West, and the Huon pine on Mount Read in the northwestern part of the island. From what I've come to understand, the Tasmanian Parks Department has an agenda of its own—deep in the pockets of the mining and lumber concerns—and decided to thwart my efforts. A friend in Sydney granted me some perspective when he suggested thinking of Tasmania as Australia's Alaska. Things are done by a different set of rules, and sometimes no rules at all.

In the wild, *Lomatia tasmanica* calls dark, riparian rainforest gullies home, shaded by heavy vegetation. According to published research by geneticist Jasmine Lynch, the population consists of several hundred stems spread over a distance of 1.2 kilometers, and reaching up to eight meters in height, should the willowy branches stand erect. At the very least, I was able to lay eyes on some clippings from the lomatia propagated at the Royal Tasmanian Botanical Garden. (Though technically it is the same plant, simply seeing clippings in pots in a nursery is a far cry from a two-day hike in the South West Wilderness, one of the most inaccessible parts of Australia, to the place it has called home for 43,600 years.)

Lorraine Perrins, curator of rare and threatened flora, told me that the Hobart botanical garden and another in Canberra are the only places the lomatia can be found outside its natural habitat, and even then it is not on public display. The clippings are so sensitive, in fact, that the only time one of them spent half a day in public view in just slightly different conditions, it died. That hardly bodes well for its survival. In the wild, it is threatened by *Phytophthora cinnamomi*, an invasive plant pathogen

Lomatia Tasmanica #1211-0426 (43,600 years old; Propagated clone)

ROYAL TASMANIAN BOTANICAL GARDEN, HOBART

Lomatia Tasmanica #1211-0441 (43,600 years old; Research Greenhouse)

ROYAL TASMANIAN BOTANICAL GARDEN, HOBART

which, without proper precautions, can be tracked in on one's shoes and lead to root rot in susceptible plants. Botanists at the garden are trying to graft limbs of the *Tasmanica* onto other related lomatia species, with limited success. In the meantime, it lives in the only way it knows how: by cloning itself over and over again, theoretically immortal, though that is unlikely to continue for long, given the instability of our climate to come.

TASMANIAN
LOMATIA

{ 27 }

Huon Pine

AGE
10,500 years

LOCATIONS
Mount Read, Tasmania; Royal Tasmanian
Botanical Garden, Hobart

NICKNAMES
N/A

COMMON NAME
Huon pine

LATIN NAME
Lagarostrobos franklinii

Dead Huon Pine adjacent to living population segment #1211-3609 (10,500 years old)

MOUNT READ, TASMANIA

Huon Pine #1211-4033 (10,500 years old)

MOUNT READ, TASMANIA

Huon Pine # 1211 - 0445 (10,500 years old; propagated clone)

ROYAL TASMANIAN BOTANICAL GARDEN, HOBART

I drove angry all the way from Rosebery to Strahan, where I indignantly bought a two-dollar bag of Huon pine wood shavings at a souvenir shop, the fragrant wood sought after like cedar for closets. After six months of navigating the infuriating bureaucracy that is the Tasmanian Parks Department, I thought I had found my "little way through" with a guided tour to the Huon pine site. But like so many things that seem too good to be true, so was this.

Why was I even in a position that I needed to hire a guide? Long before I traveled all the way to Tasmania, I made inquiries directly to the research scientists, as always, and they genially offered to escort me to the sites of both the lomatia and Huon pine, adding my name to their research permits. Back in 2006 when I originally contacted a researcher in Parks regarding a visit to the aforementioned lomatia, her primary concern was the timing for the demanding hike, as the weather can be harsh and unpredictable. When I changed my itinerary to visit in late 2011 instead, my advocate had since departed Parks, and I was in no way prepared for the veritable briar patch of red tape I encountered in her absence. For six months, I wended my way through multiple layers of bureaucracy (and even as far as the Lamont-Doherty Tree Ring Lab back in New York State) in hope of convincing the powers that be to grant me access, gathering letters of support and verifying my abilities to follow all protective protocols. Unfortunately, there is one person at Parks who doles out the permits; access to these sites depends upon her; and she denied my requests, even going so far as to make professional threats to those who chose to help me. I was perplexed, to say the least. Only in Tasmania. And thus it was that I found myself with my so-called guide, paying top tourist prices, on our way to the ancient stand of Huon pines on a private mining site.

The age of the stand of Huon pines was determined by dating some pollen collected from the bottom of the lake bed further down the slope, which was determined to be a genetic match to the living stand. (Other species of trees are present amid the stems of the colony.) Just like Pando, the Huon colony is male, but unlike Pando, whose individual aspen stems don't live longer than a few hundred years at most, many of the individual Huon stems are 500 to 1,000 years old. In fact, some have been found to surpass the 2,000-year mark, determined using standard methods of dendrochronology. That gives the Huon pine the unique distinction of being the only known organism to meet my age qualifications twice: as a unitary stem over

2,000 years, and simultaneously part of a clone that's over 10,000. Mike Peterson discovered two other ancient individual trees in two different remote sections of Tasmanian wilderness, the Harmon tree and the Big Huon Pine, or BHP for short. The Harmon is at least 2,000 years old, and the BHP is at least 3,000, and maybe older.

One must pass through the mining company's guard station in order to proceed up into the mountains. I was there in December, Austral summer, but it was chilly as we began our ascent up the rocky dirt road. Finally, we reached a gate—no fence—just a gate, to which my guide had one of the very few keys. A biologist back in Hobart later told me that the wooden-planked path we passed through was actually surrounded by dead Huons from the same colony, killed in a fire some years back. And while I was able to pick out the living Huons from a distance, stretching down to Lake Johnson, I was not allowed near any of them. Hence, my acutely felt frustration.

On my return to Hobart, I revisited the Royal Botanical Gardens, where botanists had successfully propagated a clipping from the Mount Read stand. Technically speaking, this is the same 10,500-year-old organism, though, like the lomatia, removed from its original context. My photographs at the site, had I been given proper access, would not have done any harm, as I would have employed the safety protocols in place to prevent the introduction of pathogens. Politics, bureaucracy, mining, and forestry are another story entirely.

According to the Australian National Botanic Gardens, oil from the Huon has been employed for dressing wounds and treating toothaches and been used as an insecticide. The rot-resistant timbers were used for shipbuilding. And perhaps, just like the dubious status of products made from endangered wildlife, some consumers might find furniture crafted out of endangered trees all the more desirable for their exclusivity. Yet the stand still stands. Most Huon pine has now either already been logged or is protected.

How do we balance human demands with the long-term survival of the planet? As I stood on the rock-strewn beach in Strahan, toes in the cold water, I thought about Macquarie Island, even more remote than Tasmania, stepping-stone to Antarctica and likewise lacking a permanent human population, a world away on an invisible far shore.

Eucalyptus

NEW SOUTH WALES

AGE
13,000 years

LOCATION
New South Wales,
Australia

NICKNAME
[Redacted for protection]

COMMON NAME
Eucalyptus

LATIN NAME
[Redacted for protection]

WESTERN AUSTRALIA

AGE
6,000 years

LOCATION
Meelup,
Western Australia

NICKNAME
Meelup mallee

COMMON NAME
Eucalyptus

LATIN NAME
Eucalyptus phylacis

Rare Eucalyptus (species redacted for protection) #1211-2233 (13,000 years old)

NEW SOUTH WALES, AUSTRALIA

Rare Eucalyptus # 1211 - 2105 (13,000 years old)

NEW SOUTH WALES, AUSTRALIA

Rare Eucalyptus, outlier #1211-1714 (13,000 years old)

NEW SOUTH WALES, AUSTRALIA

There are approximately 700 different species of eucalyptuses, allowing room for quite a lot of diversity. The great majority of eucalypts originally hail from Australia, but they can now be found in many frost-free areas the world over (in some cases a welcome addition, and in others an all-out invasive species). The group includes a rainbow type whose bark is so colorful it looks like an art class has had at it. Others are employed in the making of everything from didgeridoos, to fibers for fine papers, to oil for cough drops (mentholyptus, anyone?). And of course koalas are the most famous ingesters of eucalyptus leaves, the limited nutritional value of which factor into their sleeping twenty hours a day. But the koalas aren't likely to show much interest in the eucalypts I was after—both of them "mallees"—a term that refers to sending up multiple stems from a root system as opposed to a single, unitary trunk. The result is something rather shrub-like. Koalas prefer older, sturdier trees, which are becoming scarcer because of habitat destruction caused by human development. This in turn is is making the koalas vulnerable in some areas.

The first eucalypt I went to visit was far beyond vulnerable: it was critically endangered. It took quite some doing to get permission to see the 13,000-year-old mallee in New South Wales. I'd uncovered some mentions of its existence, but its exact location is kept under tight wraps, in part because of the extreme rarity of the species, and in part because it's living on a private mining site. After gathering substantive support from both a lawyer and someone with political heft in Australia, I was granted access, under the condition that I not share the species name or any location information beyond the state it resides in. There are only five known individuals in this species left in existence, one of which is likely a clone, bringing the number of individuals down to four. A local resident first discovered the species in 1985, likely recognizing its small, distinctive leaves as something out of the ordinary, just as Mitch Provance did with the Palmer's oak in Riverside, California—coincidentally, 13,000 years old as well.

It was overcast the day I drove out to the site with John Briggs, one of the primary researchers, and also a member of the recovery team working toward its preservation. The tree is cordoned off from active mining area with various low tarps and bright orange plastic fencing. The main section is probably no more than fifteen feet tall, and is composed of more than seventy-five stems, its root system substantially larger than the growth above ground might indicate. A little more than 130 feet away lives another identical, though significantly shorter, tuft (around six feet tall). Briggs

has been waiting for *years* for the lab results on the radiocarbon dating and genetic testing that will confirm that the two are one and the same organism; however, the distance and growth-rate analysis provide early indications that it has been growing clonally for at least 13,000 years and perhaps many more. A few early, anemone-like white flowers were just starting to bloom that late December day. Research has shown that the species does not set seed well, and when it does, many of those seeds lack embryos, rendering them infertile. What's more, when new seedlings do sprout, they tend to exhibit "a lack of seedling vigor, suggesting that a post-zygotic lethality system may be operating in this taxon." (That's according to Michael Crisp, who first described the species in 1988.) In other words, the clonal mallee strategy is the only viable means for this species to survive.

We spent some time in the wooded area, and then walked over to the adjacent active mine with the foreman, who seemed quite happy for our company. It was raining by the time Briggs drove me to Canberra so I could catch a bus back to Sydney. We spoke more as we drove, and I could hear the frustration in his voice as he described the bureaucratic obstacles such as that which delayed his test results. We also discussed some of Australia's other environmental challenges, namely its long list of feral, nonnative animals, among them, cats, camels, and cane toads. The mention of cats reminded me of a story that Rob Price had told me about a small, flightless bird—the Stephen's Island Wren—which may have been sent into extinction by a lone feline interloper introduced by the island's lighthouse keeper, incidentally also the person who first indentified the species.

I returned to the home of Rob Todd and Sandra Domelow that evening, a welcome home away from home in the midst of this multipronged and many-mile journey. The next day I would fly to Perth, where I would stay with Rob's brother Dave and his family. There is something especially wonderful about being invited into someone's home when you're so far from your own.

———

The second eucalypt hadn't been on my original docket. I first learned about the Meelup mallee from conservation biologist Kingsley Dixon at the King's Park and Botanic Garden in Perth. I'd asked Dixon about gaining access to the stromatolites, and he volunteered information on the tree as well. While I generally try to do all

Meelup Mallee, Eucalyptus #1211-0701 (6,000 years old)

Meelup Mallee and Indian Ocean #1211-0791 (6,000 years old)

my research ahead of my travels, this wasn't the first time I've learned about another ancient organism in pursuit of something else entirely. Luckily this eucalypt was a doable day trip from Perth, which I could take instead of my "day off." Besides, I was less keen to go swimming after Dave Todd told me some stories about the recent shark-related deaths at the beach near their house.

First discovered in 1992 by two eastern Australian botanists, the 6,660-year-old Meelup mallee has had a much rougher go of it than its New South Wales cousin, though it is substantially easier to access. First, it was bisected by a road, then nearly destroyed entirely when a parking area was built to facilitate a scenic overlook onto the Indian Ocean, although it was discovered just in the nick of time. Later, parts of it were also destroyed by fire, but the mallee growth habit—those lignotubers containing ready buds that sprout after fire—allowed it to regenerate. In fact, some eucalyptuses start their lives as a single stem, but convert to a mallee growth strategy after the extreme duress of a fire.

When I arrived in Perth I drove directly to meet Dixon at his office in the gardens, and he took me out to some clones propagated in their research nursery. The Meelup mallee clones are growing well in cultivation and flowering, though not yet producing much seed. Dixon shared that recent shifts in rainfall patterns are creating increased periods of drought (and related drought stress) in the historically rainy winters, and conversely, high humidity in the previously dry summers. The humidity in turn encourages "a wide range of new and nasty pathogenic fungi . . . and exacerbates susceptibly to bacterial cankers that can cause the death of whole systems." In other words, the Meelup mallee might have survived fires and the building of roads and parking lots, but it might not survive the changing climate.

Dixon snipped off a leafy branch from a hardy plant and handed it to me. I drove the several hours south to Meelup the following morning, reaching the costal town in the unremitting midday sun. I spotted the associated roadside markers, pulled over in the relocated parking area, then matched up the leaf structure with the clipping from Dixon, confirming I'd found the original.

Stromatolites

AGE
2,000–3,000 years

LOCATION
Carbla Station, Western Australia

NICKNAME
N/A

COMMON NAME
Stromatolites

LATIN NAME
N/A (Bound Cyanobacteria)

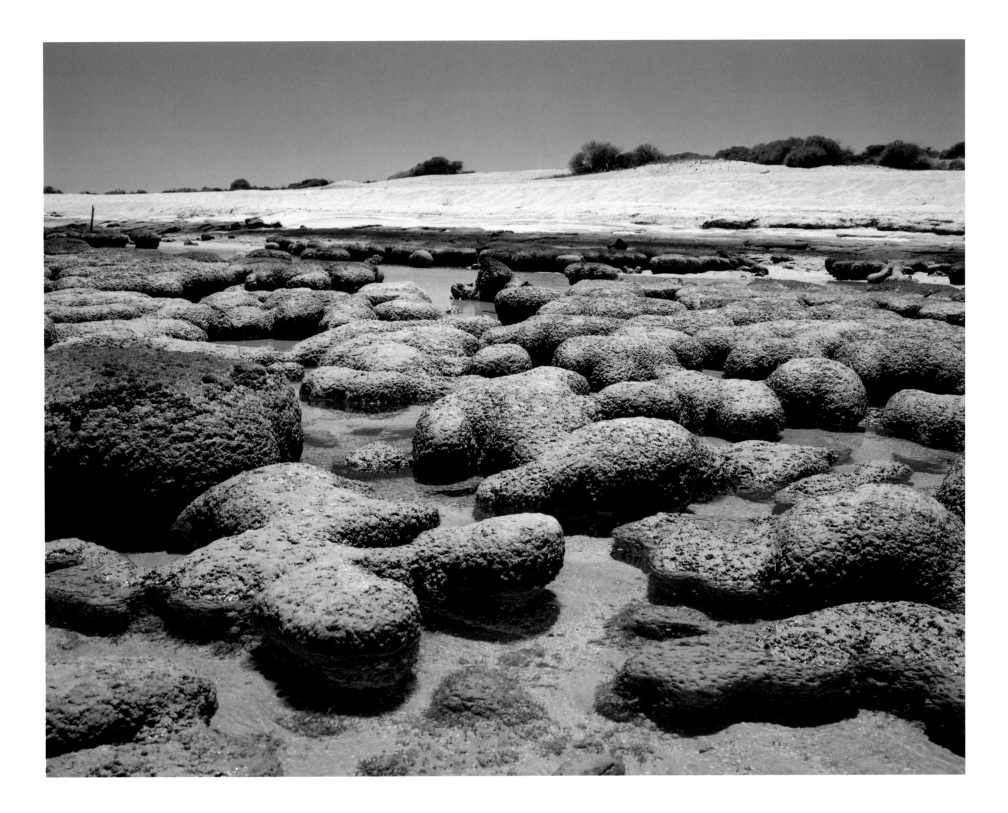

Stromatolites #1211-0512 (2,000-3,000 years old)

CARBLA STATION, WESTERN AUSTRALIA

Stromatolites, Microbial Mat # 1211-0061 (2,000 - 3,000 years old)

CARBLA STATION, WESTERN AUSTRALIA

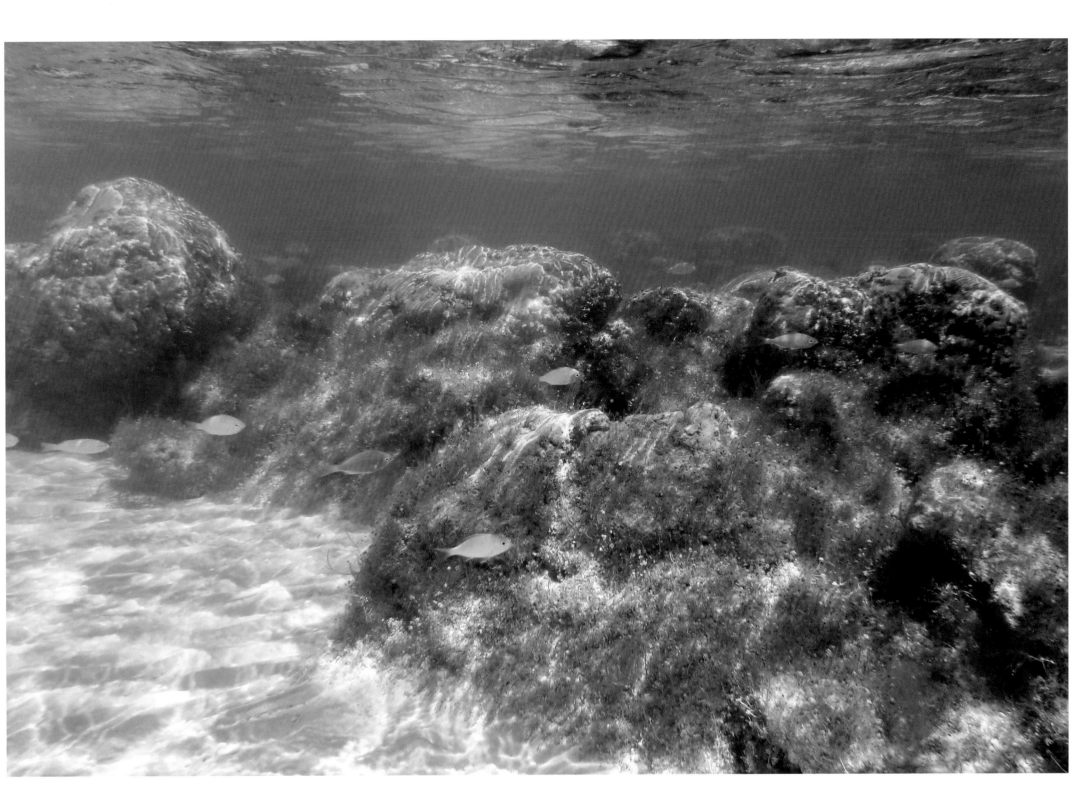

Sub-surface Stromatolites #1211-0950 (2,000-3,000 years old)

CARBLA STATION, WESTERN AUSTRALIA

Stromatolites #1211-0518 (2,000-3,000 years old)

Wagon tracks through dead Stromatolites #12/1 - 0235

SHARK BAY, WESTERN AUSTRALIA

Four billion years ago, Earth would have been completely unrecognizable to us. There were no continents and very little oxygen. It's hard to say exactly when life first appeared and what exactly that life was—in fact, it's remarkable that we know so little about the origins of life on our planet. We know more about surfaces of other planets than we do about the beginnings of life on our own. One thing we do know, however, is that about 3.5 billion years ago, the stromatolites began to form and took on the colossal job of oxygenating the planet. It was another 3 billion years before the first multicelluar organisms emerged.

Stromatolites break a lot of rules in that they can be simultaneously considered to be biologic and geologic: they are composed of bound cyanobacteria (and sometimes bacteria-like Archaea) combined with nonliving sediments. There are differing theories among researchers about their makeup, either that they are built up over time to form the sometimes mushroom-like structures, or conversely that those forms are the result of the whittling away of larger microbial mats into individual mushroom-like forms. Either way, they require sunlight to perform photosynthesis, the end product of which is oxygen. Stromatolite fossils can be found all over the planet, and living colonies can still be found in Belize and the Bahamas. But the oldest and healthiest population lives in a hypersaline bay north of the Hamelin Pool in the restricted area of Carbla Station in Western Australia. The Shark Bay stromatolites, the most famous and most frequently visited, are for the most part actually dead, which you can readily tell from the fact that they've turned black.

Before I set out from Perth on the more than 500-mile drive, Dave Todd put the fear of the outback in me, piling up my little rental car with many extra gallons of water, plenty of sunscreen, and nonperishable food should I run into any car trouble along the way.

It was a long, hot drive.

Despite the fact that the farm was run by a relatively young couple and I was the only guest and there to work, I didn't feel all that welcome at Carbla Station. The ranger, Ross Mack, on the other hand, who had been a little reticent at first to take me out to the site, ended up being one of the kindest and most helpful people I met on this expedition. (At the end of our outing, he decided to give me his old Nikonos

underwater camera—the same model as the one I took to Spain for the *Posidonia* sea grass, only in proper working order. He drove the two or more hours from the Department of Environment and Conservation office in the town of Denham all the way back down the peninsula to the other side of the Shark Bay the next morning just to give it to me.)

Mack picked me up in his specialized park service truck, and we drove further down the dirt road, past a herd of feral goats, and out onto the beach. Lines of stromatolites stretched down the shoreline in either direction—much further than I expected—and others extended out into the water, gradually disappearing beneath the waves.

The temperature climbed to 112°F. It wasn't the easiest shoot day. I had permission to snorkel among the water-bound stromatolites, but not scuba, which would have required additional layers of official supervision. The hypersalinity in the pool and my lack of a dive belt to weigh me down made it virtually impossible to stay beneath the water's surface. I stripped off my wetsuit to decrease buoyancy, which helped a little, but it was still quite difficult to stay still enough to make the photos I wanted. I swam in the direction that Mack indicated should yield the best views, and indeed, I saw the stromatolites' rock-like forms, substantially larger than those above water, and some covered with other undersea life. For a fleeting moment, I looked back through a window of time onto an Earth without continents and only the most primitive forms of life. The stromatolites at the shoreline, half in the water and half out, battered by the intense sun, only heightened the primal connection of some of the earliest life on the planet, waiting and wanting to evolve.

A crater from a meteorite can be found just a little ways inland from the beach amid the craggy vegetation. Standing on a microbial mat in the intense heat, it doesn't feel all that farfetched to imagine that life on Earth could have started on this very beach with a microscopic stowaway from elsewhere in the incomprehensible vastness of the universe.

ANTARCTICA

Moss

ELEPHANT ISLAND	SOUTH GEORGIA
AGE 5,500 years	AGE 2,200 years
LOCATION Elephant Island	LOCATION South Georgia
NICKNAME N/A	NICKNAME N/A
COMMON NAME Antarctic moss	COMMON NAME Antarctic moss
LATIN NAME *Chorisodontium aciphyllum*	LATIN NAME *Polytrichum-Chorisodontium*

Approaching Elephant Island #0212-0557

ANTARCTICA

My first ever overnight at sea was spent on some of the roughest ocean anywhere on the planet: the Drake Passage. I was in search of 5,500-year-old moss. In Antarctica.

A couple of years had passed between receiving a hot tip on the old moss from a friend's travel guide and getting my hands on published research. Finally, I unearthed a 1987 paper by Svante Björck and Christian Hjort confirming the age and location of the moss on Elephant Island—named for the elephant seals, not the pachyderms—which arcs eastward beyond the Antarctic Peninsula. I tracked them down at Lund University in Sweden, with a barrage of questions.

There is a special thrill to meeting researchers who not only study these ancient organisms but who are also the first to discover and identify them. It underscores what is so easy to forget in our quotidian existence: there is so much yet to be done, so much we do not know—and brushing against the arm of discovery is invigorating. As far as we know, twenty-five years later, not a single person had set eyes on the old moss since they discovered it. That is, until my visit.

Elephant Island is perhaps best known as the infamously inhospitable landmass made home by the marooned Shackleton crew. In 1914, the last voyage of "The Heroic Age of Antarctic Exploration," Ernest Shackleton and his twenty-eight-man crew set out to make Antarctica's first-ever land crossing. That objective never stood a chance, but their unfathomable tale of survival more than earned its nickname, the *Endurance Expedition*. Their ship crushed and sunk by the Weddell Sea, they spent months living on the ice before an impossible journey to the solid ground of Elephant Island. What was left of their rations tapered off then disappeared entirely, tobacco one of the hardest losses. They took it so hard, in fact, they attempted to smoke native lichen, though with little satisfaction. Thank goodness their camp was on the opposite side of the island from the moss bank or they might have attempted to smoke that, too.

Antarctica is *enormous*, and the chance of finding anything, let alone a little dark growth against the glare of snow and ice—well, good luck. It was pre-GPS when Björck and Hjort did their field research. They'd been dropped off by helicopter, and therefore couldn't suggest an approach beyond the name of the nearest bay. I put out feelers to NASA, the British Antarctic Survey, and Google for help. Ultimately it was

Google Earth that came through, connecting me with the Polar Geospatial Center at the University of Minnesota, where they work with some of the most sophisticated remote imaging technologies currently in use.

These days it is easier to reach Antarctica from space than from Earth. But that wasn't going to stop me from trying.

––––––––––

The storm in the distance was on top of our ship in minutes. Snow whipped past the windows and whitecapped, steel-gray waves battered the sides, disturbing the ship's rhythmic rocking from front-to-back and side-to-side, turning it into something entirely unpredictable. Despite my best attempts at mind over matter, I spent my first morning at sea doubled over vomiting, and the rest of the day in meclizine-medicated sleep. Thankfully my discomfort was short-lived. Like so many ships in the night, we had made it through the open ocean, and something magical started to happen: *We were in Antarctic waters.*

The prescient captain had sighted the first iceberg, dark and distant, the previous day. But in the clear light of the third morning, their numbers multiplied. Some were sizeable, reflecting back pockets of saturated blues, others like shards of ice cubes melting in a neglected drink. Dots of land reappeared, mountainous and snow-covered, and the animal sightings started in earnest: Adélie and Gentoo penguins, cormorants, crab-eater seals, storm petrels, belligerent skuas, giant albatrosses. A leopard seal captured an Adélie for lunch, batting it about, catlike, though not in play. It was trying to crack it open like a nut to get at the tender parts inside.

Meanwhile, I was looking for something else on our first stop, Cuverville Island, close to, but not quite on, the continent. Large moss banks and orange lichens flanked the steep inclines off the beach, the guano of the penguin colony providing nutrients, the bryophytes literally creating their own turf on rocky outcroppings where the snow and ice have trouble keeping hold.

We pressed further southward, then anchored in Neko Harbor. I stepped from the ship down onto a Zodiac, and was greeted by a pair of humpbacks, popping heads

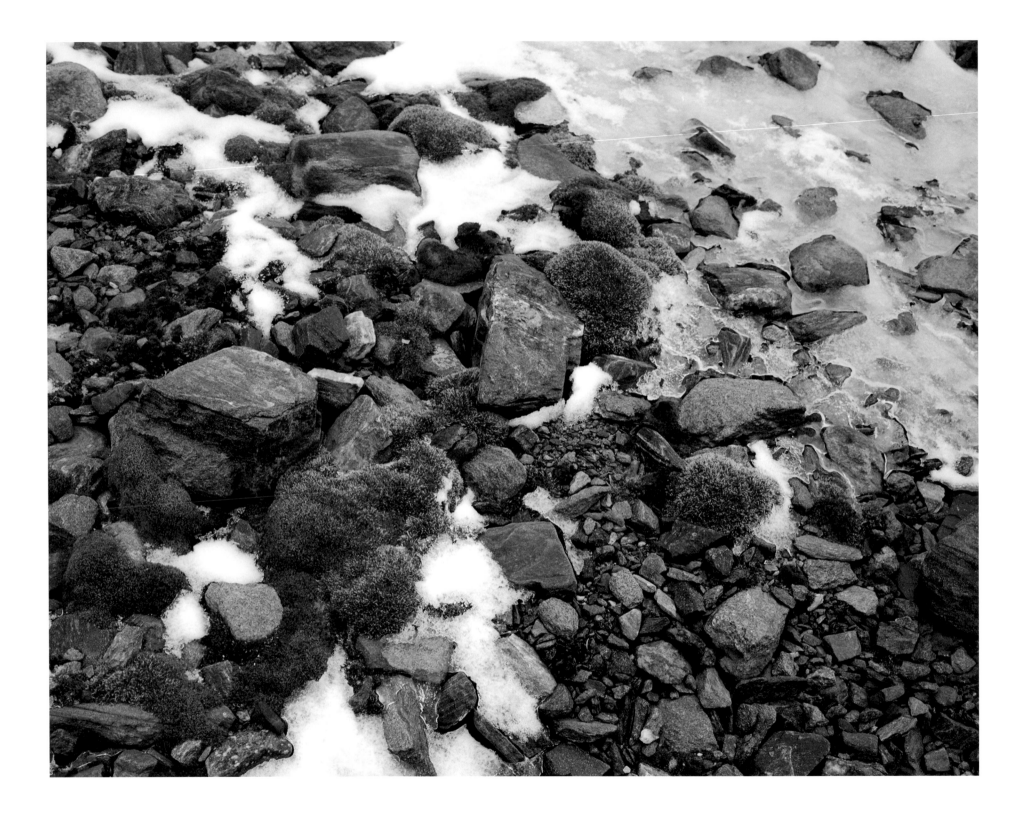

Moss Growth on Southwest coast #0312-08B35

ELEPHANT ISLAND, ANTARCTICA

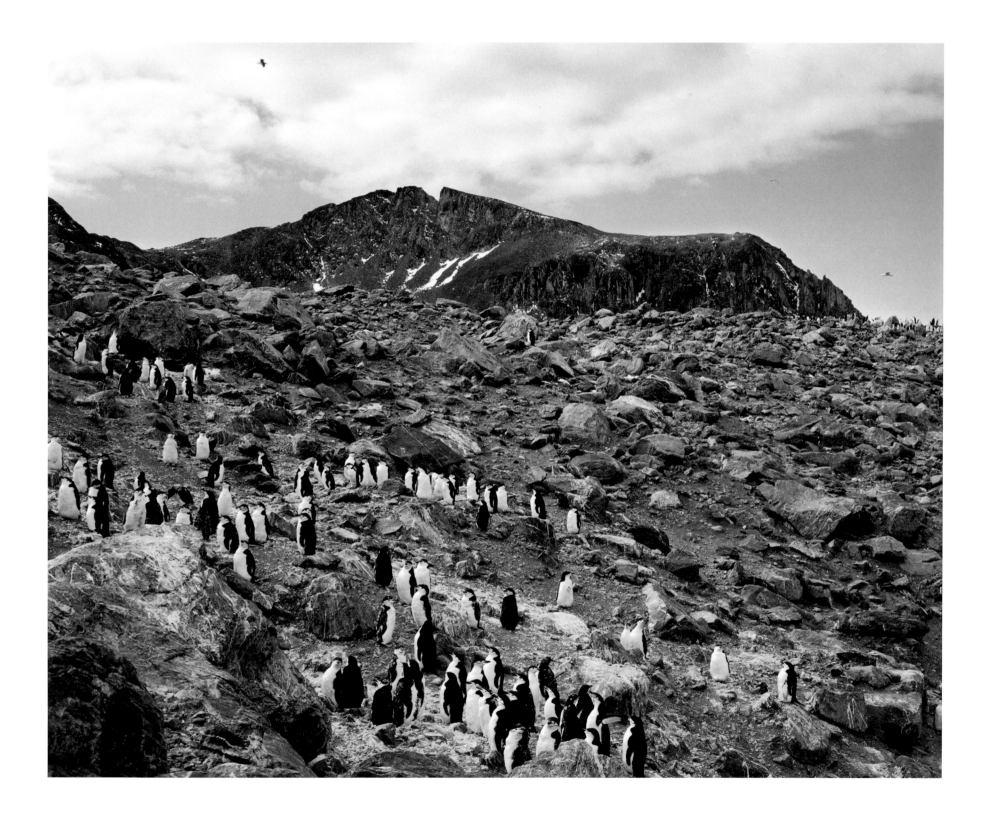

Antarctic Moss # 0212 - 7A12 (5,500 years old)

ELEPHANT ISLAND, ANTARCTICA

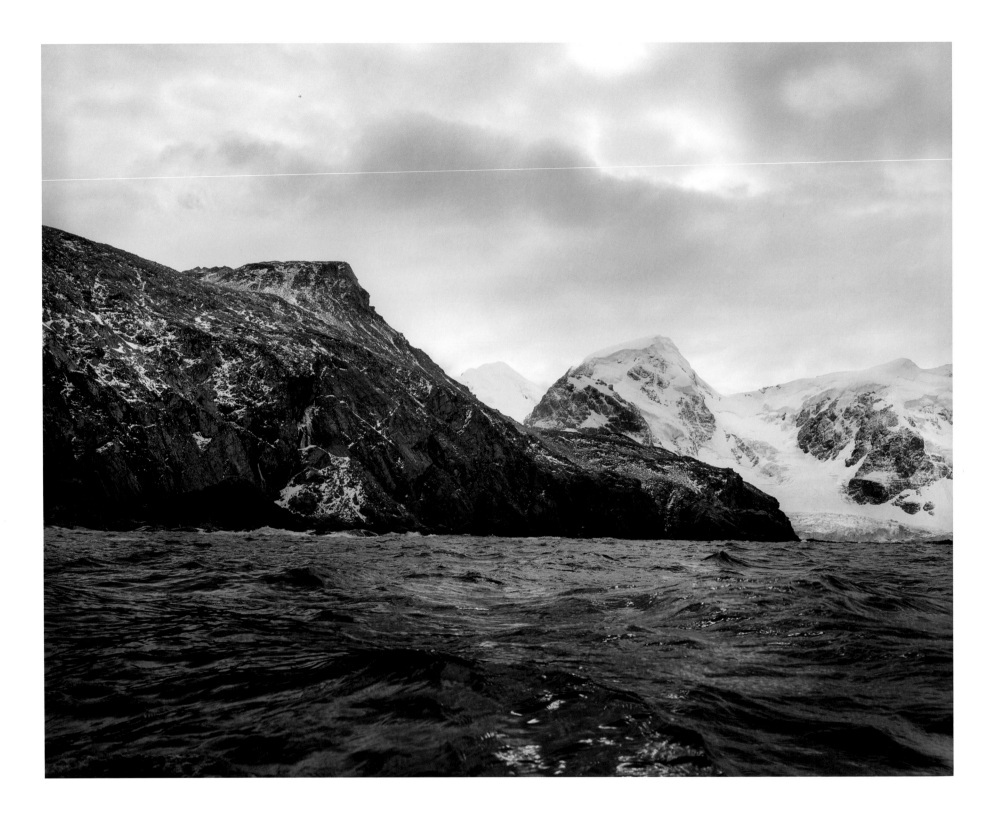

Antarctic Moss # 0212-7B33 (5,500 years old)

ELEPHANT ISLAND, ANTARCTICA

and tails above the surface. When their curiosity was sated they receded back into the deep, and we to a bit of sandy beach, muck boots splashing lightly in the icy water.

I was gripped, almost physically, with the sheer magnitude of this place, frozen in deep time yet brimming with uniquely adapted life.

I set foot onto my last continent for the first time.

———————

We'd come upon Elephant Island in the night. I was up before the alarm, standing on the bridge with the captain, looking at a 1987 photograph from the original research expedition. As I tried to match the forms in the cyan, dust-specked picture with the outlines of the rocky coastline, I realized the downward slope in the photo was angled in the wrong direction—it had been scanned in backward. Not only that, but the scientific paper misidentified the background landmass as Clarence Island when it is, in fact, Cornwallis. These understandable human errors underscore the difficulty of maintaining accuracy in this vast and largely homogeneous continent, particularly before GPS. The challenge was so great, in fact, that one of the first ancient mosses discovered in the early 1980s has already been lost to history— discovered once and never found again.

Our first stop was Point Lookout, on the far west. I eagerly went ashore with the staff. My chances of setting foot on Elephant Island had been given in single digits, so I wasn't going to miss this opportunity, even though my ambitions were set eight or nine miles to the east. So many different factors had to align to make a landing. Clear skies aren't enough; the total of any given day's weather is compounded many times over, brewing on one shore and actualizing on another.

When we landed on the rocky beach, I parted from the group and scaled a steep, icy slope to browse a number of small mosses. From afar it had seemed improbable that anything could live here. But the cushions of green were luxuriant. Meanwhile, the group had shifted position on the beach below, so I had to make my way through packs of chinstrap penguins and less benign adolescent fur seals and elephant seals—one of them so large it hardly seemed real. My heart beat wildly as

they barked their complaints and bared their dull, bacteria-riddled teeth at me. Any one of them could bowl a person over with their ungainly body weight, like a couple of angry football players advancing clumsily in a shared sleeping bag.

From the other side of the gauntlet, a naturalist waved me through with a big OK sign.

Once safely returned to the ship, I went directly back to the bridge. In addition to the original materials, I was equipped with some of the more advanced tools of the intervening twenty-five years, thanks to the help of Paul Morin of the Polar Geospatial Center. A high-resolution map of nautical approaches and a marked-up satellite image of Elephant Island were open on my laptop. We neared Walker Point, which morphed from an abstraction into a tangible form jutting out between two blankets of glaciation.

The captain picked up the binoculars, fixed his gaze slightly starboard, and then handed them to me. The skies were clearing, and I could see the moss, a blush of warm green sunning itself on a high shelf of otherwise frozen, spiny mountain. *I see it. I am here.*

I bolted down to the mudroom, where the expedition leader, a naturalist and legendary explorer Peter Hillary geared up to join me on a rapid-fire landing. I had an extremely short window of time to get ashore and make some photographs. We climbed aboard a Zodiac suspended alongside the ship on a device that looked suspiciously like a rope swing and were slowly lowered into the bucking waves below.

We sped across the distance to the shore, pounding hard against every wave while I white-knuckled a thick rope in one ungloved hand, later bloody from the friction. I clutched a camera inside the pocket of my parka with the other. At moments we were completely airborne, an exaggerated second hanging in the air, bracing for impact. I thought back to my 2008 expedition to Greenland, where Martin Appelt, the Danish archeologist, had coached me to relax my muscles as we careened across the fjord. No one wins a battle of strength against these seas.

Once ashore, Hillary—who has scaled Everest more than once, trekked overland to the South Pole, and served as trusted guide of Neil Armstrong to the North Pole—

became my photo assistant, helping get cameras out of waterproof bags designed to protect against the salty sea spray. We scampered up slippery rocks, stirring up a riot of wildlife as I scanned for a vantage point to make images of the moss. The bank was high on a cliff, at least a couple hundred meters up and still some distance away, but just as we landed it was time to return to the ship.

I depressed the shutter and advanced the film.

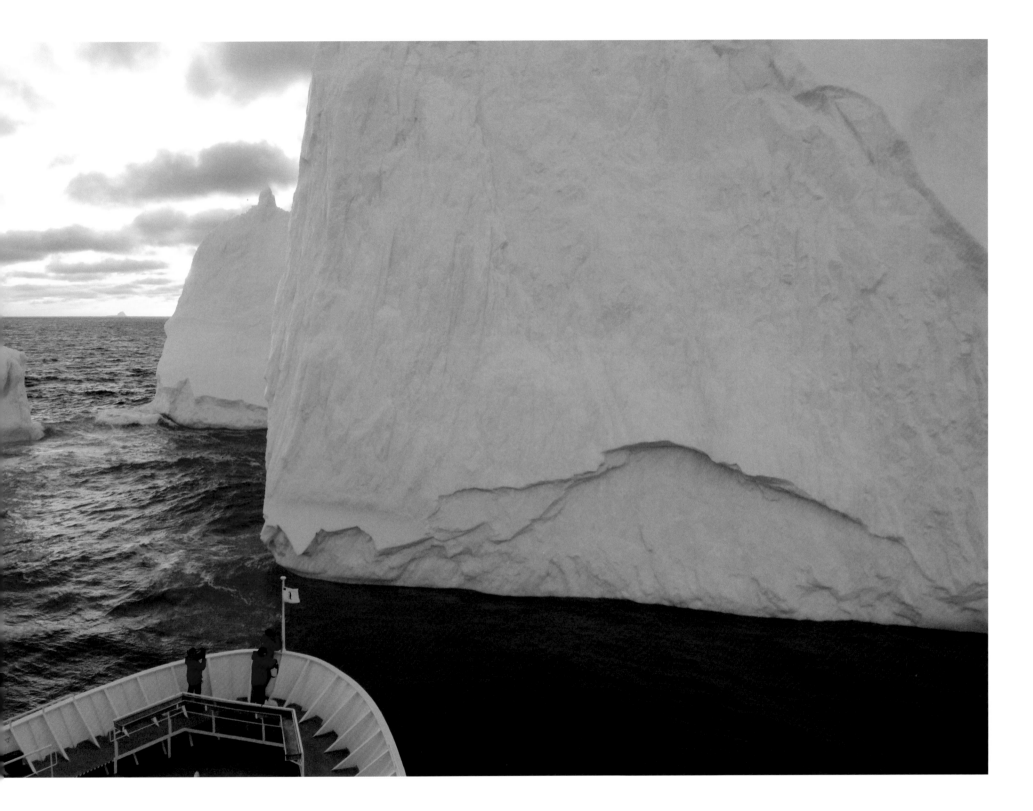

Icebergs #0212-0398

Almost exactly one hundred years ago, five men set out on an 870-nautical-mile journey on a twenty-two-foot glorified rowboat across the Drake Passage. Shackleton and his crew were coming to their own rescue.

I, too, was headed to South Georgia; the same route, though hardly the same journey. I peered out the windows of the *National Geographic Explorer*, secure and comfortable, as we rounded the far eastern point of Elephant Island and the very cove where Shackleton and his men found some small respite from the icy waters. I drew a mental picture of that place, too depleted after my morning's efforts to get my camera.

Two days later we were in South Georgia, a veritable paradise of animals, vegetation, and exposed geology, like the history of the world writ large on the landscape itself. And here, too, are etched the final chapters of the Shackleton story; the thumbnail of a beach where they first landed, the spot where they set out across terrain just this side of passable, the last ridge that separated an impossible journey of perseverance back into a remote outpost of civilization: a whaling station in Stromness Bay.

The captain pulled us so far into the harbor we were practically on the beach. Despite some cloud cover and a bit of snow coming in, conditions were calm, and I hopped into a Zodiac with Stephanie Martin, a marine mammal researcher, and we zipped down one harbor to Husvik. The moss I was now after, my "backup moss," if you will, is 2,200 years old and growing on top of a 9,000-year-old fossilized moss bed. Fortified with research and a map provided by Nathalie Van der Putten, who discovered it, I scanned the outline of the topography to home in on Kanin Point.

The beach and tussock grass was so lousy with seals that Martin became my de facto seal bodyguard, and likewise instructed me on how to keep them at bay. The first rule is to make loud noises. The second is to carry a paddle from the Zodiac. One might be tempted to smack a snarling fur seal on the head, but it isn't necessary— just tapping them on the flippers is deterrent enough. (Which is not to say that no one got bitten over the course of the expedition.)

I climbed through the tussock and saw the ancient mounds of peat. I had found it.

Medusa Kelp in Hercules Bay

SOUTH GEORGIA

Antarctic Moss, Whale bones #0312-0014 (2,200 years old)

Antarctic Moss #0312-14A05 (2,200 years old)

KANIN POINT, SOUTH GEORGIA

Whaling Station Remains #0312-16B33

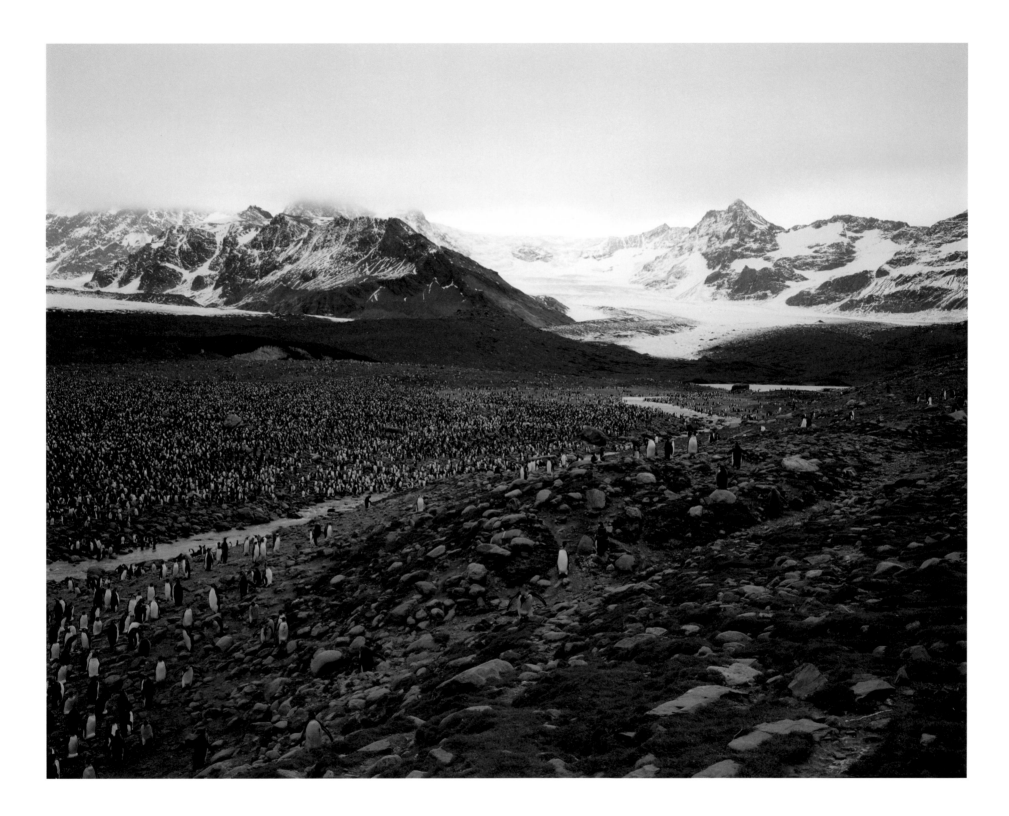

300,000 King Penguins # 0312-13416

GOLD HARBOR, SOUTH GEORGIA

Overland to Shackleton's Grave # 0312-16A01

TOWARD GRYTVIKEN, SOUTH GEORGIA

Elephant seal guarding Shackleton's grave # 0312-40150

GRYTVIKEN, SOUTH GEORGIA

I took some photos, this time close in, feeling unbelievably fortunate to have found not just one, but both of these ancient moss banks. Later that same afternoon, I hiked overland from a little inlet across a magnificent, hilly landscape to the plot where Shackleton is buried. My heart was once again gripped with the magnitude of this place, ancient and primeval in its makeup. It was like seeing the planet in earnest for the first time.

If Shackleton's story had been written as fiction, surely someone would criticize it for having an unrealistic number of obstacles. He had returned to South Georgia five years after his harrowing circuit, and, as if living on borrowed time, died of a massive heart attack the very night he arrived. He died having no idea he shared Elephant Island with one of the oldest living things on the planet, or that he would end his journey in South Georgia just a stone's throw from yet another. But I have a feeling he would have approved of the quiet perseverance of these unassuming mosses, in this landscape that speaks of deep time, the humbling power of the natural world, and the precariousness of life in its clutches.

I poured some whiskey on Shackleton's grave, and some for me, too.

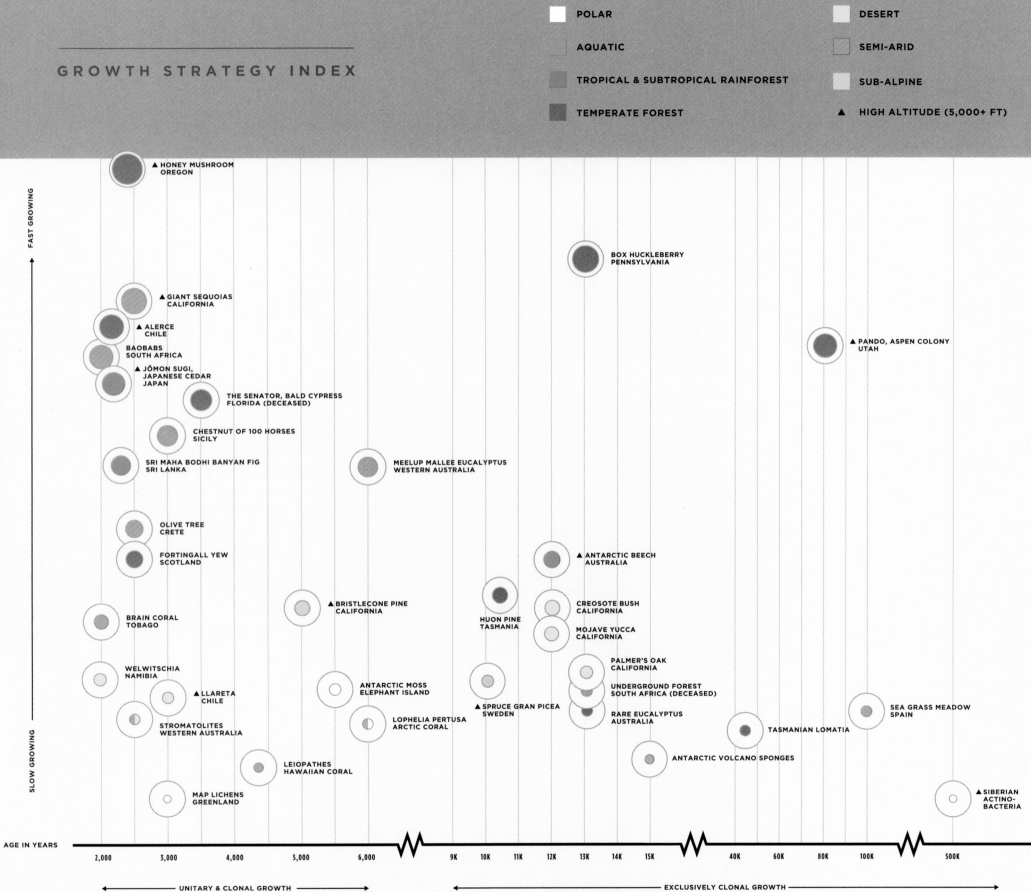

GROWTH STRATEGY INDEX

Legend:
- POLAR
- AQUATIC
- TROPICAL & SUBTROPICAL RAINFOREST
- TEMPERATE FOREST
- DESERT
- SEMI-ARID
- SUB-ALPINE
- ▲ HIGH ALTITUDE (5,000+ FT)

Y-axis: ROUGH GROWTH RATE ESTIMATIONS ACCOUNTING FOR BOTH SPREAD AND VOLUME — FAST GROWING (top) / SLOW GROWING (bottom)

X-axis: AGE IN YEARS

Data points:
- ▲ HONEY MUSHROOM, OREGON
- BOX HUCKLEBERRY, PENNSYLVANIA
- ▲ GIANT SEQUOIAS, CALIFORNIA
- ▲ ALERCE, CHILE
- BAOBABS, SOUTH AFRICA
- ▲ JŌMON SUGI, JAPANESE CEDAR, JAPAN
- ▲ PANDO, ASPEN COLONY, UTAH
- THE SENATOR, BALD CYPRESS, FLORIDA (DECEASED)
- CHESTNUT OF 100 HORSES, SICILY
- SRI MAHA BODHI BANYAN FIG, SRI LANKA
- MEELUP MALLEE EUCALYPTUS, WESTERN AUSTRALIA
- OLIVE TREE, CRETE
- FORTINGALL YEW, SCOTLAND
- ▲ ANTARCTIC BEECH, AUSTRALIA
- ▲ BRISTLECONE PINE, CALIFORNIA
- CREOSOTE BUSH, CALIFORNIA
- HUON PINE, TASMANIA
- MOJAVE YUCCA, CALIFORNIA
- BRAIN CORAL, TOBAGO
- WELWITSCHIA, NAMIBIA
- PALMER'S OAK, CALIFORNIA
- ANTARCTIC MOSS, ELEPHANT ISLAND
- UNDERGROUND FOREST, SOUTH AFRICA (DECEASED)
- ▲ LLARETA, CHILE
- SEA GRASS MEADOW, SPAIN
- ▲ SPRUCE GRAN PICEA, SWEDEN
- RARE EUCALYPTUS, AUSTRALIA
- STROMATOLITES, WESTERN AUSTRALIA
- LOPHELIA PERTUSA, ARCTIC CORAL
- TASMANIAN LOMATIA
- ANTARCTIC VOLCANO SPONGES
- LEIOPATHES, HAWAIIAN CORAL
- MAP LICHENS, GREENLAND
- ▲ SIBERIAN ACTINO-BACTERIA

X-axis values: 2,000 | 3,000 | 4,000 | 5,000 | 6,000 | 9K | 10K | 11K | 12K | 13K | 14K | 15K | 40K | 60K | 80K | 100K | 500K

← UNITARY & CLONAL GROWTH → ← EXCLUSIVELY CLONAL GROWTH →

Roads Not (Yet) Taken

I haven't yet visited everything on my map, nor do I think that every species that has made it past the 2,000-year mark is represented—namely because there's no chance we've indentified them all yet. "Phase 1" of this project took a decade (culminating with this book), and "phase 2" may well be the rest of my life. Given that practically half of my subjects have been discovered in the past thirty years alone, just imagine how many we could find in the next thirty, should we turn our attentions to it.

So, why is it that I haven't visited everything I *do* know about?

(1) I learned about a subject too late.

Antarctica seemed to serve as a logical demarcation for the end of phase 1, but unfortunately that meant that some other worthy subjects I learned about later wouldn't make the cut, namely due to lack of time and funding. This was the case for the more than 4,000-year-old Grand Ginkgo King in Li Jiawan, China, and the *Tnjri chinar* plane tree in Armenia, which someone just brought to my attention last week.

(2) Safety.

As a single, atheist, American woman of Jewish descent, I did not feel safe enough to travel to Iran for the 4,000-year-old cypress of Zoroaster. When it came down to it, I considered two things. First, I have other cypresses already in the project, lessening the need to photograph this one. Second, I don't feel educated enough in a cultural, social, or political sense to make the trip, given the instability in the region. I truly wish it were otherwise, and do not mean offense to anyone in making that decision, especially the Iranians who encouraged me to visit. It's worth stating again: these organisms are global symbols that transcend the things that divide us. (Speaking of which, check out the SESAME project, an ambitious scientific cooperative of Middle Eastern nations, for an excellent and hope-filled example of science bridging seemingly unbridgeable cultural gaps.)

(3) I learned about a subject after I reached a distant country, but didn't have the time or resources to add it to my itinerary.

The first time I ran into this problem was with some clonal aloe in South Africa,

which Braam van Wyk told me about when I met with him in Pretoria. Later in Cape Town with Ernst van Jaarsveld it happened twice more: I learned about an ancient elephant's foot (a plant, not taxidermy—or pachydermy) in the Eastern Cape, and about a lead tree in Namibia, from whence I had just come. But I was leaving the African continent that afternoon. Likewise, while in Australia, I was reminded of the Te Matua Ngahere, a kauri tree in New Zealand that had somehow slipped from my list, when there was just no feasible way to add a tenth or eleventh stop to that already breakneck itinerary. In early 2013 I almost cobbled together a last-minute trip to visit a gentleman friend in Auckland and the kauri tree in one fell swoop, but when he got cold feet, I called it off entirely after taking a hard look at my credit card balance.

(4) I don't have a submarine.

Sometimes a girl really does need a submarine. Or an ROV (remotely operated vehicle), at least. The deepest and coldest seas are home to four of my would-be subjects, all which happen to be the only other animals that join the brain coral in surpassing the 2,000-year mark: three older corals and a sponge, located in the Arctic, Hawaii, and Antarctica.

There's a 2,742-year-old *Gerardia* coral, and nearby, the 4,265-year-old *Leiopathes*, a black coral related to sea anemones, both discovered in exceedingly deep waters off the Hawaiian archipelago using a submersible vehicle—approximately 1,200 feet down. Older still, in Arctic waters off the Norwegian shelf lives the 6,000-year-old *Lophelia pertusa* coral, around 330 feet down.

The oldest animal on the planet could be the 15,000-year-old *Anoxycalyx joubini* volcano sponge off the McMurdo shelf in Antarctica. I'm not sure of their exact depth, but no one has visited the oldest among them face-to-face, in fact, as they were found using a SCINI ROV—that's "Submersible Capable of under Ice Navigation and Imaging Remotely Operated Vehicle."

In a sense you could say that after visiting Antarctica, there's nowhere left to go but space. But of course that's not true. There is always underwater. And back to Antarctica. Or both.

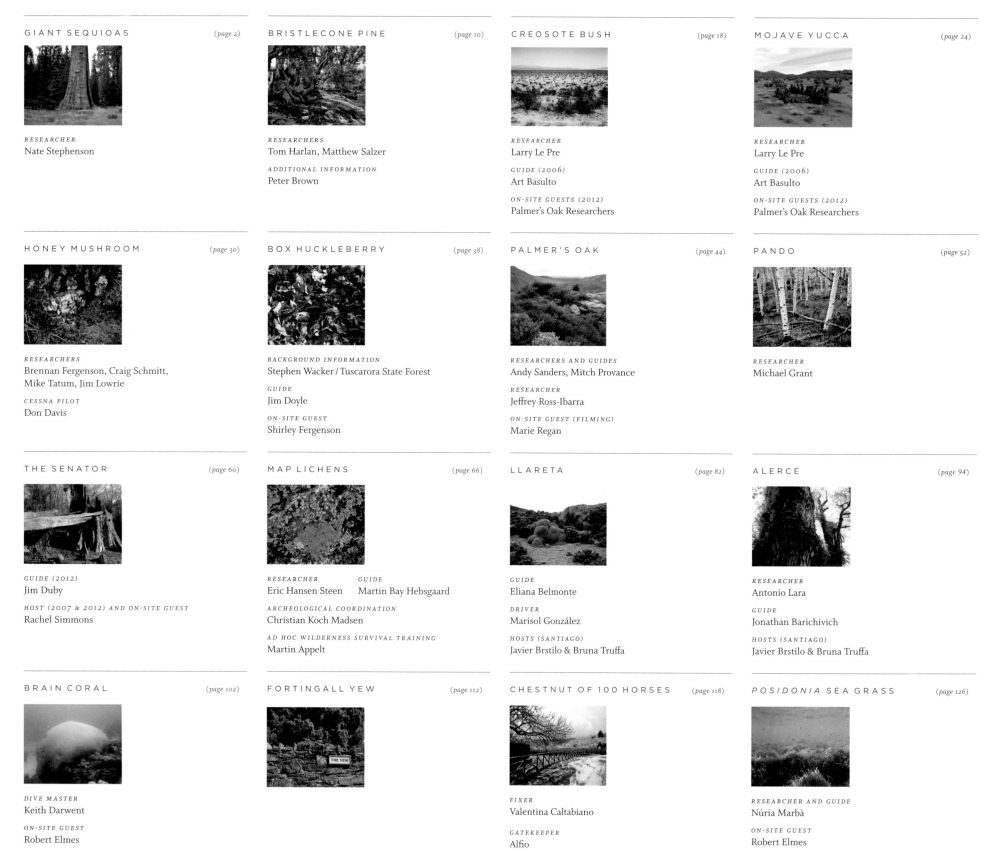

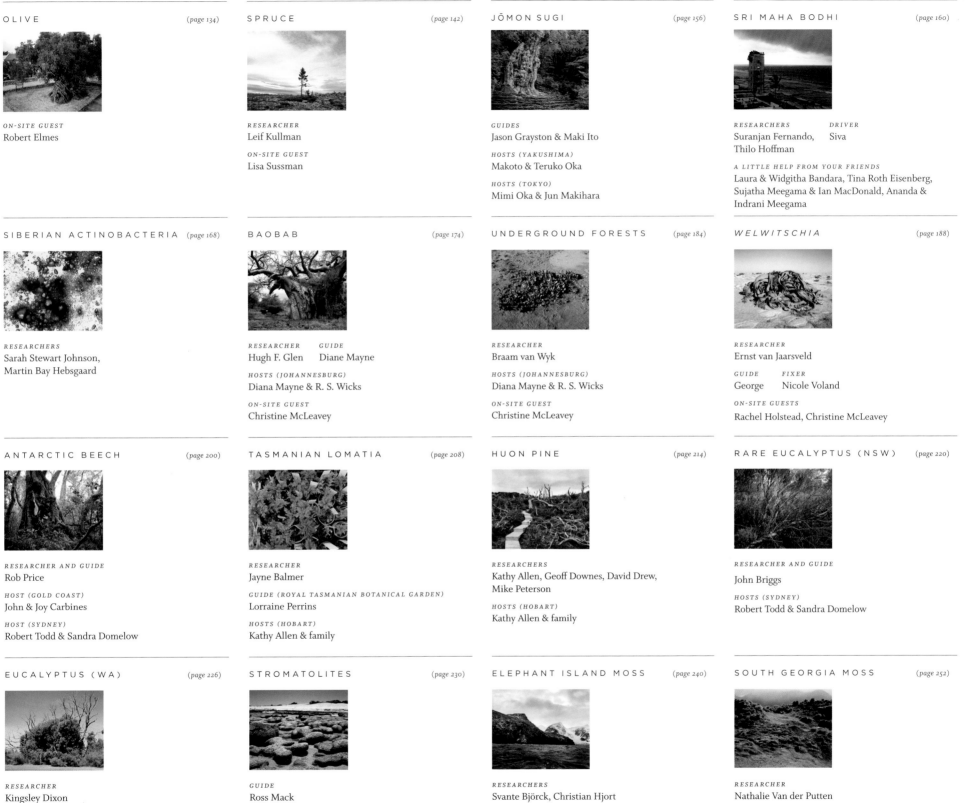

GLOSSARY

ARCHAEA. Primitive organisms comprising their own domain separate from bacteria and eukaryotes, Archaea are thought to have had a their own evolutionary history, distinct from other forms of life. They are prokaryotes, indicating that they do not have nuclei, nor do they have organelles bound by membranes. They often, but not always, live in extreme conditions.

BACTERIA. Like Archaea and eukaryotes, bacteria constitute their own domain. They are prokaryotic single-celled organisms that take on a great number of different shapes and forms and are found in almost every known environment on Earth.

CLONE; CLONAL COLONY. A group of genetically identical plants, bacteria, or fungi that originate through vegetative growth or cell division, as opposed to reproducing sexually.

DENDROCHRONOLOGY. The study of annual tree-ring patterns, or growth rings, allowing for accurate and reliable age determinations for individual trees.

EUKARYOTES. Comprising the domain Eukaryota, eucaryotes are single-celled or multicellular organisms defined by their cellular structure, consisting of a nucleus containing genetic information along with membrane-bound organelles performing organ-like functions within the cell. The plant kingdom, as well as those of animals, fungi, and slime molds, are all part of the domain Eucaryota.

EXTREMOPHILES. A blanket moniker given to microorganisms that grow and thrive in environments that are often fatal to most other life forms. Their ability to flourish in environments that include extremes of temperature, pressure, acid or alkaline levels, and salinity adds to the controversial possibility that they were tied to the beginnings of life on Earth, potentially originating from elsewhere in the universe.

LIGNOTUBERS. Found primarily in woody shrubs and trees subject to drought and fire, lignotubers are growths below the plant stem that store buds and nutrients, allowing new stems to sprout after a stressful period or incident.

LICHENOMETRY. The practice of employing the study of the growth rates and patterns of lichens to determine the amount of time a surface—such as rock or archeological site—has been exposed. Such information is often used in tandem with other dating methods to help confirm the age of a subject. Lichenometry can be especially helpful in more recent time periods, where radiocarbon dating is less accurate.

MYCOLOGY. The study of fungi.

PROKARYOTES. Usually unicellular (though not always), prokaryotic organisms are defined by a cellular structure lacking a nucleus; all their component elements are simply bound by their outer membrane.

RADIOCARBON DATING. A widely used scientific method for dating organic materials, also referred to as carbon dating, or carbon-14 dating. The practice examines the ratio of decayed carbon 14 to stable carbon 12. Because of the 5,700-year half-life of carbon 14, the technique is useful back to about 60,000 years. It is less useful for dating younger materials, where the carbon 14 has had less time to decay.

TREE-RING CHRONOLOGY. Utilizing the tree-ring counts from multiple trees, highly accurate chronologies over large time scales can be built. For instance, a 2002 study in Sweden utilized 880 living, dry dead, and subfossil northern Swedish pines to create a precise 7,400-year tree-ring chronology, as opposed to a single tree of that age.

UNITARY ORGANISM. A genetically and physically defined individual organism.

VEGETATIVE REPRODUCTION; SELF-PROPAGATION. The asexual reproduction of new individuals through means such as rhizomes, suckering, and tubers, but not via the sexual production of seeds or spores. Over time, self-propagating plants can constitute a clonal colony.

CHRONOLOGICAL INDEX

BIOME INDEX

EARLY ITERATIONS OF SOME OF THE CHAPTERS APPEARED ON THE *NEW YORK TIMES* LENS BLOG AND BRAINPICKINGS.ORG